THE OTTOMAN SILK TEXTILES
OF THE ROYAL MUSEUMS OF ART
AND HISTORY IN BRUSSELS

ROYAL MUSEUMS OF ART AND HISTORY
with the collaboration of
the **ROYAL INSTITUTE FOR THE CULTURAL HERITAGE**

The Ottoman Silk Textiles
of the Royal Museums of
Art and History in
Brussels

Daniël DE JONGHE
Marie-Christine MAQUOI
Ina VANDEN BERGHE
Mieke VAN RAEMDONCK
Vera VEREECKEN
Chris VERHECKEN-LAMMENS
Jan WOUTERS

BREPOLS

D/2004/0095/6

ISBN 2-503-51186-4

Printed in the E.U. on acid-free paper

Photography
 Raymond Mommaerts
 Raoul Pessemier
Typography
 Dominique Coupé

CONTENTS

Introduction

Anne Cahen-Delhaye, Acting Director

The Royal Museums of Art and History, commonly known as the Cinquantenaire Museum, possess a collection of about 1200 Islamic art objects (not counting some 1000 potsherds from Fustat). These objects originate from countries between Spain and India and date from the 7th to the beginning of the 20th century. The emphasis is on silk textiles, a fact that we owe to Isabella Errera (Florence 1869-Brussels 1929) who donated or bequeathed some 300 Islamic silk fabrics to the museum. Moreover, Isabella Errera was not only an enlightened patron, but also a real connoisseur of ancient textiles. Among her publications, the three catalogues –in which each considered textile is illustrated– constitute a study aid for researchers still today.

Of the 300 Islamic textiles, 43 are Ottoman and form the subject of this study. With the exception of two for which we have our doubts, these specimens were woven in the major metropolitan weaving centres of the Ottoman Empire, namely Bursa, Istanbul and their surroundings. All date from the period between the late 15th and the early 19th century. Two of the three main types of weaves are represented. Firstly the velvets, of which the collection includes 25 examples, one of them being an important *çatma*, probably the earliest preserved in the world. Secondly the *kemha* or *lampas* fabrics, of which we preserve 16 specimens, 6 of them bearing inscriptions, the others decorated with various patterns. The third main type of Ottoman weaves, the *serâser* or cloth of gold and silver, rare in Western collections, is not represented here. Finally, the collection contains two silks in a distinctive weave, extended tabby, one of which is a military banner. Although these fall slightly out of the otherwise homogeneous group, they were not excluded from this study because they were certainly produced within the Ottoman realm.

The aim of this catalogue is to publish this ensemble, to put on record a *status quaestionis* of the relevant knowledge we have gathered and to place it at the disposal of other museum curators and researchers. Since the scrutiny of the weaving technology and of the natural dye analyses can lead to a better understanding of the silk industry, special focus has been laid on these aspects. At the same time it offers concrete elements to delimit groups of textiles, as well as one day perhaps groupings of workshops or production centres. The standard work on Ottoman silk textiles, *IPEK*, written by Nurhan Atasoy *et al.*, came out in 2001 and we drew on the information it procured with great appreciation. Pieces from the Topkapı Palace Museum in Istanbul and from the Mevlana Museum in Konya became known, as well as nearly 70 dateable items preserved in churches and imperial treasuries in the Balkans and Northern Europe, giving at least a *terminus ante quem* for some of our pieces. Moreover, this up-to-date study of archival documents and of (art-) historical aspects was of great help.

The present catalogue is the result of the collaboration between different specialists who remain otherwise responsible for their part of the work. The technological study of the velvets was executed by Daniël De Jonghe, textile engineer and independent scientific collaborator in our museum since 1978. The *lampas* fabrics and distinctive weaves have been studied by Chris Verhecken-Lammens, also an independent scientific collaborator in this institution since 1989. For the natural dye analyses and conservation treatment, the museum appealed naturally to the Royal Institute for the Cultural Heritage also located in the Cinquantenaire complex. Here, the study and the report of the natural dyes was performed by Ina Vanden Berghe, textile engineer, and Dr Jan Wouters, chemist, Head of the Laboratory of Materials and Techniques, with the prac-

tical assistance of Marie-Christine Maquoi, lab technician. The conservation treatment has been carefully kept by several restorers working under the responsibility of Vera Vereecken, Head of the Textile workshop, who also wrote the reports and comments on this aspect. The curator of the Islamic collection, Mieke Van Raemdonck, traced the origin of the collection, situated the silks in their context and described them.

We owe great gratitude to these specialists, both for the work they have done on the objects preserved under our responsibility and for their contribution to this catalogue. Finally, we thank Mieke Van Raemdonck for editing this catalogue, which we hope will contribute to a greater acquaintance with and appreciation of the treasures our museum preserves within its walls.

Acknowledgments

The authors wish to express their gratitude to the following persons for giving them access to their collections and/or supplying them with precious information:

Nobuko CAJITANI, The Metropolitan Museum of Art, New York
Ingrid DE MEÛTER, Royal Museums of Art and History, Brussels
Marie-Hélène GUELTON, Musée des Tissus, Lyon
Frances PRITCHARD, The Whitworth Art Gallery, The University of Manchester
Ulrike REICHERT, *Deutsches Textilmuseum Krefeld*
Jean-Marie SIMONET, Royal Museums of Art and History, Brussels
Frieda SORBER, Mode Museum, Antwerp
Jennifer M. WEARDEN, Victoria & Albert Museum, London

1. Isabella Errera and the origin of the collection

Mieke Van Raemdonck

Among the 43 Ottoman silks studied in this catalogue, 39 were collected by Isabella Errera. In 1903, she donated 24 of them, namely those she had acquired between 1894 and 1901[1]. The 15 others, which she had purchased between 1901 and 1914[2], were initially deposited in the museum as a loan and eventually bequeathed[3]. Thus the Royal Museums of Art and History of Brussels have this benefactor to thank for the predominant part of the Ottoman textile collection. Actually, this conclusion applies more or less to the museums' textile collection in its entirety. The gift of Isabella Errera, which encompasses in all 764 pieces, forms roughly the quarter of the whole museums' textile collection[4]. Because of the importance of this donation, a gallery was dedicated to this enlightened patron, who was not only gifted with excellent taste, but who became –thanks to an open mind and an intellectually inspiring and internationally oriented entourage– a real connoisseur of ancient textiles. Among her publications, her three catalogues form still now an important study aid for researchers[5]. For these reasons it seemed useful to evoke here her background and her relation to our institution[6].

Born in Florence on 5 April 1869, Isabella was the daughter of John Goldschmidt from Frankfurt and of Sophie Francetti. In 1890 Isabella married Paul Errera, an art patron, jurist, professor and, from 1908 to 1911, Rector of the *Université Libre de Bruxelles*. This marriage allowed Isabella plenty of time and opportunity to devote herself to her research in the field of art history[7] and to enlarge the art collection of the Errera family. With her husband, she kept a famous *salon*[8] where the intellectual and artistic upper class of Brussels was weekly assembled. The Erreras especially supported young artists amongst the rising movement of the *Libre esthétique,* namely Fernand Khnopff who painted her portrait[9] and offered her the printed cotton *The four seasons* of Walter Crane she donated subsequently to the museum[10] and Octave Maus who devoted probably the first article to her special field of interest, the ancient textiles[11]. As far as we could retrace, this article is the only one that allows us to have a close look inside the core of her collection. Octave Maus is therefore a privileged witness.

In 1900, after having visited the collection of the lady, he called "Mme Paul Errera of Brussels, who, not content with being merely a charming mondaine, has devoted herself to the fascinating pursuit of collecting art textiles with an ardour seldom seen[12]", he wrote: "Her collection was started in 1891 (sic), most of the specimens coming from Paris or from Spain and Italy. There are now nearly 500 articles in this fine collection, all methodically classified and artistically arranged in their glass cases. A well-arranged catalogue adds much to the interest of this almost unique display. The most ancient specimens of textile work in Madame Errera's collection are of Coptic origin, while the most recent date from the end of the eighteenth century". And further: "With a spirit of generosity worthy of more frequent imitation, Madame Errera has recently presented a part and promised the rest of her treasures to the *Musée des Arts Décoratifs et Industriels* in Brussels[13]". From this article it became clear that the subject of the study of Isabella Errera was the ornamentation of textile fabrics through the ages, without any geographical or time limits. Her aim was to "trace stage by stage the successive evolutions of taste from the remotest times", as Octave Maus formulated it in the introduction of his article, adding: "therein are reflected as in a clear mirror all the contributions of the various ages towards the development of what we term 'decorative feeling'[14]".

This unique testimony is illustrated with 10 photographs of "some of the most important specimens[15]". The descriptions and attributions of the textiles are detailed and they manifestly result-

ed from a discussion between Octave Maus and Isabella Errera in front of the objects. Hereby fall names of experts like M. Bock[16] of Aachen, M. Forrer[17] of Strasbourg and M. Lessing of Berlin[18]. No doubt, Isabella Errera was introduced in the circle of textile experts by her uncle, Baron Giulio Francetti (1840-1909), who was himself a great collector of textiles and who donated his collection in 1906 to the city of Florence where it is still kept in the Bargello Museum. In 1907, Isabella Errera devoted an article to him and his donation[19], wherein she explained that the collection of her uncle was the result of about forty years of research and that it contained textiles from antiquity to the end of the 18th century. Some were considered rare because of their beauty, dimensions and the fact that they had become, according the author, untraceable or inaccessible because of their high price[20].

In 1897 I. Errera was charged by the Minister for Sciences and Arts with the classification of the collection of textiles and embroideries of what was then called the *Musées royaux des Arts décoratifs et industriels* of Brussels[21]. The attention of the Belgian state to decorative arts, *in casu* textiles, fits with the spirit of the times and illustrates the international trend in the mid-nineteenth century to create museums of 'applied' or 'industrial' art. The purpose was to provide good examples of design, unspoilt by the mass production caused by industrialisation, and this without regard to their origin[22]. On the other hand, Isabella Errera had been rapidly integrated in her country of adoption and had soon acquired a good name as an expert in ancient textiles. Once in the museum, she became a member of the *Comité de la Section des Industries d'Art* and remained actively involved in the museum organisation until her death. Meanwhile, together with her husband, she created within the Brussels public a movement of generosity towards our institution, which often resulted in other gifts. Finally, she favoured not only the textile collection but also the Egyptian Department[23].

In the introduction of her first catalogue of 1901 Isabella Errera gave a perfect synthesis of her own work. She stressed the importance of publishing all pieces of a given ensemble, illustrating them with photographs rather than with long descriptions, of avoiding hypotheses and of making repeated references to eminent specialists in the field. In the present catalogue, these same principles will be followed.

Isabella Errera and the origin of the collection

Notes

1. Velvets: inv. IS.Tx.664, 785, 792, 1200, 1201, 1202, 1203, 1204, 1205, 1207, 1208, 1209, 1210, 1211, 1212, 1213, 1215; lampas fabrics: inv. IS.Tx.1216, 1217, 1218, 1219, 1228, 1280; extended tabby: inv. IS.Tx.1233.

2. Velvets: inv. IS.Tx.450, 806, 1229, 1231, 1232; lampas fabrics: inv. IS.Tx.660, 681, 807, 808, 809, 811, 1257, 1259, 1261; banner: inv. IS.Tx.1223.

3. A copy of the testament, dated 27 November 1926, is preserved in the museum archives *(dossier: Don 1.112, Errera – Van Halteren)*. It is signed with Isabella (sic) Errera. So are also her handwritten letters *(dossier transmis par le Musée de Mariemont en 1985: lettres 1904, lettre E, lettres 1905, lettre E, demandes et lettres 1914, D-G)* and a copy of her first catalogue *Collection d'anciennes étoffes*, 1901 (p. 192).

4. DELMARCEL G., Isabella Errera (1869-1929), in *Liber Memorialis 1835-1985*, Koninklijke Musea voor Kunst en Geschiedenis, Brussels, 1985, p. 100.

5. *Collection d'Anciennes Étoffes réunies et décrites par Madame Isabelle Errera. Catalogue orné de 420 photogravures exécutées d'après les clichés de l'auteur*, Brussels, Librairie Falk Fils, 1901, 197 p.; *Musées royaux des Arts Décoratifs de Bruxelles. Catalogue d'Étoffes Anciennes et Modernes décrites par Madame Isabelle Errera. Deuxième édition ornée de 600 photogravures exécutées d'après clichés originaux*, Brussels, Goossens & Lamertin, 1907, 331 p.; *Musées royaux du Cinquantenaire. Catalogue d'Étoffes Anciennes et Modernes décrites par Madame Isabelle Errera*, troisième édition ornée de 1.000 photogravures exécutées d'après clichés originaux, Brussels, Vromant & Lamertin, 1927, 420 p.; *Collection de Broderies Anciennes décrites par Madame Isabelle Errera. Catalogue orné de 104 photogravures*, Goossens & Lamertin, 1905, 64 p.; *Collection d'Anciennes Étoffes Égyptiennes décrites par Isabelle Errera. Catalogue orné de 454 photogravures*, Musées Royaux des Arts Décoratifs de Bruxelles, Goossens & Lamertin, 1906, 211 p.

6. The biographic data come from the following sources: CAPART J., Nécrologie, in *Bulletin des Musées royaux d'Art et d'Histoire*, 3, no. 5, 1929, p. 112; REINACH S., Isabella Errera, in *Revue archéologique*, 5, XXX, 1929, p. 127-128; BAUTIER P., Errera (Isabelle), in *Biographie nationale de Belgique*, T. 31, suppl. T. 3, 1962, col. 328-332; DELMARCEL G., art. cit., in *Liber Memorialis*, p. 99-106; ERRERA-BOURLA M., *Une histoire juive. Les Errera. Parcours d'une assimilation*, Brussels, Éditions Racine, 2000.

7. She assembled an important library of art history and applied art, she opened to researchers and finally legated to the *École nationale supérieure d'Architecture et des Arts décoratifs (La Cambre)* in Brussels, created in 1926 by her friend, the architect Henry van de Velde. Moreover, she published several encyclopaedic works on painting: *Dictionnaire-répertoire des peintres depuis l'antiquité jusqu'à nos jours*, éd. Hachette, 1913, suppl. 1924; *Répertoire des peintures datées*, éd. Van Oest, 2 vol., 1920-21; *Répertoire abrégé d'iconographie*, 3 vol., 1929. Finally, she devoted articles to single objects, for example: *Le tissu de Modène. Extrait des Annales de la Société d'Archéologie de Bruxelles*, Brussels, 1903, p. 5-18.

8. Held in Brussels, firstly in the corner house between avenue Marnix and rue du Champ de Mars, from the year 1918 on, in a 18th c. *Hôtel de Maître*, rue Royale 12-14. See also: GOEDLEVEN E., *Het hotel Errera. Ambtswoning van de Vlaamse Regering te Brussel*, Ministerie van de Vlaamse Gemeenschap, Afdeling Monumenten en Landschappen, Davidsfonds/Leuven, 2003.

9. Oil on canvas, signed Fernand Khnopff 1893, private collection, illustrated in the exhibition catalogue *Fernand Khnopff*, Tokio, 1990, p. 118. We thank Dr. F. Leen, Royal Museums of Fine Arts, Brussels, for this information.

10. Inv. Tx.948 see: TILLIET M.-F., Tissus anglais aux Musées royaux d'Art et d'Histoire: de William Morris à l'Art Nouveau, in *Bulletin des M.R.A.H.*, Brussels, T. 50, 1978, p. 173-176.

11. MAUS O., The ornamentation of textiles. Mme Paul Errera's collection at Brussels, in *The Studio*, vol. 19, London, 1900, p. 255-262. The *Libre Esthétique* played an active role in the diffusion of the ideas of William Morris and the *Arts and Crafts* movement. From Belgium, this new style reached France where it got its definitive name around the end of 1895, namely *Art Nouveau* (TILLIET M.-F., art. cit., p. 165).

12. MAUS O., *art. cit.*, p. 258.

13. ID., p. 258.

14. ID., p. 255.

15. ID., p. 258.

16. Franz Bock (1823-1899) was canon in Aachen. He became interested in Egyptian textiles, visited Egypt in 1885 where he acquired textiles he exposed in Düsseldorf in the same year. His main activity in the field of textile study was, however, to assemble a collection of medieval pieces from church treasures in Belgium, Holland, Germany and Switzerland. During the last decades of the 19th century, his collections were sold and dispersed. I. Errera purchased 103 Egyptian textiles from him (on the 472 published in her *Collection d'Anciennes Étoffes Égyptiennes, op. cit.*, 1916).

17. Robert Forrer (1866-ca.1950) was an archaeologist who participated in the excavations of Achmim in Egypt which he published: FORRER R., *Die Gräber- und Textilfunde von Achmim-Panopolis*, Strasbourg, 1891; *Römische und byzantinische Seidentextilien aus dem Gräberfelde von Achmim-Panopolis*, Strasbourg, 1891; *Die frühchristlichen Altertümer aus dem Gräberfelde von Achmim-Panopolis*, Strasbourg, 1893. I. Errera bought one Egyptian textile from him (*Collection d'Anciennes Étoffes Égyptiennes, op. cit*, cat. 53), and 12 textiles from various origins (*Catalogue d'Étoffes Anciennes et Modernes, op. cit.*, cat. 4 B, 12, 13 A 23, 35, 43 A, 53, 64, 65 A, 66, 87 and 98).

18. Curator of the textile collection in Berlin and author of the catalogue: *Die Gewebesammlung des Kunstgewerbemuseums*, Berlin, 1900-1901. I. Errera bought a number of pieces from this museum (*Collection d'Anciennes Étoffes Égyptiennes, op. cit.*, cat. 351, 352 and 372; *Catalogue d'Étoffes Anciennes et Modernes, op. cit.*, cat. 1 DD, 1 GG, 1 LL, 2, 25, 34, 36, 42, 45, 188) and exchanged two textiles with the same museum (ID., cat. 30 and 295).

19. Errera I., *Il dono del Barone Francetti al Bargello*, in *Bollettino d'Arte,* I, X, Rome, 1907, p. 28-34.

20. Id., p. 28. Also: Fanelli R. B., *Saggi introduttivi*, in *Tessuti italiani del Rinascimento. Collezioni Francetti Carand. Museo Nazionale del Bargello,* exhibition catalogue, Prato, 1981-82, p. 14. The Francetti collection comprised, according to the collector, about 600 pieces, many to become study objects for artists, archaeologists and, in general, for everyone interested in the history and technique of the silk art. According to R. Fanelli, the textiles were purchased directly from families in financial problems, from churches or from the great antiquarians of that time in Italy (Cantoni, Salvadori, Sangiori,

Guggenheim), in Paris, Brussels, London, Monaco and Berlin. She mentions further the practice among antiquarians of splitting up the textiles which came into their possession, and the practice among collectors of exchanging pieces. This explains, for example, with respect to the Ottoman textiles, that from the velvet inv. IS.Tx.1231 of which I. Errera says it was given to her in 1901 by *"le Baron Jules Francetti, de Florence",* there is another fragment in Florence (Suriano C. M. & Carboni S., *La seta islamica. Temi ed influenze culturali – Islamic Silk. Design and Context,* 9th International Conference on Oriental Carpets, Florence, Museo Nationale del Bargello, 1999, cat. 34) and that I. Errera exchanged a textile (Inv.

IS.Tx.664) with Gustave Vermeersch (Gent 1841-Brussels 1911), another great art collector and benefactor of the Cinquantenaire Museum. Those practices were customary at that time.

21. Capart J., *op. cit.,* p. 112.

22. Islamic artefacts were already valued for providing lessons in design at the Great Exhibition in London in 1851. (Vernoit S. (ed.), *Discovering Islamic Art. Scholars, Collectors and Collections,* London–New York, 2000, p. 22.). Right from the beginning I. Errera bought Islamic pieces, which she defined as *"travail oriental, travail arabe, travail persan"* (those of which she thought they were Turkish, were catalogued under *"travail oriental"*).

23. Capart J., *op. cit.,* p. 112.

Isabella Errera and the origin of the collection

2. Function and context of the silk textiles. An outline

Mieke Van Raemdonck

Function

Most Ottoman silks preserved in Western museum collections are distinguished by a figuration in clear, symmetrical compositions with bold motives on a plain ground and with contrasting colours in which crimson prevails. The sumptuous appearance of these lustrous silks, abundantly brocaded with gold and silver threads, makes them visually appealing and impressive, even from a distance. For these reasons they were a perfect vehicle for expressing imperial splendour and power. Sewn into ceremonial garments worn by the royal family and its suite during official parades and receptions, they were perfectly appropriate for making a great impression on both Turkish subjects and foreign visitors.

The occasions for these public appearances of the court were numerous: there were the regular ones like the processions on Friday and on the recurring religious feasts, but also occasional ones like the accession of the sultan or his triumphant entry after a successful military campaign. For such events, even lengths of silk fabrics were used to decorate the streets, held up to act as crowd barriers along the route of parades[1], spread out on the ground in front of the sultan and his suite[2] and distributed after the ceremonies among the courtiers according to their rank.

Naturally, silks played an essential role in the protocol of bestowing robes of honour, *khil'at,* on members of the court as a form of expressing favour or as a reward for delivered services[3]. But also foreign delegations received ceremonial garments they were required to don before being admitted to the court. An eloquent testimony of this is to be found in the story of Ogier Ghiselin de Busbecq's mission as the Habsburg ambassador to the Ottoman Sultan Süleyman I, the first edition of which was printed by Christoffel Plantin in Antwerp[4]. In his first "Turkish letter", Ogier Ghiselin de Busbecq describes how two large, embroidered mantles reaching to the ankles were draped on his shoulders and how he could hardly bear them. The members of his suite also received silk garments in different colours. Even the letter the sultan gave him was wrapped in an "envelope of gold thread"[5]. Silks were vital in public ceremonies, but they also procured status to the ruling class. Moreover, as much as precious stones and metals, they provided a means to accumulate wealth[6].

Silk textiles, especially velvets –Turkish velvets being rarely used for kaftans– were largely employed for furnishing the houses in the form of wall hangings, curtains, cushion covers[7] and ground-coverings. Sofa cushion covers, *yastık yüzüs,* have been woven in pairs[8], even in sets of four[9]. Luxury furnishing fabrics served also as diplomatic gifts, like the velvet cushion cover presented to Frederick I, King of Sweden by Abdi Paşa of Algiers in 1731[10]. Sumptuous Ottoman wall hangings were used in the West to confer lustre to great ceremonies, as was the case with the nine lengths of brocaded silk used at the coronation ceremony of Ivan IV 'the Terrible' (r. 1547-1584)[11].

Most textiles studied in this catalogue fall under this group of characteristic sumptuous silks. Six pieces show different features though and are to be seen in a different context. It concerns

green or red silks with religious texts inscribed in zigzag bands. These have a funeral function: they cover the coffin when carried to the grave[12] and are sometimes placed on the tomb.

Finally, the collection comprises a military banner of the *sandjak*-type. As symbol of Turkish military eminence, such a banner was gladly seized by the enemy and, together with the proclamation of the victory, presented as a trophy.

Silk industry

As in Byzantium, the Ottoman silk trade and industry depended to a large extent on silk of Iranian origin. The raw silk, which means the undyed silk filaments that had been reeled from cocoons reared on the southern littoral of the Caspian Sea, was transported by caravans to the Ottoman capital of Bursa. The infrastructure for this trade –namely roads, bridges and caravanserais– existed already from the Seldjuk (1171-1307) and early Ottoman periods[13]. However, from 1400 onwards the trade from North Iran to Bursa flourished exceptionally. In Bursa, the raw silk was weighed, taxed and sold to merchants who were, in the 15th century, mostly Genuese, Venetians, Florentines and Judes[14]. A mulberry plantation, needed for sericulture, was not recorded in Bursa until the later 16th century[15], and for the significant local production of raw silk of a reliable quality, one had to wait until the second half of the 17th century[16]. On the whole, the silk trade between Iran and Turkey was a dominant factor in the economy of the two countries, and the wars between them had serious repercussions on their economy and finances[17].

Silk weaving already existed in several Seldjuk cities in Anatolia[18] but, as a natural consequence of the growing role of Bursa as transhipment harbour for raw silk, the manufacture of silk fabrics appears to have developed there from the later 14th century on. Documents give evidence of the fact that in the 15th century superior and fine silks were woven in Bursa. A list of presents given in 1483 to a Venetian ambassador mentions three kinds of Bursa silk fabrics of the second half of the 15th century: a velvet wrought with gold thread, *çatma,* a dotted velvet and a *kemha* or brocaded silk[19]. The city supplied silk textiles to the local market and especially to the Ottoman court, but also to Iran, to Europe, and increasingly in the 16th and 17th centuries to Poland and Russia. After the conquest in 1453, the silk weaving industry seems to have extended to Istanbul[20] where it was reorganised around the middle of the 16th century by Rüstem Paşa, the Grand Vizir of Sultan Süleyman I (r. 1520-1566). Looms where registered[21] and salaried artisans, *ehl-i hiref,* produced there directly for the court for fixed prices.

This created rivalry between the two silk manufacturing centres. On the whole, Bursa remained the leading centre. Silk thread had still to be imported from Bursa and was dyed there and twisted in threads for the warps and wefts before being transported to the imperial workshops of Istanbul. In Bursa the market was more diverse. The weavers sold the silk and the industry was traditionally, as in Europe, dominated by the guilds. Especially the weaving of velvet, *kadife,* experienced a remarkable revival in the 17th century. In Istanbul, however, the production was dependent on court commission and specialised in the manufacture of *serâser,* cloth of gold and silver, and of *kemha,* multicoloured silks in the lampas weave, used for the court protocol. *Kemha* had the shortest period of flowering, its production declining at the end of the 16th century. In fact, in the 17th century the court reduced its patronage of the arts and the numbers of *ehl-i hiref* artists.

Both centres lost their monopoly anyway in the 17th century to other centres around the empire: Chios, Morea in the Peloponnesos, Bilecik (specialised in furnishing fabrics, especially

cushion covers), Ankara, Nardin, Tokat and Tunis[22]. In the early 18th century there was a general decline of the silk weaving industry, even if the production of raw silk expanded in that period. Monochrome silks and fabrics with small motifs[23] seem to replace the impressive traditional bold fabrics which had made the international reputation of Ottoman silk. This decline continued in the 19th century, probably due to the competition from Europe's mechanised textile industries.

Artistic aspects

Because of its economic importance and prestige, the Ottomans kept the trade and production of silk under their strict control. Periodically, the government took active measures when it felt that high standards were falling. In 1502 for example, a judicial enquiry complained about three types of problems in the Bursa silk industry: first about the quality of the raw materials such as silk, metallic threads and dyestuffs, second about the quantity of materials used in the subsequent stages of production and third about the quality of the weaving including the number of warp threads per given loom width[24]. The response of the government to these problems was to return to earlier standards, namely those in force under the reign of Sultan Mehmet II in the 1470s. This document is illustrative of the tensions that existed continuously between the government and its quality exigencies and the economic pressure under which the factories had to work.

The silk manufactory was more dependent on the fluctuations of the market than other art disciplines. The materials needed for the production of manuscripts or ceramics, for example, were –compared to those for silk weaving– relatively cheap and easily obtainable within the empire. Silks were also more export-oriented than other art products, so the silk industry was for the Ottomans far more important in terms of export revenues than any of the other art disciplines.

Thus, only the most skilled artists worked in silk production. Some designers created patterns for specific fabric weaves, and different drawlooms were also dressed to produce specific types of weave structures. The reorganisation of the silk industry in the middle of the 16th century went along with the introduction of a new style. Between 1550 and 1560 the new designs were standardised in the imperial design atelier *nakkaçhane,* and continued for the second half of the 16th century before declining at the end of the century. This new Ottoman style was mostly visible in the *kemha* production, but also in ceramics, the tile revetments of the mosque and tomb of Rüstem Paşa (completed after 1561) being the most clear example of its emergence.

Finally, while the mutual influences between Italian and Ottoman silks are so obvious that oft only technical elements can make the distinction between the two, the differences between Ottoman and Safavid silks are generally apparant. In the bulk of the Ottoman silks, at least until the 18th century, bold motifs stand out well against a plain background and the colour schemes are limited, while in the Safavid silks fine designs fill the background in multiple tones. Safavid textiles often bear figurative scenes rarely found on Ottoman ones, with the exception of those commissioned by the Orthodox Church in Russia[25].

Notes

1. Illustrated in a painting from the *Edri Fetibnâmesi,* ca. 1598, Topkapı Palace Library, Istanbul, MS.H.1609, folios 68b-60a: 'Mehmed III's return from his victorious campaign in Hungary' in ATASOY N., DENNY W. B., MACKIE L., TEZCAN H., *IPEK. The Crescent & the Rose. Imperial Ottoman Silks and Velvets,* London, 2001, fig. 14, p. 26-27.

2. Illustrated in a painting from the *Surnâme,* ca. 1582, Topkapı Palace Library, Istanbul, MS.H.1344, folio 12a: 'Prince Mehmed arriving at the palace of Ibrahim Paşha in the Hippodrome' in ID., fig. 13, p. 24.

3. Illustrated in a painting from the *Surnâme* (details), Topkapı Palace Library, Istanbul, MS.H.1344, folios 425b-426a: 'The presentation of *kbil'at* robes to the members of the Chancery, lieutenant company commanders, infantry officers, and Janissari captains' in ID., figs. 18-20, p. 30-31.

4. *Itinera Constantinopolitanum et Amasianum ab Augerio Gisleno Busbequio ad Solimannum Turcarum Imperatorem C. M. oratore confecta. Eiusdem Busbequy de re militari contra Turcam instituenda consilium,* Antwerp, 1581, Museum Plantin-Moretus, R.19.6, p. 97.

5. The texts says: *"panno aureo tectis"* in ID., p. 97.

6. INALCIK H., Harîr. II. Empire Ottoman, in *Encyclopédie de l'Islam,* T. III, 1971, p. 222.

7. Illustrated in a page of an album of circa 1600, Los Angeles County Museum of Art: 'Sultan Selim II on a cushion with *yastık*-cover' in ERBER C. (ed.), *Reich an Samt und Seide. Osmanische Gewebe und Stickereien,* Bremen, 1993, p. 72.

8. An almost complete example is inv. IS.Tx.1201.

9. ATASOY N. *et al., op. cit.,* p. 321.

10. Cushion cover preserved in the Royal Armoury, Stockholm, 3661 in ID., no. 74, p. 252.

11. Hanging preserved in the Kremlin Museum, Moscow, TK-529 in ID., no. 12, p. 242.

12. Illustrated in a miniature from the *Süleymannâme,* 1579-1589, Chester Beatty Library, Dublin, MS.T.413, folio 115b: 'The burial of Sultan Süleyman' in ID., fig. 12, p. 24.

13. INALCIK H., *op. cit.,* p. 217-218.

14. ID., p. 219.

15. ID., p. 220.

16. ID., p. 221.

17. ID., p. 219.

18. ID., p. 217.

19. ÖZ T., *op. cit.,* p. 26. We link the *Çintamani* velvet inv. IS.Tx. 792 to the two first mentioned types.

20. ID., p. 55.

21. ID., p. 55: Firman of 1564.

22. ATASOY N. *et al., op. cit.,* p. 172-175.

23. There are no such textiles in the collection.

24. ATASOY N. *et al., op. cit.,* p. 162-164.

25. An example in ID., plate 53, p. 101.

Function and context of the silk textiles. An outline

3. Technology of the velvets

Daniël De Jonghe

1. Characteristics

All the brocaded velvets examined have the following features in common:

1.1. Structure[1] (fig. 1 to 8)

- The velvets are executed in a structure in which the pile is squeezed between a squeezing pick* and a foundation pick* bound in the same foundation shed*. The squeezing pick is entered before the pile rod* and the foundation pick is entered behind the pile rod, except for velvet IS.Tx.1215. By comparison with velvet IS.Tx.664 and 792 where the material of the squeezing weft* is identical to the material of the foundation weft, we consider that the sequence of the picks in this two velvets is the same as for the other velvets.
- On the reverse, the pile warp* threads are supported by means of a supplementary weft* (the supporting weft*).
- The squeezing weft and the supporting weft always consist of the same material and are entered by means of the same shuttle[2].
- Each cut pile has an U-shape.

- **Weave***
- The weave of the foundation fabric is always 5-end satin* warp face, décochement* 3 (fig. 1 to 8).
- The weave of the squeezing weft is always 4.1 twill* S warp face, with all of the foundation warp threads. Each pick of the squeezing weft is entered on one side of the pile rod in the same satin shed as the foundation pick, which is behind the pile rod, in order to squeeze together this two picks, securing in this way each tuft of pile.
- The weave of the supporting weft is always 4.1 twill S warp face, with all of the foundation warp threads. In fact the supporting pick is entered in the same foundation shed as the following foundation pick. It is separated from the foundation pick by the pile warp (see also: weave of the selvages).
- The weave of the brocading weft* is always 4.1 twill S weft face, with 1/3 of the foundation warp threads.
- Weave of the pile warp(s):
- Under all the foundation, the squeezing and the brocading picks and above all the supporting picks.
- In the pile effect 1: pile warp a above the rod, pile warp b under the pile rod.
- In the pile effect 2: pile warp b above the rod, pile warp a under the pile rod.
- In the brocaded and the voided effect: under the pile rod.
- Weave of the selvages: the weave of the selvages is always the same as the velvet fabric. But the absence of pile warp threads means that the squeezing pick is added to the following foundation pick and similarly the supporting pick is added to the following foundation pick. In a shed of the selvages, a squeezing pick together with a first foundation pick alternate with a supporting pick combined with a second foundation pick.

* see: Glossary of the technical terms, p. 123-125.

- **Warp and weft step***

All the velvets analysed have a warp step of 1 tuft. When there are 2 pile warps the warp step is 1 tuft by the pile warp. Only one velvet is an exception to this rule: velvet IS.Tx.792 with a warp step of 2 tufts. This velvet has a double warp count: in fact the second pile warp of a 2-pile warp arrangement has been replaced by the same material as the first pile warp (see: 4. The arrangement of the pattern device on a drawloom for weaving the Ottoman velvets with 2 pile warps).

The weft step of the analysed velvets is always 1 pass* (1 tuft, 2 brocading picks).

- **Weave direction, direction of the tufts and location of the squeezing weft**

It was not easy to find out in what direction the velvets were woven. But in order to determine whether the position of the squeezing weft was in front of the tufts or behind them, it was necessary to discover the weave direction. Only for velvet IS.Tx.1203 we were able to do this. The pattern of this velvet has a clear direction. We established by means of a broken warp thread, that the velvet was woven from the bottom to top of the pattern. In this case the squeezing weft was entered before the pile rod. In the same velvet we established that the tufts have a slight inclination in the opposite direction. This observation is very interesting. If it applies to all velvets woven on rod velvet looms, then it enables us to identify the weaving direction of all the Ottoman velvets. As it was impossible to identify the weaving direction of the other velvets by another method such as the direction of the tufts, we contacted a modern mill where carpets are woven on pile rod looms. We were informed that the direction of the tufts on this type of carpet also was always opposite to the weaving direction[3]. This discovery confirms that the direction of the tufts does not depend on the structure of the velvet but only on the weaving procedure. As a conclusion it can be stated that, on pile rod velvets, the direction of the tufts indicates the weaving direction: this is opposite to the tuft direction. The first result of the examination on the basis of pile direction is that all the velvets, for which the pattern has a direction, were woven from the bottom to the top of the pattern. One patterned velvet only is an exception to this rule: namely the right part of velvet IS.Tx.1215, this piece is woven from top to bottom of the pattern. The second conclusion is that the position of the squeezing weft in all the Ottoman velvets examined is in front of the tufts with only one exception, once again, the two pieces of IS.Tx.1215. In table 1 piece IS.Tx.1215-Left is treated in the normal way. The only difference from the other velvets is the interchanging of the position of the squeezing weft and the foundation weft. Piece IS.Tx.1215-Right is treated as it was woven on the loom: The same interchanging of the position of the squeezing and the foundation weft, same pile direction, same weave direction, but an inverted pattern direction.

- **Number of the shuttles**

The velvets with a squeezing/supporting weft differing from the foundation weft were clearly woven with two shuttles, one for the squeezing/supporting weft and one for the foundation weft. But, where the material of all the wefts is the same (IS.Tx.664 and IS.Tx.792), they were also woven with two shuttles: one for the squeezing/supporting weft and one for the foundation weft. Theoretically the wefts could be entered by means of only one shuttle. This has not been done because of the weave structure of the selvages (see above).

- **Brocading weft**

The two picks of the brocading weft between two pile rods are always entered immediately after the pile rod (see also: 2. The execution of Ottoman brocaded cut velvets).

It appears that the above structure is characteristic of Ottoman velvets.

Table 1 shows the relation between: the direction of the tufts (Tu.D.), the weaving direction (Wv.D.), the direction of the pattern (Pa.D.) and the location of the squeezing weft: in front of the tufts or behind them (Lo.Sq.W.). *Remark*: all the pieces are treated as they were woven on the loom. The weave direction is always ↑, from the observer away, and the tuft direction is always towards the observer ↓.

Velvet	Tu.D	Wv.D.	Pa.D.	Lo.Sq.W.	Material of the wefts	T/cm2
IS.Tx.450	↓	↑	↑	▬ ◐◐ ▬	**Found. weft; paired schappe silk** Tufts Squeez. weft; thin silk without app. twist **Sometimes same material as found. weft**	12x11,5=138
IS.Tx.664	↓	↑	↑	▬ ◐◐ ▬	**Found. weft; silk without app. twist** Tufts **Squeez. weft; same material as found. weft**	12,5x12=150
IS.Tx.785	↓	↑	↑	▬ ◐◐ ▬	**Foundation weft; schappe silk** Tufts **Squeezing. weft; cotton**	12,5x9,5= 118,75
IS.Tx.792	↓	↑	↑	▬ ◐◐ ▬	**Found. weft; silk without app. twist** Tufts **Squeez. weft; same material as found. weft**	28,5x12,4= 353,4
IS.Tx.806	↓	↑	↱⟲	▬ ◐◐ ▬	Foundation weft; paired cotton Tufts Squeez. weft; thin silk without app. twist	15x11= 165
IS.Tx.820	↓	↑	↑	▬ ◐◐ ▬	Foundation weft; paired cotton Tufts Squeez. weft; thin silk without app. twist	14x10,5= 147
IS.Tx.1200 1/2 & 1200 2/2	↓	↑	↑	▬ ◐◐ ▬	Foundation weft; paired cotton Tufts Squeez. weft; thin silk without app. twist	12x10= 120
IS.Tx.1201 Left & 1201 Right	↓	↑	↑	▬ ◐◐ ▬	Foundation weft; paired cotton Tufts Squeez. weft; thin silk without app. twist	12x8= 96
IS.Tx.1202	↓	↑	↱⟲	▬ ◐◐ ▬	**Foundation weft; paired cotton** Tufts Squeez. weft; thin silk without app. twist	14x11= 154
IS.Tx.1203	↓	↑	↑	▬ ◐◐ ▬	Foundation weft; paired cotton Tufts Squeez. weft; thin silk without app. twist	13x9= 117
IS.Tx.1204 Left & 1204 Right	↓	↑	↱⟲	▬ ◐◐ ▬	Foundation weft; paired cotton Tufts Squeez. weft; thin silk without app. twist	12x12= 144
IS.Tx.1205	↓	↑	↱⟲	▬ ◐◐ ▬	Foundation weft; paired cotton Tufts Squeez. weft; thin silk without app. twist	14x12= 168

IS.Tx.1206	↓	↑	↑	▬▬ ⊖⊖ ▬▬	**Foundation weft; fourfold cotton** Tufts Squeez. weft; thin silk without app. twist	12x5,5= 66
IS.Tx.1207	↓	↑	↻	▬▬ ⊖⊖ ▬▬	Foundation weft; paired cotton Tufts Squeez. weft; thin silk without app. twist	12x10= 120
IS.Tx.1208 1/2 & 1208 2/2	↓	↑	↑	▬▬ ⊖⊖ ▬▬	Foundation weft; paired cotton Tufts Squeez. weft; thin silk without app. twist	13,3x9= 119,7
IS.Tx.1209	↓	↑	↑	▬▬ ⊖⊖ ▬▬	Foundation weft; paired cotton Tufts Squeez. weft; thin silk without app. twist	14x11= 154
IS.Tx.1210	↓	↑	↑	▬▬ ⊖⊖ ▬▬	Foundation weft; paired cotton Tufts Squeez. weft; thin silk without app. twist	14x10= 140
IS.Tx.1211	↓	↑	↑	▬▬ ⊖⊖ ▬▬	Foundation weft; paired cotton Tufts Squeez. weft; thin silk without app. twist	12,5x9= 112,5
IS.Tx.1212 Left & 1212 Right	↓	↑	↑	▬▬ ⊖⊖ ▬▬	Foundation weft; paired cotton Tufts Squeez. weft; thin silk without app. twist	12x9= 108
IS.Tx.1213	↓	↑	↑	▬▬ ⊖⊖ ▬▬	Foundation weft; paired cotton Tufts Squeez. weft; thin silk without app. twist	12,5x6,5= 81,25
IS.Tx.1215 Left	↓	↑	↑	▬▬ ⊖⊖ ▬▬	**Squeez. weft; thin silk without app. tw.** **Tufts** **Foundation weft; paired cotton**	13x8= 104
IS.Tx.1215 Right	↓	↑	↑	▬▬ ⊖⊖ ▬▬	**Squeez. weft; thin silk without app. tw.** **Tufts** **Foundation weft; paired cotton**	13x8= 104
IS.Tx.1229	↓	↑	↑	▬▬ ⊖⊖ ▬▬	**Found. weft; paired bourrette silk** Tufts Squeez. weft; thin silk without app. twist	12x9= 108
IS.Tx.1231	↓	↑	↻	▬▬ ⊖⊖ ▬▬	**Foundation weft; paired schappe silk** Tufts Squeez. weft; thin silk without app. twist	12x10= 120
IS.Tx.1232	↓	↑	↑	▬▬ ⊖⊖ ▬▬	Foundation weft; paired cotton Tufts Squeez. weft; thin silk without app. twist	12x6= 72
IS.Tx.1262	↓	↑	↑	▬▬ ⊖⊖ ▬▬	**Found. weft; fourfold schappe silk** Tufts Squeez. weft; thin silk without app. twist	12x10= 120

Table 1. Tu.D. ↓ The direction of the tufts is towards the observer.

Wv.D. ↑ The weaving direction is away from the observer.

Pa.D. ↑ The pattern is woven from bottom to top;

↓ from top to bottom; ⟲ no direction

T/cm² tufts/cm: horizontal x vertical = tufts/square centimetre

⊖⊖ Squeezing weft in front of the tufts; ⊖⊖ Squeezing weft behind the tufts.

1.2. Foundation warp and weft

Out of the 25 velvets examined, 14 of them have a S-spun and 8 a Z-spun silk foundation warp (IS.Tx.450, 664, 785, 1206, 1213, 1229, 1231, 1262). Only velvet IS.Tx.792 (*çintamani*) has a Z-spun/S-plied foundation warp, IS.Tx.1232 a Z-spun/Z-plied silk foundation warp, and IS.Tx.1201 a silk foundation warp without apparent twist.

Out of the 25 examined velvets 17 of them have a paired cotton Z-spun foundation weft. The foundation weft of velvet IS.Tx.450 and IS.Tx.1231 is paired schappe silk S-spun, of IS.Tx.664 and IS.Tx.792 silk without apparent twist, of IS.Tx.785 S-spun schappe silk, of IS.Tx.1206, four-fold cotton, of IS.Tx.1229 paired bourrette silk, and of IS.Tx.1262 fourfold schappe silk.

1.3. Pile warps

The velvets IS.Tx.664, 785, 792, 820, 1200, 1201, 1203, 1206, 1207, 1209, 1211, 1212, 1213, 1215, 1229, 1232 and 1262 have only one pile warp (fig. 1 and 2). The velvets IS.Tx.450, 806, 1202, 1204, 1205, 1208, 1210 and 1231 have two pile warps (fig. 3 and 4).

1.4. Proportion of the warps

Apart from velvet IS.Tx.792, all the examined velvets with only one pile warp have a pro-portion of 6 foundation warp threads to 1 pile warp thread (fig. 2). The velvet IS.Tx.792 has a proportion of 4 foundation warp threads to 1 pile warp thread to 2 foundation warp threads to 1 pile warp thread (fig. 8).

The velvets with two pile warps always have a proportion of 4 foundation warp threads to 1 pile warp thread a, and 2 foundation warp threads to 1 pile warp thread b (fig. 4).

1.5. Squeezing and supporting weft

Apart from the velvets IS.Tx.664, IS.Tx.785 and IS.Tx.792, all the velvets have a squeezing and supporting weft of thin silk without apparent twist (fig. 1 to 4). By analysing IS.Tx.1211 it was clear that the squeezing and supporting weft were entered by one and the same shuttle.

Velvet IS.Tx.785 has a Z-twisted cotton squeezing and supporting weft (fig. 5 and 6).

Velvets IS.Tx.664 and IS.Tx.792 have the same silk squeezing and supporting weft without apparent twist as the foundation weft. But they are entered by means of two shuttles: one for the foundation weft and another one for the squeezing/supporting weft (fig. 7 and 8). The squeezing/supporting weft of velvet IS.Tx.450 is partly silk without apparent twist, and partly the same material as the foundation weft, paired schappe silk.

1.6. Metal threads

A further characteristic of these velvets is the kind of metal thread. The metal threads used in the velvets examined are a silver, or on both sides gilded silver strip usually wrapped in S-direction around a silk core. Only in velvets IS.Tx.1200, IS.Tx.1211 and IS.Tx.1212 the metal strip is twisted in a Z-direction. In most of the velvets the metal strip does not completely cover the silk core (known by the French term: "riant"). In velvet IS.Tx.1211 the metal strip is very *riant*. Only in vel-vets IS.Tx.792 and IS.Tx.1200 the metal strip totally covers the silk core (French term: "couvert").

2. The execution of brocading on Ottoman brocaded cut velvets

When analysing Ottoman brocaded cut velvets four characteristics can be established.

- The floats of the returning brocading weft are positioned on one edge of the pattern on the face of the velvet and on the other edge at the reverse of the fabric (fig. 12). A systematic check reveals that the brocading wefts return on the reverse of the fabric at the pattern limit near the selvage: on the left half of the fabric at the left limit and on the right half of the fabric on the right limit (fig. 9). This means that the brocading weft is brought into the shed in the opposite direction according to the position of the pattern segment at the left or at the right side of the fabric's symmetry axis. For pattern segments positioned on the symmetry axis the brocading weft is returned on the reverse of the fabric at the right limit.

- The brocading weft does not return immediately at the limit of the pattern. It extends a few millimetres between the pile (fig. 10 and 12).

- The outline of the brocaded surface is irregular and does not follow exactly the limit of the pile surface (fig. 10 and 12).

- The brocading weft comes up between the two foundation picks between which the pile is also pressed. The following brocading pick disappears to the reverse side of the fabric between the same two picks (fig. 9 and 11). This means that the two brocading sheds are executed immediately after the pile shed and before the shed of the following foundation pick.

These four features can be explained as follows:

- The brocading of velvet fabrics is not executed in the same way as other brocaded fabrics. The brocading shuttle is entered locally in the shed. On the loom this is done more easily on the right side of the fabric. At this side the short floats of the returning brocading weft are perceptible. A brocaded fabric normally is woven right side down. But a velvet fabric is not woven right side down because of the loops formed in the pile warp thread. These loops above the velvet rod need to be cut. Thus the velvet fabric is woven right side up and also the brocading is executed right side up. This means that all the brocading floats should be found on the right side of the fabric. However, it is impossible to return the brocaded weft on the right side as a velvet rod has to be passed over it. The brocading floats would make it impossible to cut the velvet pile. A velvet rod can be passed by having the brocading weft on the reverse side of the fabric. When the velvet structure is drafted with two brocading picks between two velvet rods, then on one end the brocading weft can be returned on the front of the fabric but on the other side it must be returned on the reverse (fig. 12). In this case the proportion of the brocading weft to the velvet rods is 2 to 1.

When the brocading weft is to be brought to the reverse of the fabric, it is logical to do this at the limit of the pattern near the selvage. The manipulation of the brocading bobbin from the front to the back and vice versa is then at its easiest.

Why the brocading weft is always returned at the right edge of the pattern segments positioned on the symmetry axis is not clear.

- If the brocading weft was returned exact at the edge of the pattern the appearance would be badly affected. To avoid this disfigurement the return of the brocading weft is executed a few millimetres past the limit of the brocading surface (fig. 10). The tufts hide the extension of the brocading weft. These extra millimetres of the brocading weft are clearly visible on velvets where the pile has worn away (e.g. on IS.Tx.1229). While it appears that the returns of the brocading weft are executed in a capricious way, the ends of the brocading weft do not form a smooth edge. The brocading picks terminate in arbitrary places (fig. 12). From this observation one can conclude that on this sample there were no lashes* to build the brocading shed. Indeed, it is impossible to make lashes for brocading sheds, as the brocading picks are only bound by 1/3 of the foundation warp threads. Therefore the weaver has no control over the place where he has to enter the brocading weft into the brocading shed. To solve this problem the weaver looks to the last entered velvet

rod and where there are velvet threads lacking on this rod there the brocading picks should be entered. The brocading pick is then entered a distance from just before the empty place on the velvet rod to just behind this place. Since the extension of the brocaded pattern is imperceptible, there is no need to return the brocading weft according to a regular circumference. Hence the chaotic picture of the brocaded pattern of velvet fabrics where the pile has worn out. Moreover during the returning, the brocading weft is only held by the last binding thread of this pick. As the brocading weft is bound in 1.4 weft twill weave on the foundation fabric by only 1/3 of the foundation warp threads, the binding points of the brocading picks are distanced from each other by about 15 warp threads. For many of the Ottoman velvets this distance is about 2 mm.

- The two brocading picks are entered after the entering and binding of the velvet rod (fig. 11). This approach makes it easier for the weaver to control the places where the velvet loops are lacking and to see where he has to enter the brocading weft.

3. The execution of the small borders in some Ottoman velvets

In velvets IS.Tx.1201 and IS.Tx.1202/1204 a small border passes round the piece suppressing the pattern.

On the basis of data from IS.Tx.1201 we have attempted to explain the execution of this feature. Round this piece a small border, ± 3,5 cm wide, is positioned approximately 15 cm from the selvages and 10,5 cm from the upper and lower end. The vertical parts of this border are composed of 3 pile lines each with a width of 6 tufts, separated from each other by a voided line with a width of 12 missing tufts. The horizontal parts are composed of 3 pile lines each with a height of 4 tufts, separated from each other by a voided line with a height of 8 missing tufts. The border crosses the repeats concealing the pattern.

We suppose the following procedure:

On fig. 13 the procedure is illustrated for the vertical borders. At the beginning of the vertical border a short rod (lifting rod) is entered under those pile warps which have to form the 3 vertical pile lines (fig. 14 L.R.), and an other short rod (suppressing rod) is entered above those pile warps which have to be suppressed in order to form the voided lines (fig. 14 S.R.).The lifting rod is entered behind the figure harness* and the suppressing rod is entered in front of the harnesses. In order not to hinder the opening of the following sheds (2 foundation sheds, 2 brocading sheds, 1 squeezing shed and 1 supporting shed), after the entering of the pile rod (P.R.) the lifting rod (L.R.) has to be pushed backwards. For the same reason, the suppressing rod has to be transferred behind the figure harness and also pushed backwards. These two rods can be reused to make the whole length of the vertical pile line border. For the horizontal borders longer rods have to be used. These rods can be used only for the height of a line (4 times, 8 times, 4 times, 8 times and 4 times).

4. The arrangement of the pattern device on a draw loom for weaving the Ottoman velvets with 2 pile warps

The identification of the double warp count with a 2 pile warp step of the velvet IS.Tx.792 (*çintamani*)[4], enables us to suggest that the drawloom* for velvets with two pile warps was arranged in a special way. An arrangement by which the simple cords were placed one by one (simple cord 1 for tail cord 1 of pile warp A, followed by simple cord 1 for tail cord 1 of pile warp B, etc.) would be unsuitable for entering the lashes into the simple cords. An arrange-

ment by which the simple cords are separated into two simples, one for each pile warp (fig. 15), positioned next to each other, removes this problem. On such an arrangement of the simple the point paper plan* (fig. 16), or equivalent plan, should be read twice, once for the construction of the lashes on the first simple for the pile effect of pile warp A and once for the wider construction of the same lashes on the second simple for the pile effect of pile warp B (fig. 15). This arrangement of the simples also implies an arrangement of the figure harness in two parts, one after the other (fig. 17). Arranged in this way, a warp step of 1 tuft per pile warp is normal. But when the second pile warp is of the same material as the first pile warp in order to double the warp count of the tufts, as in velvet IS.Tx.792 (*çintamani*), then the point paper plan (fig. 18) has to be read twice also, in order to construct each lash on the first and the second simple (fig. 19 and 20). In this way a warp step of two tufts cannot be avoided. The presence of the two pile warps enhances the quality of the velvet but, because of the warp step of two tufts, the linear quality of the pattern is not improved contrary to the observation of Atasoy[5].

The Brussels *çintamani* has a vertical point repeat* and in the second horizontal half height, the pattern is placed in quincunx* (fig. 21). This means that only one quarter of the full pattern repeat (fig. 21, hatched section) has to be transposed into a point paper plan (or equivalent plan). Fig. 18 is the result of this transposition. We estimate that the number of pile warp threads in a comber unit of the *çintamani* velvet IS.Tx.792 is 156 threads per pile warp and 192 tufts lengthwise in half the repeat height. Thus the point paper plan was made with 156 squares (or units) in the width and 192 squares (or units) in the height, each square representing one tuft of each pile warp. For the full repeat in the height, the point paper plan has to be read a second time from bottom to top and in the opposite direction from B to A, in order to construct on both simples the lashes of the second half height of the pattern repeat. The full simple contained in the width two times 156 (= 312) simple cords (table 2K) and in the length two times 192 (= 384) lashes (table 3G).

Remarks

- The same identification has been done by Reingard Neumann/Ulrike Reichert[6]. The analysis of the *çintamani* velvet Nr G 1/2 of the Erber publication (fig. 23) demonstrates that all the technical features are the same as those of the Brussels *çintamani*. There is only a small difference in the construction of the pattern repeat (fig. 22). Instead of a full horizontal repeat in quincunxes, only the tiger stripes (----------➤) have been placed in quincunx, whilst the balls (⎯⎯⎯⎯➤) have been given a straight repeat. Despite this difference, it would be possible to realise the pattern repeat of the Erber *çintamani* by means of the pattern device used for the Brussels *çintamani*. Only the lashes from 193 to 320 (forming the balls in quincunx) may not have been used. They are replaced by the lashes from 1 to 128 (forming the balls in the first half of the pattern repeat). Thus the whole cycle of lashes to be drawn is: from lash 1 to 192, from 1 to 128 and from 321 to 384.

- The loom arrangement to weave a velvet with two pile warps is also suitable for weaving with only one pile warp. The second warp is omitted and the point paper plan is used to construct the lashes only on the first simple.

- Nurhan Atasoy *et al.*, 2001: identifies a velvet with three pile warps[7], each pile warp colour thread lies next to two foundation warp threads. By comparison to the velvets with two pile warps, we suppose that the figure harness, for this three-pile warp velvet, instead of two was divided into three parts, one for each pile warp. Also the simple should have three parts and the point paper plan has to be read three times, once for each colour, in order to construct each lash on the cords of the corresponding simples.

5. Complexity of the execution

The complexity of the execution of the velvet depends upon various factors.

5.1. The preparation of the pattern device

This includes many actions:

- Concerning the warp(s):

The pile warp threads have to be wound on bobbins; the bobbins have to be placed on the loom; the pile warp threads have to be entered in the leashes* of the figure harness. Therefore, the warping and mounting of a warp for a velvet with 2 pile warps demands two times more work and time than for a velvet with only one pile warp (table 2, G), and three times more work and time for a velvet with three pile warps.

- Concerning the simple:

• The number of simple cords is proportional to: the width of the comber unit* of the pattern repeat and eventually of the vertical border, the count of warp units and the number of pile warps (table 2: (C+E)/2xHxG).

• To construct the lashes a design has to be made and then a point paper plan, or equivalent plan, of the design has to be executed. On this paper each square represents one warp unit and one weft unit. By means of this plan the lashes are constructed on the simple cords. In this way the extent of manual labour for the execution of the simple is proportional to: the number of simple cords and the number of lashes. The number of lashes is the product of the height or half the height of the pattern repeat (table 3, A & B), combined with the height or half the height of the horizontal border (table 3, C & D), and the count of tufts in the height (table 1 & table 3F). The highest number of lashes calculated in this way is 910 for velvet IS.Tx.1200, a velvet with one pile warp, one repeat in the hole width of the fabric and a repeat with a height of 91 cm. Remark: the brocading does not influence the execution of the simple as the brocading does not require any lashes (see: 2. The execution of brocading on Ottoman brocaded cut velvets).

- *Remark*

The construction of the pattern device demands a considerable amount of time. Therefore, in modern times the characteristics of a pattern device have not changed and are used for as long as possible. When a new design is desired the width of the pattern repeat of the new design is chosen to conform to the existing comber unit. It may be assumed that the Ottoman velvet weavers worked in a similar way. Bearing in mind that the parameters to calculate the number of the simple cords (table 2K) are only approximated values, it is possible that some of the velvets were woven on the same loom or in the same workshop. Accordingly, we were able to classify most of the analysed velvets in four groups on the basis of the comber units (table 4):

- group I, velvets with 3 pattern repeats in the width of the fabric and 1 or 2 pile warps. This group includes only two velvets: the *çintamani* velvet and the velvet IS.Tx.806 with a comber unit of respectively 156 and 159 leashes.

- group II, velvets with 2 pattern repeats and 1 or 2 pile warps. This group contains four velvets, two pieces with only one pile warp and a comber unit from 217 to 224 leashes, and two pieces with two pile warps and a comber unit of twice 221 leashes.

- group III, velvets with the same features as group II. This group contains six velvets, three pieces with only one pile warp and a comber unit from 183 to 198, and three pieces with two pile warps and a comber unit from twice 186 to 193 leashes.

- group IV, velvets with 1 pattern repeat and 1 pile warp. This group contains four velvets with a comber unit from 372 to 375 leashes.

The velvets IS.Tx.664, 785, 1206, 1207, 1208, 1212, 1215 and 1232 do not fall into any of these groups.

5.2. The weaving of the velvet

- The time taken to weave a velvet depends in the first place on the count of the weft unit (table 3, F) and secondly on the brocading. The higher the count of the weft unit the longer it takes to weave a metre of the velvet.

- Some velvets are poorly brocaded and others richly. During brocading, especially with the manipulation of the brocading bobbins, the foundation fabric does not progress. The higher the brocading degree the slower the production speed. The çintamani velvet is an example of a richly brocaded velvet while velvets IS.Tx.1215 and 1212, once again, are examples of poorly brocaded velvets.

6. The quality of the product

The quality of the velvet depends on the type of warp and weft material used.

- First of all, the fibre of the warps and the wefts is an important factor in determining the quality. The material for the foundation warp as well as for the pile warp is always silk. The material for the wefts differs greatly. Many velvets have a foundation weft made from cotton, one has a bourrette silk foundation weft (IS.Tx.1229) others schappe silk (IS.Tx.450, 785, 1231, 1262) and only two velvets (IS.Tx.664 and IS.Tx.792, çintamani) have a real silk one (i.e. silk without apparent twist; 1.4 and tab. 1).

- Some velvets are brocaded with only silver thread (table 3, H-K) for example IS.Tx.1211, moreover the silver strip is wound around the core in very large spirals so that less metal is required. In some velvets the silver strip is wrapped around a core of yellow silk (IS.Tx.1201). In velvets IS.Tx.1202 and 1204 only a silver brocading weft with a light yellow core is used. In velvets IS.Tx.1206, 1212 and 1232, silver brocading wefts with a white (or ivory) silk core and with a yellow silk core are used in the same piece. Maybe this practice was intended to imitate pure gold thread at a lower cost. On the other hand in some pieces, such as IS.Tx.806, 1205 and 1209, gold thread is used with an ivory (or light yellow) silk core and a yellow silk core in the same piece in order to differentiate details of the motifs.

Gold thread of high quality is only used in two velvets. In velvets IS.Tx.792 (çintamani) and IS.Tx.1200, the silver strip is gilded on both sides and entirely covers the core.

Also the amount of brocaded surface affects the quality of the velvet. Some velvets are poorly brocaded and the others richly. The çintamani velvet is an example of a richly brocaded and the velvets IS.Tx.1215 and 1212, once again, of a poorly brocaded velvet.

- Furthermore, the count of tufts in both directions, as well as the number of pile warps (one, two or even three), influences the quality of the velvet. Most of the velvets analysed have a count from 12 to 15 tufts/cm in the weft direction and 8 to 12 tufts/cm in the warp direction (table 1). Only the velvet IS.Tx.792 (çintamani) is an exception with more than 28 tufts/cm in he weft direction. By comparison, IS.Tx.1206, IS.Tx.1213 and IS.Tx.1232, have only respectively 5,5, 6,5 and 6 tufts/cm in the warp direction, but they are velvets with only one pile warp and one pattern repeat across the width of the fabric. In addition, velvet IS.Tx.1206 has a four-fold cotton foundation warp.

Velvet IS.Tx.792 (çintamani) has more than 350 tufts per square centimetre, whilst most of the velvets analysed have approximately 120 to 160 tufts per square centimetre, and velvets IS.Tx.1206, IS.Tx.1213 and IS.Tx.1232 only respectively, 66, 81 and 72 tufts per square centimetre (table 1).

- Finally the height of the pile influences the quality of the velvets. However it is difficult to judge correctly the original height of the pile due to of two factors. First there is the shearing of the pile surface. After weaving, the pile surface is trimmed to equalize the pile. Today this treatment is done mechanically[8], but in the pre-industrial era this was done manually by means of

shears with very long-blades. Although there is no literature about pile-trimming at this period, it may assumed that it was carried out in a similar way to shearing the surface of woollen cloth after it was fulled and the nap was raised. This was done by one or two craftsmen with special shears, the blades of which were sometimes more than one meter in length[9].

In the second place there is the matter of wear. All the velvets analysed are worn, sometimes very severely. Therefore, it is impossible to calculate the original height of the pile. Measurements were taken on all the velvets analysed. In some velvets the height of the pile differed from 0 to 1,55 mm. The maximum height of most of the velvets are noted in table 2 column J. These measurements are not the original heights of the pile, they are merely the original pile heights less the shearing length and lose through wear.

Bearing in mind all the above factors, the best quality velvet is the *çintamani* velvet (IS.Tx.792). This velvet has the highest tuft count in both directions; indeed, in the weft direction the count is even double. All the wefts are of high quality (the foundation and squeezing/supporting weft are made from similar silk and the strip of the gold brocading weft entirely covers a core of pure silk).

Table 2. Ottoman velvets: some technical features, widthwise. The classification of the velvets is based, firstly on the number of pattern repeats in the width of the fabric without or with vertical border (vol. B), secondly on the number of pile warps (col. G).

Velvet	A width in cm	B repeat(s) number in width	C repeat(s) average width in cm	D repeat(s) vertical point repeat	E vertical border width in cm	F vertical border vertical point repeat	G pile warp(s) number	H pile warp(s) count tufts/cm	I pile warp(s) step tuft(s)	J pile warp(s) height of pile in mm	K comber unit leashes
IS.Tx.664	-	3	20.50	yes			1	12.50	1	1.00	128
IS.Tx.792	65.50	3	21.83	yes			1	28.50	2	1.45	156 twice
IS.Tx.820	60.00	2	31.00	yes			1	14.00	1	1.90	217
IS.Tx.1201	61.00	2	30.50	yes			1	12.00	1	1.25	183
IS.Tx.1203	-	2	30.50	yes			1	13.00	1	1.10	198
IS.Tx.1209	-	2	32.00	yes			1	14.00	1	2.10	224
IS.Tx.1211	60.30	2	30.15	yes			1	12.50	1	1.30	188
IS.Tx.785	>61.0	1	>61.00	yes			1	12.50	1	-	>381
IS.Tx.1200	62.00	1	62.00	yes			1	12.00	1	1.40	372
IS.Tx.1206	60.00	1	60.00	yes			1	12.00	1	-	360
IS.Tx.1207	60.00	1	60.00	yes			1	12.00	1	-	360
IS.Tx.1213	-	1	60.00	yes			1	12.50	1	1.55	375
IS.Tx.1229	62.50	1	62.50	yes			1	12.00	1	-	375
IS.Tx.1232	58.00	1	58.00	yes			1	12.00	1	-	348
IS.Tx.1262	62.00	1	62.00	yes			1	12.00	1	1.20	372
IS.Tx.1212	63.00	2+bord	20.50	yes	22.00	yes	1	12.00	1	1.55	255
IS.Tx.1215	60.00	2+bord	20.50	yes	20.50	yes	1	13.00	1	1.20	267
IS.Tx.806	-	3	21.25	yes			2	15.00	1	1.00	159 twice
IS.Tx.1205	62.50	3	20.83	yes			2	14.00	1	-	146 twice
IS.Tx.450	-	2	32.20	yes			2	12.00	1	1.40	193 twice
IS.Tx.1202	-	2	31.50	yes			2	14.00	1	1.25	221 twice
IS.Tx.1204	63.50	2	31.75	yes			2	12.00	1	1.25	191 twice
IS.Tx.1208	64.50	2	32.25	yes			2	13.30	1	1.95	214 twice
IS.Tx.1210	-	2	31.50	yes			2	14.00	1	1.45	221 twice
IS.Tx.1231	62.00	2	31.00	yes			2	12.00	1	-	186 twice

Table 3. Ottoman velvets; some technical features, lengthwise. Same classification as Table 2.

Velvet	A	B	C	D	E	F	G	H	I	J	K
	repeat		horizont. border		weft unit		simple	brocading weft			
								silver strip		gilded silver strip	
	height in cm	horizont. point repeat	height in cm	horizont. point repeat	Step	count tufts/cm	lashes	wrapped	silk core	wrapped	silk core
IS.Tx.664	24.50				1	12.00	294	S	ivory	S	orange
IS.Tx.792	31.00				1	12.40	384			S	light yellow
IS.Tx.820	32.00		13.00	no	1	10.50	473			S	ivory
IS.Tx.1201	62.00				1	8.00	496	S	yellow		
IS.Tx.1203	54.50				1	9.00	491	S	ivory		
IS.Tx.1209	65.50				1	11.00	721			S	ivory & yellow
IS.Tx.1211	47.25				1	9.00	425	Z	white		
IS.Tx.785	74.00				1	9.50	703			S	yellow
IS.Tx.1200	91				1	10	910			Z	light yellow
IS.Tx.1206	>154				1	5.50	>847	S	white & yellow		
IS.Tx.1207	84.50	yes	12.00	no	1	10.00	543			S	white
IS.Tx.1213	-				1	6.50	-	S	ivory	S	yellow
IS.Tx.1229	87.50				1	9.00	788			S	yellow
IS.Tx.1232	102.00				1	6.00	612	S	white & yellow		
IS.Tx.1262	81.00				1	10.00	810	S	ivory	S	ivory
IS.Tx.1212	43.50				1	9.00	392	Z	ivory & light yellow		
IS.Tx.1215	36.00				1	8.00	288	Z	ivory		
IS.Tx.806	20.30	yes	22.00	yes	1	11.00	233			S	light yellow & yellow
IS.Tx.1205	21.00	yes	10.50	no	1	12.00	252			S	ivory & yellow
IS.Tx.450	-				1	11.50	-			S	ivory
IS.Tx.1202	51.00	yes			1	11.00	281	S	light yellow		
IS.Tx.1204	54.00				1	12.00	648	S	light yellow		
IS.Tx.1208	70.00				1	9.00	630	S	ivory	S	light yellow
IS.Tx.1210	61.00				1	10.00	610	S	ivory		
IS.Tx.1231	110.00	yes			1	10.00	550			S	light yellow

Table 4: Ottoman velvets; classification of comber units.

Velvet	B	C	G	H	I	K
	pattern repeats		pile warp(s)			comber unit
	number in width	average width in cm	number	count: tufts/cm	step: tuft(s)	leashes
Group I						
IS.Tx.792	3	21.83	1	28.50	2	156 twice
IS.Tx.806	3	21.25	2	15	1	159 twice
Group II						
IS.Tx.820	2	31.00	1	14.00	1	217
IS.Tx.1209	2	32.00	1	14.00	1	224
IS.Tx.1202	2	31.50	2	14.00	1	221 twice
IS.Tx.1210	2	31.50	2	14.00	1	221 twice
Group III						
IS.Tx.1201	2	30.50	1	12.00	1	183
IS.Tx.1203	2	30.50	1	13.00	1	198
IS.Tx.1211	2	30.15	1	12.50	1	188
IS.Tx.450	2	32.20	2	12.00	1	193 twice
IS.Tx.1204	2	31.75	2	12.00	1	191 twice
IS.Tx.1231	2	31.00	2	12.00	1	186 twice
Group IV						
IS.Tx.1200	1	62.00	1	12.00	1	372
IS.Tx.1213	1	60.00	1	12.50	1	375
IS.Tx.1229	1	62.50	1	12.00	1	375
IS.Tx.1262	1	62.00	1	12.00	1	372

Notes

1. ATASOY N. *et al., IPEK. The Crescent & the rose. Imperial Ottoman Silks and Velvets*, Azimuth Editions, London, 2001, p. 223. In this publication the structure of Ottoman velvets is treated from another viewpoint by Milton Sonday. In his opinion the foundation pick above the supporting pick (in his terms: *front of pair* and *back of pair*) is not essential to the structure. But this pick forms part of the foundation weft and is as essential for the structure as the other foundation picks. Moreover there is no need for a special term for this pick (in his terms: *front of pair*), nor is it necessary to report the material of this pick since it forms part of the foundation weft.

2. The kind of weft does not depend on the way on which it is entered in the shed but only from the function it carries out in the structure of the fabric; (see also: DE JONGHE D., Klassering van complexe weefsels, in *Museumvisie*, 1981, p. 58-59).

3. We are grateful to Paul Vanhese, product manager of DESSO CARPETS, Waasmunster Belgium, for this information.

4. ATASOY N. *et al., op. cit.*, fig. 287; also a late 15th century *çintamani* pattern velvet (Metropolitan Museum of Art, inv. 08.109.23). This velvet has also a double pile warp count but unfortunately the warp step is not stated.

5. ATASOY N. *et al., op. cit.*, p. 223.

6. ERBER C., *Reich an Samt und Seide*, exhibition catalogue, Bremen, 1993, cat. G 1/2, p. 88-89.

7. Inv. T.154-1949, Fitzwilliam Museum, Cambridge, in ATASOY N. *et al., op. cit.*, plate 103.

8. DIJKMEIJER E., *Textiel*, vol. III, Amsterdam, 1944, p. 59-66.

9. HOFENK DE GRAAFF J.H., *Geschiedenis van de textieltechniek, Lakennijverheid - Sitsen - Zijde-industrie*, Amsterdam, 1992, p. 40.

Illustrations

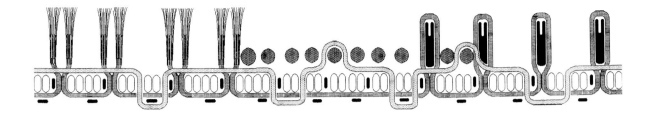

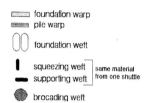 foundation warp
pile warp

foundation weft

squeezing weft ⎤ same material
supporting weft ⎦ from one shuttle

brocading weft

Fig. 1. Section, warp direction, of cut velvets with one pile warp, a paired cotton foundation weft and a squeezing and supporting weft of thin silk.

foundation warp

pile warp

tuft

foundation weft
sqeezing weft ⎤ squeezing weft and supporting weft:
supporting weft ⎦ same material from only one shuttle.

brocading weft

Fig. 2. Diagram showing the binding of cut velvets with one pile warp, a paired cotton foundation weft and a squeezing and supporting weft of thin silk.

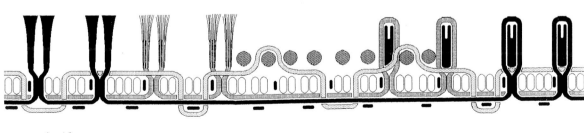

foundation warp
pile warp a
pile warp b

foundation weft

squeezing weft ⎤ same material
supporting weft ⎦ from one shuttle

brocading weft

Fig. 3. Section, warp direction, of cut velvets with two pile warps, a paired cotton foundation weft and a squeezing and supporting weft of thin silk. Remark: the second foundation warp thread between the two pile warp threads is omitted.

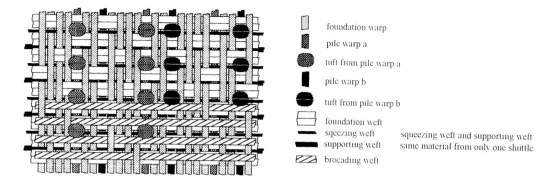

foundation warp
pile warp a
tuft from pile warp a
pile warp b
tuft from pile warp b
foundation weft
sqeezing weft
supporting weft
brocading weft

squeezing weft and supporting weft:
same material from only one shuttle.

Fig. 4. Diagram showing the binding of cut velvets with two pile warps, a paired cotton foundation weft and a squeezing and supporting weft of thin silk.

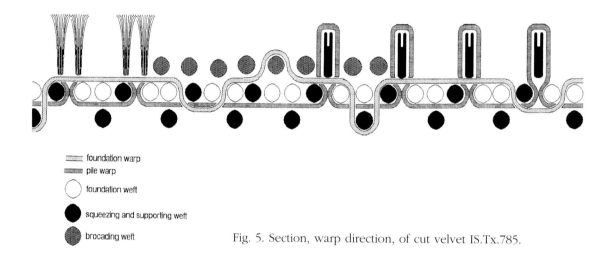

foundation warp
pile warp
foundation weft
squeezing and supporting weft
brocading weft

Fig. 5. Section, warp direction, of cut velvet IS.Tx.785.

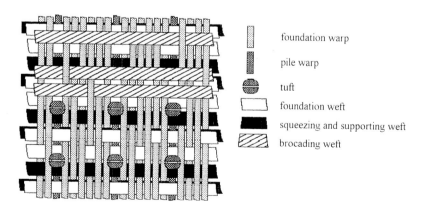

foundation warp
pile warp
tuft
foundation weft
squeezing and supporting weft
brocading weft

Fig. 6. Diagram of cut velvet IS.Tx.785.

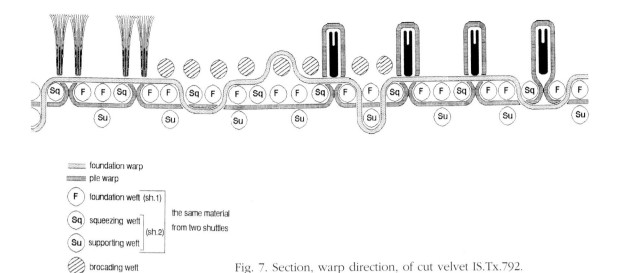

foundation warp
pile warp
(F) foundation weft (sh.1)
(Sq) squeezing weft
(Su) supporting weft } (sh.2) } the same material from two shuttles
brocading weft

Fig. 7. Section, warp direction, of cut velvet IS.Tx.792.

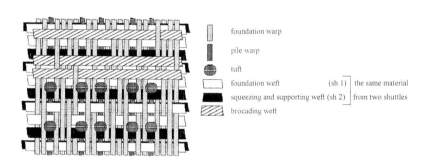

foundation warp
pile warp
tuft
foundation weft (sh 1)] the same material
squeezing and supporting weft (sh 2)] from two shuttles
brocading weft

Fig. 8. Diagram of cut velvet IS.Tx.792.

Fig. 9. Micrograph showing the reverse of a brocaded cut velvet near the left selvage. The returning brocading weft floats are positioned at the left limit of the pattern.

Fig. 11. Inv. IS.Tx.1229; detail of reverse: the two brocading picks, which are positioned between two velvet rods, are entered between the two same foundation picks. On the reverse the returning brocading weft floats link up to each other.

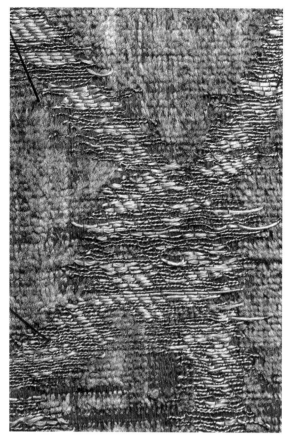

Fig. 12. Inv. IS.Tx.1229; front: the returning brocading weft floats are positioned on one side of the pattern on the front and on the other side at the reverse of the fabric.

Fig. 10. Micrograph showing the right side of brocaded cut velvet inv. IS.Tx.785 from which the pile is worn away.

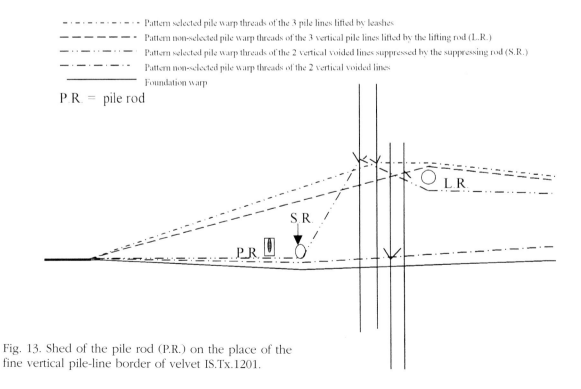

- · - · - · - · - · - · Pattern selected pile warp threads of the 3 pile lines lifted by leashes
- — — — — — — · Pattern non-selected pile warp threads of the 3 vertical pile lines lifted by the lifting rod (L.R.)
- · · — · — · · — · Pattern selected pile warp threads of the 2 vertical voided lines suppressed by the suppressing rod (S.R.)
- · — · — · — · · Pattern non-selected pile warp threads of the 2 vertical voided lines
———————— Foundation warp

P.R. = pile rod

Fig. 13. Shed of the pile rod (P.R.) on the place of the fine vertical pile-line border of velvet IS.Tx.1201.

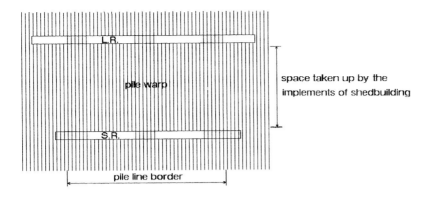

space taken up by the
implements of shedbuilding

Fig. 14. Position of the lifting rod
(L.R.) and the suppressing rod
(S.R.) in the pile warp for the exe-
cution of the fine vertical pile-line
border of IS.Tx.1201.

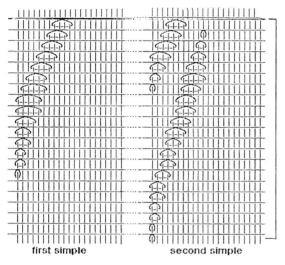

lashes for first and
second pile warp

Fig. 15. Diagram of a detail of the
simple for a velvet with two pile
warps. The lashes are constructed
according to the detail of the
point paper plan in fig. 16.

┼┼ no pile

▓ pile from first pile warp (red)

▓ pile from second pile warp (green)

Fig. 16. Detail of the point paper
plan for the pattern repeat of vel-
vet IS.Tx.806. A velvet with two
pile warps.

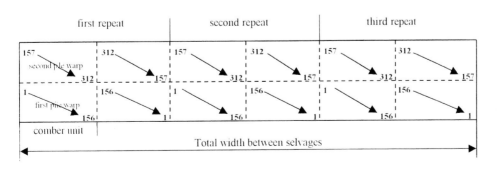

Fig. 17. Diagram of
a figure harness for
a two pile warp vel-
vet with 3 vertical
point repeats and a
comber unit of twice
156 leashes.

no pile

pile from first and
second pile warp

Fig. 18. Reconstruction of the point paper plan for vel-
vet IS.Tx.792; ⊞ pile, ⊞ no pile.

Fig. 19. Detail of the point paper
plan of fig. 18 (boxed area).

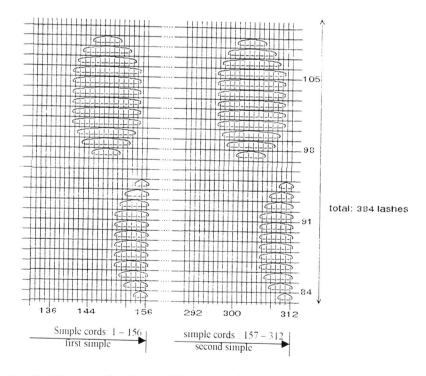

total: 384 lashes

Simple cords: 1 – 156
first simple

simple cords : 157 – 312
second simple

Fig. 20. Diagram of a detail of the simple for velvet IS.Tx.792 (*çintamani*)
with two pile warps of the same material. The lashes are constructed accord-
ing to the detail of the point paper plan from fig. 19.

Technology of the velvets

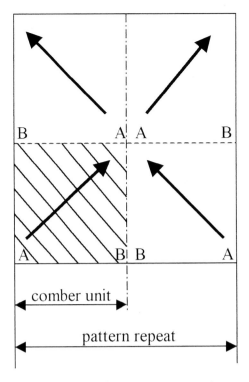

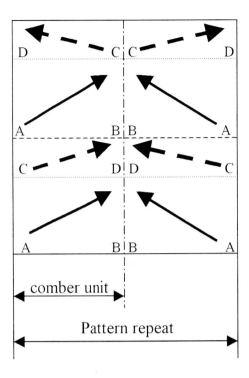

Fig. 21. Diagram of the construction of a pattern with a vertical point repeat and a repeat in quincunx in the height direction, as the pattern of the Brussels *çintamani*.

Fig. 22. Diagram of the construction of the pattern repeat of the Krefeld *çintamani*. A-B: balls; C-D: Tiger stripes.

Fig. 23. Reconstruction of the *çintamani* pattern of the velvet no. G 1/2 published p. 89 in Erber C. (ed.), *Reich an Samt und Seide.*

4. Technology of the *lampas** fabrics and distinctive weaves

Chris Verhecken-Lammens

1. *Lampas* fabrics

"*Lampas*" is a specific name for a complex weave structure of figured textiles. The Ottoman *lampas* fabrics are often referred to as "brocade", although "brocade" has no precise definition[1] and is used for any richly figured textile with a woven pattern, especially in gold and silver. Of the 16 *lampas* fabrics here described, 12 pieces have gilded-silver or silver pattern wefts.

Lampas fabrics are characterised in having two warps (foundation* and binding warp*), and two weft systems (foundation* and supplementary wefts*). These warps and wefts are used to weave a complex structure of two superimposed weaves: a warp-faced foundation weave and a weft-faced supplementary weave*.

1.1. Characteristics of Ottoman lampas (fig. 1)

- In the Ottoman *lampas* of this collection the proportion of foundation warp to binding warp varied from 3-4, 4 and 5 foundation warp threads to 1 binding warp thread.
- The warp step* is equal to one or, occasionally, two groups of the foundation warp proportion (threads between 2 binding warp threads).
- The foundation weave* is warp-faced 5-end satin[2], S- (interruption 2) or Z- (interruption 1) direction, the supplementary weave is in 1/3 Z- or S- twill, or in tabby[3]. These two weaves produce a single layer on which the motifs, made up by the weave of the binding warp and the supplementary wefts, appear above the foundation weave.
- Four pieces, all with a pattern of inscriptions, have only one silk pattern weft*. The other fabrics have 2 to 4 pattern wefts and a brocading* metal thread weft. In the same shed* the brocading weft is accompanied by the yellow or ivory silk weft to underline the colour of the metal thread.
- All 16 fabrics have an "opposite" weft sequence*, and the weft step* is one pass*.
- There are two types of selvage, belonging to groups of textiles clearly distinguishable from each other.
- To open the pattern shed, a special loom, a drawloom, has been used to separate the foundation warp according to the pattern fixed in the figure harness*.

1.2. Pattern (list in fig. 2)

The strongest visual difference between the Ottoman *lampas* textiles in the collection is in the pattern. A pattern of religious texts using a typical zigzag layout is found in a group of 6 fabrics. The second group of textiles, clearly Ottoman, is not so uniform in style.

The creation of a pattern is the work of skilled designers who had to follow some technical rules necessary for its construction on a loom[4]. The pattern is composed of units that are repeated in two ways: straight repeat* or reverse repeat*. This repetition is an important factor for setting up the figure harness. The width of the pattern unit* determines the number of pattern repeats within the width of the fabric. When we know the width of the pattern unit and the number of warp units per cm, the product of both figures gives the theoretical capacity of the figure harness. The degree of detail of the pattern depends on the warp and weft density and the value of the warp and weft step*.

Sometimes the pattern set-up is misleading as we can see in the 6 fabrics with inscriptions using a typical zigzag layout. This composition suggests a reverse warp repeat. Reading the text

makes it obvious that the pattern has a straight warp repeat of 2 to 6 pattern repeats in the width. This misleading pattern composition can also be detected in some older figured textiles of which the pattern has a vertical symmetry axis but a straight warp repeat.

The textiles of the second group with an undulating vine figuration have also a straight warp repeat[5], but those with an ogival lattice pattern have a reverse warp repeat arrangement.

1.3. Setting up the loom

Lampas fabrics were woven on a drawloom[6]. This handloom, specially equipped for weaving figured textiles, had a figure harness to create the pattern, a harness* with 5 lifting shafts for the foundation weave (satin) and a harness with 4 depression shafts to create the supplementary weave (twill 1/3 or tabby).

Lampas fabrics were woven face down for facilitating the work of the weaver and the drawboy*. The foundation warp and the binding warp had their own warp beam and in the loom they form two layers, the binding warp on top (fig. 5, A). When the loom was not in operation a constant open shed, the natural shed, existed[7]. The foundation warp was entered in the five lifting shafts, the binding warp in the four depressing shafts. These shafts were connected to treadles and manipulated by the weaver himself. Because of this special warp arrangement only one shaft has to be depressed to open the binding shed for the supplementary wefts (fig. 5, B-C). This binding shed was still open for the foundation weft but an extra lifting shaft had to be raised for the foundation weave (fig. 5, D).

The figure harness, operated by the drawboy(s)[8], controls only the foundation warp[9]. To form the pattern shed, only that part of the foundation warp that will be covered by the supplementary weft at the front side has to be lifted. A group of 3-4, 4 or 5 foundation ends (between the binding ends) is held by one heddle of a pattern shaft*[10]. This pattern shaft is connected to a pulley cord* and a tail cord* and commands one warp step in the pattern unit. The number of tail cords used to create the pattern can be deduced from analysis information and gives a theoretical capacity of the figure harness. In the collection there are three fabrics with the pattern step of two groups of warp ends[11]. The reason could be that the capacity of the figure harness of the drawloom was insufficient to weave this pattern with a pattern step of one warp group. This does not effect the quality of the fabric but results in a stepped outline of the design (fig. 6, IS.Tx.811).

The Ottoman *lampas* textiles were woven on a drawloom with a capacity from 135 up to 600 pattern shafts threaded in a straight or reversed sequence (list in fig. 2). This amount of shafts could be managed perfectly by the drawboys[12].

A simple cord* is attached to each tail cord. This group of simple cords made up the simple and contains the lashes*. One lash selects the pattern shafts needed to form one pattern shed. These lashes are grouped on a "guiding" cord according to the number of pattern sheds (2 to 4) in one pass and will be manipulated always in the same sequence by the drawboy.

The succession of these lashes in the group is constant or intermittent. In all these textiles the weft step* is equal to one pass and the number of passes depends on the weft density and the height of the pattern. A long pattern does not mean a large number of passes, as can be seen in IS.Tx.1257; this textile has a pattern of 71 cm high and a weft count of 15 passes per cm resulting in approximately 1065 passes. It also has 4 supplementary wefts, of which the yellow accompanying weft is in the same shed as the brocading metal thread weft. These two wefts are "intermittent" in certain places. Generally 3 lashes were needed in one pass; a smaller part needed only 2 lashes. In total, 3195 (1065 x 3) lashes (pattern sheds) at least make up the arrangement in weft direction.

Another example, IS.Tx.1261, having a pattern height of 54.5 cm, a weft density of 26 passes per cm and constantly 4 different pattern sheds in the pass, has approximately 1417 passes which gives a total amount of 5668 lashes or pattern sheds in one pattern unit.

1.4. Warp proportion (list in fig. 4)

The proportion of 3-4 foundation warp threads to 1 binding warp thread is remarkable and this feature occurs in 10 out of the 16 textiles. The division of the threads is mostly over four groups with a sequence of 4, 4, 4 and 3. The succession is not always in that order but it seems that 15 warp threads are divided over 4 groups. The reason is unclear, but it certainly has an effect on the total number of foundation warp threads in the width compared with textiles having a warp proportion of 4/1[13].

1.5. Weft sequence[14]

One of the main features of these Ottoman *lampas* fabrics is their weft sequence[15]. To analyse the weft sequence the design needs to be in upright direction. Textiles woven with the design oriented to the weft direction will give difficulties because it will be hard to establish how it has been woven on the loom.

Lampas with double ground weave will give a divided weft sequence. The foundation weft does not bind with the binding warp. In this case the binding shed is only formed for the supplementary picks, the foundation wefts lying between the binding sheds. Still the succession of the supplementary wefts in the binding shed is important.

In general, a "normal" *lampas* has the foundation weft as the first one in the pass followed by the supplementary wefts. In the Ottoman *lampas* fabrics the weft sequence is in "opposite" direction, always the foundation weft as the last weft in the pass, even if the pattern has only one supplementary weft. The succession of the wefts is very regular. In textiles with metal threads, the first weft is the brocading weft (metal thread) followed by the accompanying weft (yellow or ivory) and the rest of the supplementary wefts. The foundation weft is the final weft in the pass.

Who has seen professional weavers at work on a drawloom understands the importance of the weft sequence[16]. Here, the weaving process is an interaction between weaver and drawboy and regularity is a must. When visiting the drawloom workshop of Abdelkader Ourregli in Fèz[17], I was happily surprised to notice that the last pick in the pass was the foundation weft. It seems to be a tradition handed down from generation to generation.

1.6. Selvages (list in fig. 4)

Of the 16 Ottoman *lampas* fabrics, 15 pieces still have one or both selvages. As said, according to the pattern, the textiles are divided in two groups: the six "with inscriptions" and the ten with various patterns.

All those of the second group have 2 to 4 pattern wefts and a brocading metal thread weft. These textiles also share a common type of selvage characterised by densely packed foundation warp threads, paired binding warp threads and no selvage cords. The foundation weft and the pattern wefts (not the brocading weft) make up the *lampas* structure with the foundation weave at the front side. Most of the selvages have two colours in the foundation warp, crimson or green and a strip of cream warp threads near the edge. The width of selvage varies even within one piece (fig. 7, IS.Tx.808).

The six fabrics with inscriptions can be divided in two groups: 4 fabrics with only one pattern weft, and 2 fabrics with 3 pattern wefts and a brocading metal thread weft. These 2 fabrics have the same type of selvage as the 10 of the second group.

The 4 textiles with only one pattern weft have a selvage in *lampas* structure and at its edge one to 4 selvage cords. The foundation weft and the pattern weft bind with these cords in the supplementary weave (tabby or 1/3 twill). There is less homogeneity in this type of selvage and even in this group of 4 textiles differences occur (fig. 8, IS.Tx.1218).

We may conclude that within this group of 16 *lampas* fabrics, the textiles with several pattern wefts and a brocading metal thread weft have a common type of selvage.

1.7. Material (list fig. 3)

The main material used in the *lampas* textiles is silk and 12 textiles are adorned with a brocading metal thread.

There is a visual difference between warp threads and weft threads within one piece but also between different fabrics.

Z-twist silk threads, rather strong, are used for the foundation warp in four textiles[18]. This is a type of thread found in the majority of silk textiles before the 14th century[19]. These compact threads have contributed to the quality of silk fabrics and were of importance for the weight of silk, which will have had consequences for the price of the textile. In contrast to *samit* and *taqueté*[20] fabrics, the foundation warp in *lampas* has a visual aspect in the pattern. It is known that the twist influences the brilliancy of the silk thread; a loosely twisted thread has more lustre. Gradually Z-twist warp threads changed to finer S-ply threads, although in textiles of Safavid Iran[21] and in Moroccan women sashes[22] of the 16th-19th centuries, the use of Z-twisted threads is dominant.

S-ply silk threads are used for the foundation warp in 10 *lampas* fabrics.

Very often the foundation warp threads have a red colour (10 textiles), but green also occurs.

Binding warp threads are finer and of a single strand, twisted in Z- or S- direction, or without visible twist (I-twist)[23]. Most often the threads have a discreet colour.

There is more variation in the weft threads, from single strand to multiple strands* (2 to 5).

The foundation weft of 10 fabrics has a similar colour as the foundation warp. The other fabrics have a cream foundation weft.

The composition of the supplementary weft threads together with the weft density influences the aspect of the textile. In some fabrics the pattern weft does not completely cover the foundation weave as can be seen in IS.Tx.758 (fig. 9). The pattern wefts and the foundation weft are made up of 2 I-twist strands or even by a single strand, and the weft count is rather low, 16-17 passes per cm. The result is that the crimson foundation diminishes the clearness of the motifs. Another fabric, IS.Tx.1216 (fig. 10), with the pattern weft made up of 3 I-twist strands and the foundation weft of a single strand has a weft thread count of 23 passes per cm. Here the motifs clearly stand out on the crimson foundation.

Metal threads are used as brocading weft in 12 textiles. The majority of the metal threads are composed of gilded silver or silver strip S-wrapped around a silk core, S-ply or S-twist. Only in one fabric, IS.Tx.1228, a paired gilded silver wire has been used.

The Ottoman *lampas* fabrics have a specific pattern style. Their homogeneous weave structure is recognisable by the relation between warp step and the group of foundation warp threads between the binding warp threads, the weft sequence, and the combination of foundation weave (satin 4/1) and supplementary weave (1/3 twill or tabby).

Ottoman *lampas* are distinguished from Persian and Italian *lampas* of the same period by these characteristics.

2. Extended tabby with supplementary wefts

Textile IS.Tx.1233 with a recognisable Ottoman period pattern and a width of 124 cm gives a visual impression very similar to the *lampas* fabrics here described, but it is woven in a distinctive technique: the foundation weave is here a warp-faced extended tabby with brocading wefts bound in 1/7 Z-twill by the main warp to form the pattern.

2.1. Characteristics

The pattern has two pattern repeats in the width, each consisting of two pattern units placed in reverse repeat in warp direction. The dimension of this pattern is adapted to the width of the fabric and compared with the pattern in the *lampas* fabrics, two to three times enlarged. Although the height (119 cm) of the pattern is not complete, this textile was made especially to

Technology of the *lampas* fabrics and distinctive weaves

be used in this format. At the start and the end of the fabric a white line, from selvage to selvage, marks the length needed for this textile.

Instead of the 2 warp systems of the *lampas* structure, this fabric has a single warp; the foundation warp, and 2 weft systems; the foundation weft and brocading (discontinuous supplementary) wefts.

Each foundation warp thread is paired (2 S-ply) and binds the foundation weft (multiple strands) in warp-faced extended tabby weave.

The warp step is 4 paired foundation warp threads.

The brocading wefts create the pattern. Contrary to the *lampas* structure, the binding warp is lacking here and the foundation warp[24] binds the brocading wefts in 1/7 Z-twill. At the backside of the fabric these wefts float.

The weft proportion in the pass is one foundation weft to one of each supplementary weft needed for the pattern. The weft step is one pass.

As in the Ottoman *lampas* fabrics, this fabric also has an "opposite" weft sequence with the foundation weft as the final weft in the pass. The brocading weft consisting of multiple strands (0.7 mm) completely covers the foundation weave (fig. 11, IS.Tx.1233).

Both selvages consist of 4 selvage cords of 4 threads (4 S-ply) each. These 4 cords also were entered in the figure harness of the drawloom and the pattern is formed in the fabric from the first warp thread till the last one.

2.2. Setting up the drawloom

The pattern of this fabric has a reverse warp repeat with 2 pattern repeats in the width. One pattern unit needed a capacity of approximately 434 (31 x 14) tail cords. This number is comparable to that needed to weave the *lampas* fabrics (list fig. 2).

Each tail cord controlled one warp step equal to a group of 4 paired warp threads and all warp threads were entered in the figure harness.

All warp threads were also entered in two independently working harnesses. The first had at least 2 lifting shafts for the foundation weave (extended tabby) and the second 8 depressing shafts to bind the supplementary wefts. In both harnesses, the eye of the heddle through which the warp is threaded would be quite long to ensure a comfortable movement of the warp threads[25]. The setting up of the drawloom for *lampas* fabrics differs in that way that the 2 separate warps are threaded in their proper harness. The single warp of fabrics with tabby foundation weave and supplementary wefts for the pattern has to fulfil the function of the 2 separate warps in *lampas* fabrics.

IS.Tx.1233 was woven face down as were the *lampas* fabrics (fig. 12). To open the pattern shed, warp threads commanded by the figure harness were lifted and one of the 8 depressing shafts was treadled to bind the supplementary weft. In some places at the backside of the fabric, these brocading wefts float over the ground fabric and are not bound by the foundation warp, because no lifting shaft was used for the pattern shed.

We do not know if this textile is an exception among the Ottoman fabrics, it would be interesting to locate more examples.

3. A military banner

Another distinctive weave fabric: textile IS.Tx.1223, a military banner, is composed of two different silk fabrics. The rectangular section at the right side and the main field are made of one fabric, an off-white silk, woven in warp-faced extended tabby with 24 medallions formed by supplementary brocading wefts, bound by the foundation warp in irregular 1/5 twill at both sides. These 24 medallions are reversible and were specially designed for making up the banner.

The vertical green band with inscriptions and the green borders also have a foundation weave in warp-faced extended tabby, while the pattern is formed by a supplementary pattern weft: a gilded silver metal thread bound in irregular 1/5 twill by the foundation warp at both sides.

3.1. Characteristics

The off-white brocaded silk fabric of 63.5 cm width and the green patterned silk fabric of 30 cm width have similar technical features:
- A single warp consisting of paired S-twisted threads.
- Warp step of 2 paired threads.
- The foundation warp binds the foundation weft in warp-faced extended tabby.
- All threads of the foundation warp bind the supplementary wefts in irregular 1/5 twill weave at both sides.
- Two weft systems: foundation weft and supplementary weft(s).
- Weft step of one pass.
- One pass comprises one foundation weft followed by the supplementary wefts.

Medallions woven into the off-white fabric are formed by one brocading weft (5 S-twist) in red, green or pale pink (faded?) silk followed by a gilded metal thread; gilded silver strip loosely wrapped in Z-direction around an off-white silk cord (3 S-twist).

The supplementary weft of the green fabric is a pattern weft; gilded silver metal strips loosely wrapped in Z-direction around an off-white silk cord (2 S-twist).
- The selvages of both fabrics consist of 6 thick cords, each formed by several warp threads. These cords are bound in tabby by the foundation weft. In the green fabric the last two cords also bind the pattern weft.
- As a result of the weave structure the pattern is recognisable at both sides of the fabric but the texts are not readable because in mirror image.
- In both fabrics the foundation weft is rather thick (0.6-0.7 mm) and the supplementary metal thread weft is much finer (0.2 mm). Especially in the green fabric, this combination gives a rather vague pattern (fig. 13).

In spite of these similar characteristics both fabrics have a different texture. The off-white fabric with a rather low thread count of 24 paired warp threads and 8 passes per cm is light and supple. A conspicuous fold exactly in the middle of the width suggests a watered*[26] finishing treatment. Unfortunately this "moiré" effect has been lost, probably due to washing, and only the deep fold in the middle of the fabric remains.

The green fabric has 48 paired warp threads and 15 passes per cm, twice the density of the off-white fabric. This sturdy fabric answers the purpose to be used as border in the banner, protecting the more delicate off-white fabric in the centre.

3.2. Material

Both fabrics have paired S-twisted threads for the warp and multiple strands, S-twisted, for the wefts. As mentioned before[27], threads in fabrics earlier than 14th century mainly are Z-twisted and have been replaced afterwards by finer S-ply threads. S-twisted threads are not common and in the Errera collection I know of only a few examples from the 14th-15th century.

Tx.479 (Err. no: 73B), Tx.519 (Err. no: 30A) and Tx.997 (Err. no: 73) are complex *lampas*[28] fabrics with Chinese design.

Tx.693 (Err. no: 297A) is a brocaded *lampas*, Tx.706 (Err. no. 287) a warp faced 4/1 satin weave with supplementary discontinuous wefts, Tx.774 (Err. no: 212) a complex *lampas*, Tx.837 (Err. no: 237) and Tx.962 (Err. no: 382) are *lampas* fabrics. These five textiles[29] seem to have a Spanisch or Italian origin with Asian influence.

Finally, IS.Tx.88 (no. 450 in I. ERRERA, *Collection d'Anciennes Étoffes Égyptiennes,* Bruxelles, 1916) is a textile from the Mamluk period with patterned horizontal bands in compound weft-faced tabby *(taqueté)* on a tabby ground, and vertical stripes due to different colours in the warp[30].

Two banners from the collection of the "Musée des Tissus" Lyon (Inv. 35595 & 35593)[31] also have (loose) S-twisted threads and Z-wrapped metal thread. These banners are very similar in construction to IS.Tx.1223 except the weave structure is *lampas*[32].

It seems to me that this S-twisted yarn and Z-wrapped metal thread were remnants of the past that have been used in banners for a long time.

3.3. Setting up the drawloom

Although IS.Tx.1233 and IS.Tx.1223 have a ground structure of warp-faced tabby weave and a pattern formed by supplementary wefts, I propose a loom set-up to weave the fabrics of IS.Tx.1223 which differs from the one to weave IS.Tx.1233.

The pattern in the off-white fabric is made of different medallions placed in a predetermined order. Most medallions are repeated more than once except the big red medallion in the main field and the medallion in the middle of the rectangular section. The latter has a straight pattern unit in warp direction and excludes a reverse warp order suggested by other medallions in the middle of the fabric. The figure harness must have had approximately 744 weighted leashes* (width: 62 cm, 12 warp steps per cm), arranged in one straight order. I suppose, each type of medallion had its proper simple attached to the tail cords to be used when necessary.

The green fabric also had one straight warp repeat connected to approximately 700 tail cords.

Each tail cord controlled two paired warp threads (one warp step) and all warp threads were entered in the figure harness.

In contrast to the drawlooms used to weave the Ottoman *lampas* fabrics and IS.Tx.1233, this drawloom had only one harness to bind the ground weave and the supplementary wefts. All warp threads were entered in long-eyed heddles of 6 counterbalanced shafts. Threading order could be straight from shaft one to 6, but variations are possible, maybe even preferable. Shafts were connected two by two over pulleys and each shaft was connected to one treadle[33]. When treadling one shaft, the connected counter shaft will rise taking the warp threads up. Threads of the depressed shaft stay neutral, as do threads of the shafts in rest position. In both fabrics, the shaft of the first thread was connected to the shaft of the 6th thread, the second to the fifth and the third to the fourth (fig. 14).

To form one tabby shed, 3 shafts had to be depressed and depressing the other 3 shafts formed the second shed.

To open the pattern shed, warp units, selected by one lash of the simple, were lifted and one shaft was depressed to bind the supplementary weft. This depressed shaft lowers 1/6th of the lifted warp threads and its counter shaft will take up 1/6th of the warp threads in neutral position. The supplementary weft has been bound by 1/5 twill weave at the front and the back of the fabric, resulting in a reversed pattern at the back. Very often the binding was performed by the same warp threads creating a vertical line over the supplementary wefts instead of the diagonal lines of twill structure (fig. 15). These diagonal lines appear at both sides of the fabric. It is important to mention how the supplementary wefts are bound at the backside in order to understand the type of binding harness used.

Comparing the structure of the banners mentioned here, we notice a *lampas* structure and an extended tabby with supplementary wefts. Although, looking at the fabrics themselves it is very confusing and sometimes difficult to distinguish the 2 structures. Indeed, at a first glance they are very similar but the main difference is the composition of the warp. IS.Tx.1223 clearly has one warp, the banners in Lyon have 2 separate warps as can de detected in the ground weave. Hence the possible confusion between the structure of tabby with supplementary wefts bound at both sides and the *lampas* structure that we are dealing with. Two different structures do not necessary mean that they are woven on a different type of loom. Indeed, the 4 foundation warp threads between the binding weft threads could be entered in 4 counterbalanced shafts for the tabby foundation weave, and the binding warp in the 2 remaining shaft also for tabby weave.

We may assume the banner industry was in the hands of special workshops responsible for creating, weaving and making up this type of banners.

Notes

1. Here the term "brocade" is used in a broad sense. In the technical context "brocading weft" has a specific meaning (see glossary).

2. IS.Tx.808 has a broken 4/1 Z-twill weave and IS.Tx.1280 has an irregular satin 4/1.

3. IS.Tx.1216 and IS.Tx.1218.

4. For a good explanation of constructing a pattern see: SONDAY M., Pattern and weave, in: BIER C., *Woven from the soul. Spun from the heart*, Washington D.C., 1987, p. 57-72.

5. IS.Tx.807 and IS.Tx.1259.

6. Based on the weave analyses of the Ottoman *lampas* fabrics, the drawloom used seems to have a lot in common with the drawloom still in operation in Fès, Morocco. My own observation in 2000. For a description of this loom: DE JONGHE D. and TAVERNIER M., De schachtentrekstoel van Fez, in: *Bulletin van de Koninklijke Musea voor Kunst en Geschiedenis*, Brussel, 48, 1976, p. 145-162; and VIAL G., *Treize ceintures de femmes du XVIᵉ-XIXᵉ siècle*, Foundation Abegg, Riggisberg, 1980, p. 15-17.

7. This is not general. In Chengdu (China) foundation warp and binding warp have their own warp beam but form one layer in rest position.

8. MACKIE L., *Pattern books for drawloom weaving in Fès, Morocco*, in: CIETA-Bulletin 70, 1992, p. 171.

9. It is important to know if both warps are controlled by the figure harness, because this loom set-up implies a different manipulation of the harnesses by the weaver.

10. We have no description of the drawloom used in the Ottoman period but because of the mentioned characteristics of these *lampas* fabrics, I am convinced that the figure harness of this drawloom was equipped with shafts as it is in the drawloom of Fès (Morocco) today. These pattern shafts have the same function as the leaches of a drawloom.

11. IS.Tx.807, 811 and 1257.

12. MACKIE L., *op. cit.*, 1992, note 9.

13. A fabric with a warp proportion 3-4/1 and a warp count of 20 warp units/cm has 75 foundation warp threads/cm. A fabric with 4/1 proportion and 20 warp units/cm has 80 foundation warp threads/cm. In a width of 68 cm, approximately 340 warp threads will be "saved" with the proportion 3-4/1.

14. VERHECKEN-LAMMENS C., *Weft sequence and weave direction in "Byzantine", "Egyptian" and "Sogdian" silk samits of the 6ᵗʰ-10ᵗʰ Century*, in. CIETA-Bulletin 77, 2000, p. 35-44.

15. In the past, insufficient attention has been given to this feature.

16. My own observation in 1992 in China (Nanking and Chengdu) and in 2000 in Morocco (Fès).

17. I thank Frieda Sorber for introducing me to the workshop in November 2000.

18. IS.Tx.1259, IS.Tx.1261, IS.Tx.809 and IS.Tx 660 (see list fig. 3: material).

19. Following publications describing textiles from Europe, the region around the Mediterranean Sea, Central Asia and China were consulted: KING D. & KING M., *Textiles in the Keir Collection. 400BC to 1800AD*, London, 1990; VON WILCKENS L., *Mitteralterliche Seidenstoffe*, Berlin, 1992; WATT J. Y. & WARDWELL A. E., *When silk was gold. Central Asian and Chinese Textiles*, The Metropolitan Museum of Art, New York, 1997.

20. Samit and taqueté are complex structures with 2 warps and complementary wefts. In these structure the main warp (=foundation warp) is hidden between the complementary wefts.

21. BIER C., *Woven from the Soul, Spun from the Heart. Textile Arts of Safavid and Qajar Iran. 16ᵗʰ-19ᵗʰ Centuries*. The Textile Museum Washington, D.C., 1987.

22. VIAL G., *op. cit.* 1980, p. 14.

23. In analogy to the Z- and S-twist, we use I-twist for threads without visual twist.

24. All warp threads of the foundation warp are used to bind the supplementary wefts. This is different from the structure known as "liage repris" of which only one part (1/4-1/6) of the foundation warp is used to bind the supplementary wefts at the front side. "Liage repris" is a French term from the 18ᵗʰ century, see: GUELTON M.-H., *Samit and Lampas: a brief history and technical observation*. In: Samit & Lampas. Motifs indiens – Indian motifs. A.E.D.T.A/ Calico Museum, Paris, 1998, p. 25.

25. Also "clasped heddles" could be used. These heddles consist of two loops, which go over the bars and clasp each other in the centre. In this case, the warp threads are threaded above the clasp in order not to disturb the rising movement of the warp thread commanded by the figure harness. There are diverse types of heddles, see BECKER J., *Pattern and loom*, Rhodos, 1986, p. 285-291.

26. The fold is the result of folding the fabric length wise before pressing during the finishing treatment.

27. See: Material of *lampas* fabrics and note 19.

28. Tx.519 and Tx.997 have paired S-twisted foundation threads, Tx.479 has single S-twisted threads. All three fabrics have a binding warp of grège silk and a proportion of 2 foundation ends to 1 binding end (except Tx. 997 has a proportion of 2/1 and 3/1). Tx.479 and Tx.519 have a foundation weft of gilded paper strip Z-wrapped around white silk core (Z-twist) which is also used in the pattern. Tx. 997 has a foundation weft of multiple strands of white silk. These 3 textiles have a pattern weft of flat gilded paper strip. The foundation weave in Tx.479 and Tx.997 is a broken 3/1 Z-twill and in Tx.519 a 3/1 Z-twill. The supplementary weave is tabby. The selvage of Tx.519 has a *lampas* structure with off-white warp threads (see selvages of ottoman *lampas* fabrics) and Tx.997 has a selvage of 6 cords of multiple white threads bound in tabby (as in the fabrics of the banner).

29. The supplementary wefts of Tx.706 are bound in 1/4 satin by 1/8 of the main warp. Tx.774 and Tx.962 have a foundation weave in 4/1 satin, Tx.693 in tabby and Tx.837 in 1/3 twill. In those 4 fabrics the supplementary weave is similar: 2/2 twill and 1/3 twill for the gold thread.

30. IS.Tx.88 is a light silk fabric probably used as a veil or a turban.

31. I thank Marie-Hélène Guelton for her generous co-operation in analysing these banners.

32. Warp proportion: 4/1, warp step: 4 foundation threads. Two wefts: one foundation and supplementary wefts. Foundation weave: tabby, supplementary weave: tabby.

33. Shafts connected over pulleys are still in use in Mahdia (Tunisia) to weave traditional silk fabrics. When visiting

his workshop in 2001, Mr. Arous Karim told me that this weaving tradition goes back to the 14th century. This type of harness could also be used to weave some Mamluk fabrics with different structures in one piece such as IS.Tx.1739 described by De Jonghe D., Sur la technologie des soieries double-étoffe à trois chaînes, in *Riggisberger berichte*, 5, Abegg-Stiftung, Riggisberg, 1997, p. 195-208. Also De Jonghe D. and Van Raemdonck M., Het islamitisch zijde-weefsel Tx. 1739, in *Bulletin van de Koninklijke Musea voor Kunst en Geschiedenis* Brussel, deel 65, 1994 p. 75-110. Also *lampas* fabrics Tx.997 and Tx.519 (note 28) could be woven with this type of binding harness.

Illustrations

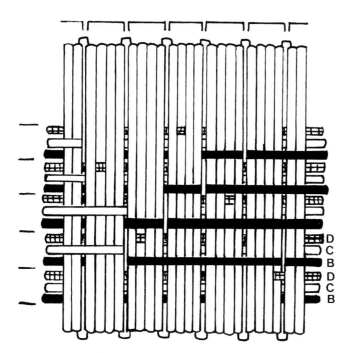

Fig. 1. *Lampas* structure.

Fig. 2. Pattern of the *lampas* textiles.

Textiles with inscriptions:

Inv. Cat.	Width	Pattern	Composition	Wa.unit/cm We.unit/cm	Capacity Fig. harness
IS.Tx.1216* Cat. L.1.2	69 cm	Wdt: 17 cm H: 48 cm	Straight repeat: 17 cm x 4	23 23	17 x 23: 390 counted: 400
IS.Tx.1217* Cat. L.1.3	Not compl. + 71 cm	Wdt: 30-31 cm H: ?	Straight repeat: 30 cm x ?	19 12	30 x 19: 570 counted:560
IS.Tx.1218* Cat. L.1.4	67 cm	Wdt: 33.3 cm H: ?	Straight repeat: 33.3 cm x 2	18 20	33.3 x 18: 600 counted: 600
IS.Tx.681* Cat. L.1.1	67.5 cm	Wdt: 11 cm H: 22-25 cm	Straight repeat: 11 cm x 6	24 17	11 x 24: 264
IS.Tx.1219 Cat. L.1.5	73.8 cm	Wdt: 19 cm H: ?	Straight repeat: 19 cm x 4	22 19-26	19 x 22: 418 counted: 427
IS.Tx.1228 Cat. L.1.6	79 cm	Wdt: 20 cm H: ?	Straight repeat: 20 cm x 4	16 7-13	20 x 16: 320

*only one pattern weft.

Textiles with various patterns:

Inv. Cat.	Width	Pattern	Composition	Wa.unit/cm We.unit/cm	Capacity Fig. harness
IS.Tx.807 Cat. L.2.3	Not compl.	Wdt: 22.5 cm H: 69.5 cm	Straight repeat: 22.5 cm x ?.	23 (11.5)* 17	22.5 x 11.5: 260
IS.Tx.1259 Cat. L.2.14	65 cm	Wdt: 17 cm H: 35.5 cm	Straight repeat: 17 cm x 4	24 18-20	17 x 24: 408
IS.Tx.660 Cat. L.2.17	Not compl.	Wdt: 14.5 cm H: 20 cm	Reverse repeat: 7.25 x 7.25 cm x ?	18-20 19-22	7.25 x 19: 138 counted: 135
IS.Tx.758 Cat. L.2.8	Not compl.	Wdt: 22 cm H: ?	Reverse repeat: 11 x 11 cm x ?	26-27 16-17	11 x 26: 290
IS.Tx.808 Cat. L.2.10	Not compl.	Wdt: 20 cm H: 46 cm	Reverse repeat: 10 x 10 cm x ?	24 16	10 x 24: 240
IS.Tx.809 Cat. L.2.11	Not compl.	Wdt: ? H: ?	Reverse repeat: Too small	22-25 21-23	
IS.Tx.811 Cat. L.2.12	Not compl.	Wdt: 34 cm H: 67.5 cm	Reverse repeat: 17 x 17 cm x ?	23-24 (12)* 17	17 x 12: 204 counted: 200
IS.Tx.1257 Cat. L.2.13	68 cm	Wdt: 34 cm H: 71 cm	Reverse repeat: 17 x 17 cm x 2	24-26(12-13)* 15	17 x 12: 204
IS.Tx.1261 Cat. L.2.15	68 cm	Wdt: 34 cm H: 54.5 cm	Reverse repeat: 17 x 17 cm x 2	22-24 26	17 x 24: 408
IS.Tx.1280 Cat. L.2.16	67 cm	Wdt: 32.5-33 cm H: 61-63 cm	Reverse repeat: 16.5 x 16.5 x 2	22-24 17-20	16.5 x 24: 400

*warp step of two groups of warp ends.

Fig. 3. Material of the *lampas* textiles: all silk yarn.

Inv.	Warp		Weft		
	Found.	**Binding**	**Found.**	**Pattern**	**Metal thread**
IS.Tx.1216 Cat. L.1.2	I2S-ply Crimson°	I-twist Ivory	I-twist Crimson°	3 I-twist Ivory	None
IS.Tx.1217 Cat. L.1.3	I2S-ply Green°	2 S-twist Cream	2 I-twist Green°	5 I-twist Ivory	None
IS.Tx.1218 Cat. L.1.4	I2S-ply Green°	I-twist Green	2 I-twist Green°	3 I-twist Ivory	None
IS.Tx.681 Cat. L.1.1	I2S-ply Red°	I-twist Cream	2-4 Z- Yel°.	2-3 Z- Ivory	None
IS.Tx.1219 Cat. L.1.5	S-twist Mustard°	Z-twist Cream	3 Z-twist Mustard°	3-4 Z-twist Crim, iv°, yel*	Gilded silver, S-wrap,* Yellow silk core S-twist
IS.Tx.1228 Cat. L.1.6	2 Z-twist (S) Green°	Z&S=1 thread Cream	2 S-twist Green	5 S-twist Crim°, iv, yel*	Paired gilded silver wire*
IS.Tx.1259 Cat. L.2.14	Z-twist Crimson°	Z-twist Cream	3 Z-twist Pink°	2 Z-twist Gr*/bl*, black, yel*	Gilded silver, S-wrap,* Yellow silk core, S-twist
IS.Tx.1261 Cat. L.2.15	Z-twist Crimson°	Z-twist Cream	2 Z-twist Ivory	3 Z-twist Gr*°, bl, iv, yel°	Gilded silver, S-wrap, Yellow° silk core, 2 S-twist
IS.Tx.809 Cat. L.2.11	Z-twist Crimson°	Z-twist Cream	I-twist Crimson°	I-twist Bl*, iv, br, yel	Gilded silver, S-wrap, Yel/cream. Silk core, I2S- ply
IS.Tx.660 Cat. L.2.7	Z-twist Pale green	1 S, 1 Z-twist Cream	3 I-twist Pale green	2 I-/ Z- twist Black, iv	Gilded silver, S-wrap, Cream silk core, 2 S-twist
IS.Tx.758 Cat. L.2.8	I2S-ply Crimson°	I2Z-ply Cream	2 I-twist Scarlet°	2 I-/ S- twist Wh, bl, gr, yel	Gilded silver, S-wrap, Yellow silk core, S-twist
IS.Tx.807 Cat. L.2.9	I2S-ply Crimson°	I2Z-ply Cream	2 Z-twist Scarlet°	2 Z-twist Iv, turq°/yel	Gilded silver, S-wrap,* Yellow° silk core S2S-ply
IS.Tx.808 Cat. L.2.10	I2S-ply Crimson°	Z-twist Cream	I2Z-ply Cream	2-3 Z-twist Iv, yel°	Gilded silver, S-wrap, Yellow silk core S-twist
IS.Tx.811 Cat. L.2.12	I2S-ply Blue	Z-twist Cream	I-twist Pale blue	2 I-twist Yel°, iv	Silver , S-wrap, Ivory silk core, I3S-ply
IS.Tx.1257 Cat. L.2.13	I2S-ply Scarlet°	Z-twist Ivory	2 S-twist Ivory	2 S-twist Iv, bl°, yel*°	Gilded silver, S-wrap,* Yellow° silk core S- twist
IS.Tx.1280 Cat. L.2.16	I2S-ply Crimson°	Z-twist Cream°	2 Z-twist Ivory	2-3 Z-twist Bl°, iv, yel°	Gilded silver, S-wrap, Yellow° silk core, S-twist

*intermittent pattern weft. -/- : latté ° dyestuff analysis.

Fig. 4. Weave of the *lampas* textiles.

Inv.	Warp Foun/Bind	Weave		
		Foundation	Supplementary	Selvage: R: right, L: left
IS.Tx.1216 Cat. L.1.2	5/1	Satin 4/1 (2)	Tabby	R + L: 0.7-0.9 cm. Lampas structure. 2 cords (binding. warps).
IS.Tx.1217 Cat. L.1.3	5/1	Satin 4/1 (1)	1/3 S-twill	R: 0.6 cm. Lampas structure 4 cords (binding warps).
IS.Tx.1218 Cat. L.1.4	5/1	Satin 4/1 (2)	Tabby	R + L: 0.2 cm. Satin weave 2 cords (binding warps).
IS.Tx.681 Cat. L.1.1	3-4/1	Satin 4/1 (2)	1/3 Z-twill	R + L: 0.7 cm. Lampas structure. R: 1 cord (foundation warps)
IS.Tx.1219 Cat. L.1.5	3-4/1	Satin 4/1 (1)	1/3 Z-twill	R + L: 0.8-1 cm. Lampas structure. No cords.
IS.Tx.1228 Cat. L.1.6	3-4/1	Satin 4/1 (2)	1/3 S-twill	R + L: 0.4 cm. Lampas structure. No cords.
IS.Tx.660 Cat. L.2.7	5/1	Satin 4/1 (2)	1/3 S-twill	R: 0.5 cm. Lampas structure No cords.
IS.Tx.807 Cat. L.2.9	4/1	Satin 4/1 (2)	1/3 Z-twill	L: 0.5 cm. Lampas structure No cords.
IS.Tx.1257 Cat. L.2.13	4/1	Satin 4/1 (2)	1/3 Z-twill	R + L: 0.4-0.5 cm. Lampas structure. No cords.
IS.Tx.758 Cat. L.2.8	3-4/1	Satin 4/1 (2)	1/3 Z-twill	L: 0.3 cm. Lampas structure. No cords.
IS.Tx.808 Cat. L.2.10	3-4/1	Broken 4/1 Z-twill	1/3 Z-twill	R + L: 1 cm. Lampas structure. No cords.
IS.Tx.809 Cat. L.2.11	3-4/1	Satin 4/1 (1)	1/3 Z-twill	R: 0.5 cm. Lampas structure. No cords.
IS.Tx.811 Cat. L.2.12	3/4/1	Satin 4/1 (1)	1/3 Z-twill	No selvage.
IS.Tx.1259 Cat. L.2.14	3/4/1	Satin 4/1 (2)	1/3 Z-twill	R + L: 0.5 cm. Lampas structure. No cords.
IS.Tx.1261 Cat. L.2.15	3/4/1	Satin 4/1 (2)	1/3 Z-twill	R + L: 0.5 cm. Lampas structure. No cords.
IS.Tx.1280 Cat. L.2.16	3/4/1	Irr. Satin 4/1	1/3 Z-twill	R + L: 0.5 cm. Lampas structure. No cords.

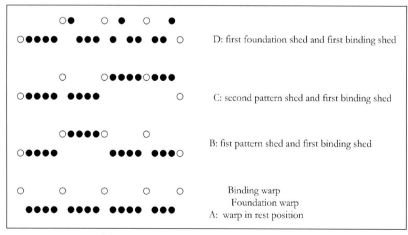

D: first foundation shed and first binding shed

C: second pattern shed and first binding shed

B: fist pattern shed and first binding shed

Binding warp
Foundation warp
A: warp in rest position

Fig. 5. One pass of *lampas* structure.

Technology of the *lampas* fabrics and distinctive weaves

Fig. 6. IS.TX811 (cat. L.2.12).

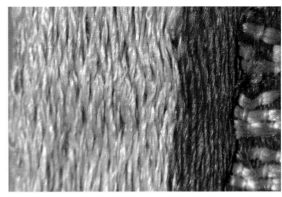

Fig. 7. IS.TX808 (cat. L.2.10).

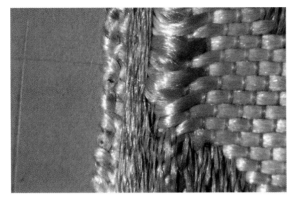

Fig. 8. IS.TX1218 (cat. L.1.4).

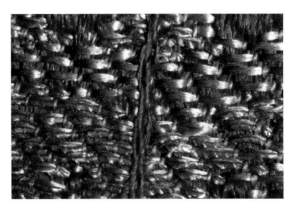

Fig. 9. IS.TX758 (cat. L.2.8).

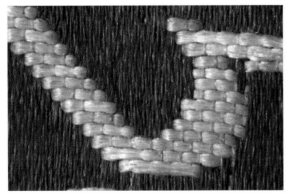

Fig. 10. IS.TX1216 (cat. L.1.2).

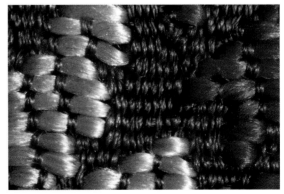

Fig. 11. IS.TX1233 (cat. D.W.1).

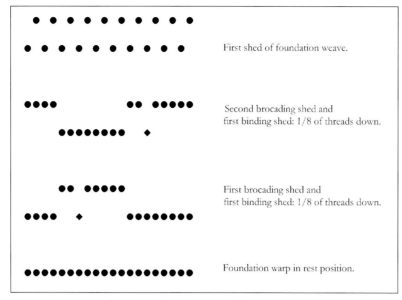

First shed of foundation weave.

Second brocading shed and
first binding shed: 1/8 of threads down.

First brocading shed and
first binding shed: 1/8 of threads down.

Foundation warp in rest position.

Fig. 12. IS.TX1233 (cat. D.W.1). One pass of the weave.

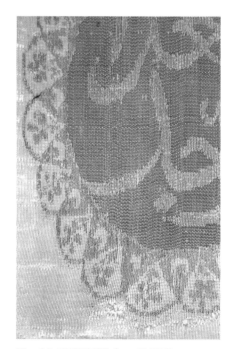

Fig. 13. IS.TX1223 (cat. D.W.2).

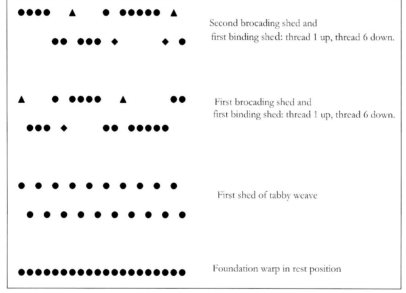

Second brocading shed and
first binding shed: thread 1 up, thread 6 down.

First brocading shed and
first binding shed: thread 1 up, thread 6 down.

First shed of tabby weave

Foundation warp in rest position

Fig. 14. IS.TX1223 (cat. D.W.2). One pass of the weave.

Fig. 15. IS.TX1223 (cat. D.W.2).

Technology of the *lampas* fabrics and distinctive weaves

5. Dye Analysis of Ottoman Silks

Ina Vanden Berghe, Marie-Christine Maquoi and Jan Wouters

1. Introduction

Since ancient times, vegetable and animal dye sources have been used to produce well-coloured mono- or polychrome fabrics. Some of them were found or cultivated over a very wide geographical area, as e.g. madder, while others are rather local dye plants. Some dye sources, as e.g. weld or woad, were applied for a wide range of common fabrics while others, as e.g. the real purple, were preserved for luxurious, expensive and delicate fabrics.

A bright collection of beautiful coloured Ottoman velvets and *lampas* was analysed at the laboratory for materials and techniques of the Royal Institute for the Cultural Heritage. The identification of the biological dye sources can, together with other technical research, contribute to situate these textiles in their geographical and historical context. Apart from 15 *lampas* and 25 velvets, a third group of two fabrics with different technological aspects (weaving technique, figuration), was considered, containing a banner (IS.Tx.1223) and an extended tabby (IS.Tx.1233).

2. Dye Analysis

Dye plants or animal dye sources are usually composed of many dye components, which contribute to the formation of the colour. To perform a large range of hues, dyers combine often two or three dye sources, which can implicate the use of different dye baths and different additives, depending on the selection of the dye sources. The dyeing procedure of vatting dyes as e.g. woad or indigo, is completely different from the dyeing with mordant dyes such as madder. In the latter case, the final colour is strongly influenced by the type of mordant used. Alum dyed madder will show a rather scarlet red shade, while a combination of iron as mordant, together with madder, produces purple to bluish shades. Hence, the actual colour of a textile is not a reliable basis for the identification of the dye sources. Moreover, the fading of the colour makes it often impossible to estimate the original colour pallet of a textile.

2.1. Method

By high performance liquid chromatography (HPLC) with diode array detection (PDA), the dye components present in a textile sample can be detected based on their spectrum, recorded in the range of 200-800 nm (UV-VIS) and their retention time. After the calculation of the relative integration values of the dye components, the natural dye source(s) can be identified. This method allows to reveal combinations of dye sources, even if only traces of a specific dye component were detected.

The sample size, necessary to perform the HPLC-analysis, depends on the hue, the intensity and the degree of fading of the colour. Generally, 10 mm of a silk yarn or 5 mm of a wool sample is considered to be sufficient to produce a reliable and significant analysis.

2.2. The identification of the type of cochineal

The type of cochineal can be identified based on the relative ratio of the peak area of the detected dye components carminic acid (ca), flavokermesic acid (fk), kermesic acid (ka) and the unknown dye component of Mexican cochineal (dcII). Therefore, the relative ratios of the characteristic components ca, dcII, fk and ka are integrated at different wavelengths (275, 290 and

420 nm) and recalculated at 275 nm with correction factors based on the relative ratio of the spectral absorbance of each component at the different wavelengths (275, 290 and 420 nm). Then, the results are compared to a series of references of different types of cochineal (Mexican, Armenian and Polish) and evaluated statistically[1].

The relative amount of dcII is one of the characteristic parameters in the identification of the type of cochineal. DcII is a minor peak falling just before the principal peak of carminic acid and commonly only detectable as a 'shoulder' of the ca peak, which makes it difficult, if not impossible, to perform an exact integration of the dcII component. Hence, integration implies an under or over estimation of the dcII peak, according to the application of skimming or valley-to-baseline integration, respectively. As the integration procedure (at different wavelengths) is at the basis of the whole identification system, the spreading of the percentage of dcII and the impact of it on the identification of cochineal was examined in detail.

3. Results

Natural dye analysis was performed on 144 samples of brightly coloured warp and weft threads and dyed core yarns of gold and silver threads of the Ottoman *lampas*, velvets and the third group of textiles. The different natural dye sources identified are enumerated in table 1; the common names are mentioned in the first column, the Latin nomenclature (if possible to specify) in the second, the abbreviations in the third and the typical dye components in the last column. The type of warp and weft threads, as determined by the technical analysis of Mrs C. Verhecken-Lammens and Mr. D. De Jonghe, is described in table 2, together with the abbreviations. The overview of the dye sources, identified in the series of velvets, *lampas* and the third group of textiles are described in respectively tables 3, 4 and 5.

3.1. The yellow dye sources

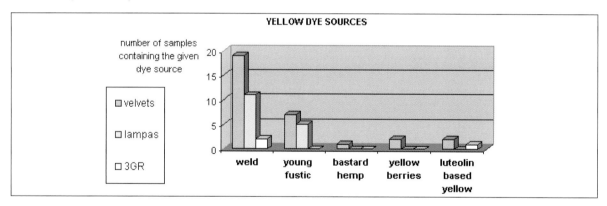

Fig. 1. The distribution of the yellow dye sources in relation to the type of textile (dyed core yarns of gold and silver threads not included).

The distribution of the yellow dye sources in relation to the type of textile is shown in fig. 1.

The two main yellow dye sources are weld and young fustic. They are frequently detected, both in the *lampas* as in the velvets. Weld (*Reseda luteola* L.) is found in 11 samples of the 15 analysed *lampas* as well as in 19 samples of the 25 ottoman velvets, while the other principal yellow dye source, young fustic (*Cotinus coggygria* Scop.) is identified in 5 *lampas* and 7 velvet samples (dyed core yarns of metal threads not included).

Young fustic or dyer's sumach, is a yellow dye source growing in the South of Europe, South-East Europe and Minor-Asia, as well as in China. Both in the series of the velvets and the *lampas*, young fustic was detected frequently in combination to weld. In former analyses

Table 1. Natural dye sources.

Common name	Latin nomenclature	Abbreviation	principal dye components
Madder	Rubia tinctorum L.	Rt	alizarin, purpurin
Mexican cochineal	Dactylopius coccus Costa	Dc	carminic acid
Armenian cochineal	Porphyrophora hamelii Brandt	Ph	carminic acid
Indian lac	Kerria lacca Kerr	Kl	laccaic acid A
Red wood	Caesalpinia sp.	Cs	brasilein
Weld	Reseda luteola L.	Rl	luteolin, apigenin
Young fustic/dyer's sumach	Cotinus coggygria Scop.	Cc	fisetin, sulfuretin
Bastard hemp	Datisca cannabina L.	Dca	datiscetin
Rhubarb	Rheum sp. or Rumex sp.	Rs	emodin, chrysophanin
Berries	Rhamnus sp.	Rha	rhamnetin
Indigoid	Isatis tinctoria (woad) or Indigofera sp. (indigo)	Ind	indigotin, indirubin
Henna	Lawsonia sp.	Ls	lawson
Tannin	-	Ta	ellagic acid

Table 2. Description and abbreviations of the sampled warp and weft threads.

Description of the type of thread	Abbreviation
Foundation warp	fwa
Foundation weft	fwe
Pile warp	pwa
Pattern weft	pawe
Accompanying weft	awe
Binding warp	bwa
Binding weft (= supporting weft)	bwe
Brocading weft	brwe
Core of gold thread	cgw
Core of silver thread	csw
Sewing thread	sew
Selvage warp	sewa
Passementerie	pas

Table 3. Natural dye sources detected in the Ottoman velvets (*: traces of dye components detected).

OTTOMAN VELVETS				RED	YELLOW	BLUE	TANNIN
IS.Tx.1204	1204/1	red	pwa	Armenian cochineal			tannin
	1204/2	blue	pwa	Madder and cochineal		Indigoid	
IS.Tx.1210	1210/1	green	pwa	madder*	weld*	Indigoid*	
	1210/2	red	pwa	cochineal and lac dye			tannin
IS.Tx.1229	1229/1	red	pwa	Armenian cochineal, madder and henna*			tannin
	1229/2	brown/red	fwe	Madder and henna*			tannin
	1229/3	red	bwe	Madder and henna*			tannin
	1229/4	yellow	sewa	madder	weld		tannin
	1229/5	red	fwa	Armenian cochineal and madder			tannin
	1229/6	yellow	cgw	madder	weld & young fustic		
	1229/7	yellow	brwe	madder	weld	Indigoid	tannin
IS.Tx.792	5458/1	red	pwa	Armenian cochineal	weld		
	5458/2	yellow	fwa		weld & young fustic		
	5458/3	yellow	cgw		weld & young fustic		
IS.Tx.1211	1211/1	red	pwa	Mexican cochineal			
	1211/2	yellow	fwa	madder	weld & young fustic		tannin
	1211/3	ecru	fwe		yellow berries		
IS.Tx.1215	1215/1	yellow	fwa	madder	young fustic & bastard hemp		tannin
	1215/2	red	pwa	Mexican cochineal			tannin
	1215/3	ecru	fwe	madder*	young fustic* & yellow berries*		
IS.Tx.1262	1262/1	red	pwa	Mexican cochineal			tannin
	1262/2	red	fwe	madder			tannin

OTTOMAN VELVETS				RED	YELLOW	BLUE	TANNIN
	1262/2'	red	fwe	madder & henna*			tannin
	1262/3	red	bwe	madder & henna*			tannin
	1262/4	orange	fwe	madder & henna*			tannin
	1262/5	yellow	fwa	madder	weld		
IS.Tx.450	450/1	red	pwa	Lac dye & madder			tannin
	450/2	yellow	pwa	madder	weld	Indigoid	
	450/3	red	fwe	madder			tannin
	450/4	red	bwe	Mexican cochineal			tannin
	450/5	red	fwa	madder			tannin
	450/6	ivory	cgw	madder*	young fustic* & bastard hemp		tannin
IS.Tx.806	806/1	blue	pwa	madder*		Indigoid*	
	806/2	red	pwa	Mexican cochineal			tannin
	806/3	yellow	cgw		weld		
	806/1a	yellow	cgw		weld		
IS.Tx.1201	1201/1	red	pwa	Mexican cochineal			tannin
	1201/2	ivory	fwa				
	1201/3	yellow	cgw	rhubarb*	young fustic*		
IS.Tx.1200	1200(2/2)/1	red	pwa	Mexican cochineal & red wood			tannin
	1200(2/2)/2	yellow	cgw	rhubarb*	young fustic*		
	1200(2/2)/4	green	sewa	madder*	weld	Indigoid	tannin
IS.Tx.1205	1205/1	red	pwa	Mexican cochineal			tannin
	1205/2	green	pwa	madder*	weld	Indigoid	
	1205/3	ivory	fwa				
	1205/4	yellow	cgw		weld*, young fustic* & yellow berries*		
	1205/5	ivory	csw				
IS.Tx.1208	1208(2/2)/1	red	pwa	Mexican cochineal			tannin
	1208(2/2)/2	green	pwa	madder*	weld	Indigoid	
	1208(2/2)/4	yellow	cgw		young fustic & bastard hemp		tannin
IS.Tx.1212	1212/1	red	pwa	Mexican cochineal & madder*			tannin
	1212/2	yellow	cgw				tannin
IS.Tx.1209	5877/3	red	pwa	Mexican cochineal			
	5877/4	yellow	cgw		weld & young fustic		
	5877/5	ivory	cgw	madder & red wood			
IS.Tx.1202	1202/2	red	pwa	Mexican cochineal			tannin
	1202/3	blue	pwa	cochineal* & madder*		Indigoid	
	1202/4	green	sewa		luteolin based yellow	Indigoid	
IS.Tx.1203	1203/1	red	pwa	Mexican cochineal			tannin
IS.Tx.664	664/1	blue	pwa	madder		Indigoid	
	664/2	red	fwa	lac dye & madder			
	664/3	red	fwe	madder			tannin
	664/4	red	bwe	madder			tannin
	664/5	orange	cgw	madder*	young fustic*		tannin*
	664/6	ivory	csw	madder*			
	664/7	yellow/ green	brwe	madder	weld	Indigoid	
	664/1a	orange	cgw		young fustic* & bastard hemp*		
IS.Tx.1213	1213/1	red	pwa	lac dye			
	1213/2	yellow	fwa	madder	young fustic		tannin
	1213/4	yellow	cgw				
IS.Tx.1231	1231/1	red	pwa	lac dye			
	1231/2	green	pwa	madder	weld	Indigoid	
	1231/3	yellow	fwa	rhubarb*	weld* & young fustic*		
	1231/4	ivory	fwe	madder & rhubarb*	weld* & young fustic*		
	1231/5	yellow	cgw		weld & young fustic		
IS.Tx.1232	1232/1	red	pwa	madder			tannin
	1232/2	yellow	fwa	red wood*			
	1232/3	yellow	csw		weld & young fustic		tannin
	1232/4	white	csw				
	1232/5	green	brwe	madder	weld	Indigoid	
	1232/6	yellow	fwa	madder	weld	Indigoid	
IS.Tx.785	785/1	green	pwa	madder	weld	Indigoid	
	785/2	red	fwe	madder			tannin*
	785/2'	red	fwe	madder & red wood*			tannin
	785/3	red	bwe	madder			tannin*
	785/4	red	fwa	madder			tannin*
	785/5	yellow	cgw		weld & young fustic		
IS.Tx.820	820/1	green	pwa	madder*	luteolin based yellow	Indigoid	
IS.Tx.1206	1206/1	red	pwa	madder			tannin*
	1206/2	green	bwe	madder*	weld*	Indigoid*	
	1206/3	dark ochre	fwe	madder*			tannin*
IS.Tx.1207	1207/1	light brown	pwa				
	1207/2	dark brown	pwa				

Table 4. Natural dye sources detected in the Ottoman *Lampas* (*: traces of dye components detected).

OTTOMAN *LAMPAS*				RED	YELLOW	BLUE	TANNIN
IS.Tx.808	808/1	crimson	fwa	Mexican cochineal & red wood			tannin
	808/2	yellow	awe		weld & young fustic		
IS.Tx.811	811/1	yellow	pawe		weld & young fustic	Indigoid	tannin
IS.Tx.1216	1216/1	crimson	fwa	Mexican cochineal			tannin
	1216/2	crimson	fwe	Mexican cochineal			tannin*
IS.Tx.1217	1217/1	green	fwa	rhubarb*	weld*	Indigoid*	
	1217/2	green	fwe	rhubarb*	weld*	Indigoid*	
IS.Tx.1219	1219/1	mustard	fwa	rhubarb*	weld*		
	1219/2	ivory	pawe			Indigoid*	
	1219/3	crimson	pawe	Armenian cochineal			tannin
IS.Tx.1218	1218/1	green	fwe	rhubarb		Indigoid	
	1218/2	green	fwa	rhubarb		Indigoid	
IS.Tx.1228	1228/1	green	fwa		weld	Indigoid	
	1228/2	crimson	pawe	Armenian cochineal			tannin
	1228/3	yellow	awe		weld & young fustic		
IS.Tx.1257	1257/1	scarlet	fwa	madder & red wood			tannin*
	1257/2	blue	pawe	madder		Indigoid	
	1257/3	yellow	awe	madder*	weld* & young fustic*		
	1257/4	yellow	cgw		weld* & young fustic*		tannin*
IS.Tx.1261	1261/1	crimson	fwa	Mexican cochineal			tannin
	1261/2	yellow	awe		weld		
	1261/3	red	sew				
	1261/4	green	pawe		weld	Indigoid	
	1261/5	yellow	cgw		weld & young fustic		
IS.Tx.807	5458/24	scarlet	fwe	madder			
	5458/25	crimson	fwa	cochineal & madder*			tannin
	5458/26	turquoise	pawe			Indigoid	
	5458/27	yellow	awe	madder	weld		
IS.Tx.1280	5458/19	cream	bwa				
	5458/20	crimson	fwa	Mexican cochineal			tannin
	5458/21	yellow	awe		young fustic	Indigoid	
	5458/22	blue	pawe			Indigoid	
	5458/23	yellow	cgw		young fustic & luteolin based yellow		
IS.Tx.681	5877/1	red	fwa	Armenian cochineal			tannin
	5877/2	yellow	fwe	red wood			
IS.Tx.758	758/01	crimson	fwa	Mexican cochineal			tannin
	758/02	scarlet	fwe	madder			tannin
IS.Tx.809	809/1	crimson	fwa	Mexican cochineal			tannin
	809/2	crimson	fwe	Mexican cochineal			tannin
IS.Tx.1259	1259/01	pink	fwe	madder & red wood			tannin

Table 5: Natural dye sources in the third group of Ottoman textiles (*: traces of dye components detected).

THIRD GROUP				RED	YELLOW	BLUE	TANNIN
IS.Tx.1223	1223/01	green	wa		weld	Indigoid	
	1223/02	crimson	we	Mexican cochineal			tannin
IS.Tx.1233	1233/1	purple	wa	Armenian cochineal		Indigoid	tannin
	1233/2	crimson	brwe	Mexican cochineal			tannin
	1233/3	yellow	brwe		weld	Indigoid	
	1233/4	pale green	brwe	madder	luteolin based yellow	Indigoid	
	1233/5	blue	brwe	cochineal & madder		Indigoid	
	1233/6	crimson	pas	Mexican cochineal			tannin

of a series of Florentine Borders in our laboratory, the same combination of young fustic and weld was found[2]. Important in this context is the description of an ochre dyeing method of silk in Florence, mentioned in *'L'arte della seta in Firenze - Trattato del secolo XV'* (published for the first time by Girolamo Gargiolli in Florence in 1868): after mordanting silk with alum, 'sumac' (probably referring to sumach yellow, also called Venetian sumach or young fustic) is boiled up together with weld to refresh the colour, followed by the dyeing in multiple dye baths[3].

An unidentified luteolin based yellow dye source is detected in the three groups of textiles (velvets IS.Tx.1202 and IS.Tx.820, *lampas* IS.Tx.1280 and the extended tabby IS.Tx.1233). A part from the main peak luteolin, three other unidentified spectra were found.

Bastard hemp (*Datisca cannabina* L.) is since ancient times a well-known yellow dye source in the Far East. It can be used on wool, silk or vegetable textiles, even without mordant, to produce a brilliant yellow shade. This flavonoid yellow dye source has a West-Asian origin, but it has also been cultivated in India as well as in Italy or in the South of France. It combines a good light fastness with a bright yellow colour. In the Ottoman textiles, it is only detected in the velvet series and always together with young fustic: in the yellow/orange coloured core fibres of gold threads of IS.Tx.1208, IS.Tx.664 and IS.Tx.450 and in the yellow foundation warp of velvet IS.Tx.1215.

Yellow dyed silk produced by using berries (*Rhamnus* sp.) was found in the ecru foundation wefts of velvets IS.Tx.1211 and 1215 and in the yellow core of the gold thread of velvet IS.Tx.1205. It was not detected in the *lampas* textiles. It is not possible to specify the Rhamnus species, but most probable dye sources are the berries from the only in Turkey growing variant (*Rhamnus petiolaris*) (Turkish name: cehri) or the yellow berries from *Rhamnus saxatilis, amygdalinus* or *oleoides*, growing in Asian Turkey and Persia[4].

3.2. The red dye sources

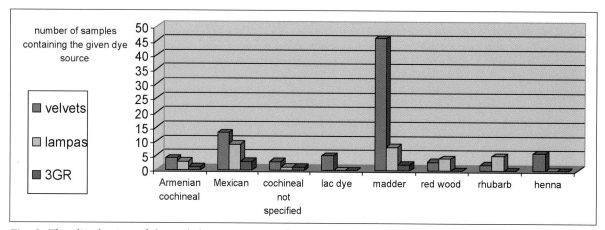

Fig. 2. The distribution of the red dye sources in relation to the type of textile (dyed core yarns of gold and silver threads not included).

Insect red

The distribution of the red dye sources in relation to the type of textile is shown in fig. 2. A range of 7 biological sources of red dyes could be identified. The red dye sources derived from scale insects are abundantly present in the three groups of textiles, except lac dye, which is only detected in velvet samples. The insect dyes are the principal red dye source to produce the crimson (bluish red) colour.

Carminic acid, the main dye component of cochineal, was detected in 17 velvets and 11 *lampas*.

The identification of the type of cochineal is done as described before (see 2.2). Each chromatogram containing carminic acid, where dcII couldn't be integrated precisely, was integrated by under and over estimation of the dcII component. Figures 3A and 3B show the influence of the integration condition on the statistical identification of the cochineal type. The over and under estimated samples are situated together with the deviation area of each reference type of cochineal. The deviation areas were formed, based on the mean value and the standard deviation of all analysed references of that type of cochineal.

Both figures show the same tendency, but the type of cochineal is better pronounced by using an over estimation of the dcII component (fig. 3A).

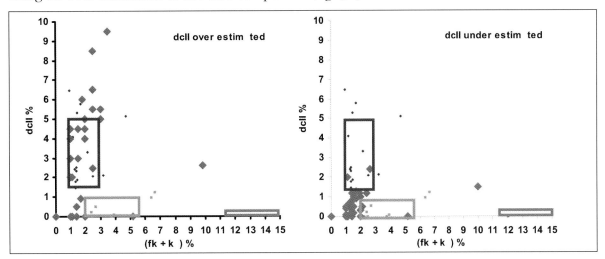

Fig. 3. Statistical evaluation of the type of cochineal.
 Fig. 3A. Exact or over estimation of dcII component.
 Fig. 3B. Exact or under estimation of dcII component.
 ■ reference area of Mexican cochineal, ▨ Armenian cochineal and ▨ Polish cochineal and the ◆ Ottoman textile samples.

Armenian cochineal (*Porphyrophora hamelii* Brandt), the endemic species only found in the region of mount Ararat, is identified in 8 Ottoman samples, from 4 velvets and 3 *lampas*.

One sample, from the velvet IS.Tx.1210, shows a very exceptional location in both graphs of fig. 3. On the one hand, the high relative amount of fk+ka (9.8%) suggests the presence of the Polish variety and excludes the Mexican and Armenian ones, while on the other hand, the amount of dcII (2.6%) clearly refers to the Mexican type. As the sample doesn't match with any of the three references types of cochineal, another, unidentified type of cochineal might have been used. The local cochineal type in Central Anatolia, called Ekin cochineal (*Porphyrophora tritici*), could be a possible species, but as this species is not longer existing, it is impossible to verify this[5]. From the theoretical point of view, this particular composition could also reflect a mixture of Mexican cochineal with kermes (*Kermes vermilio* Planchon).

In all other 23 samples, Mexican cochineal (*Dactylopius coccus* Costa) could be identified. Mexican cochineal was imported to the Ottoman Empire since the second part of the 16th century. It soon became the most common type for scale insect dyeing[6]. No Polish cochineal, which would suggest a rather European origin, was detected in this series of Ottoman textiles[7].

There where only a small amount of the main component of cochineal was detected, it is impossible to specify the type of cochineal. Those results are mentioned in the tables and the figures as 'cochineal'.

In textile IS.Tx.1233, the extended tabby of the third group, both Armenian and Mexican cochineal are detected; the Armenian one, together with an indigoid dyestuff and tannin in a

purple warp thread, while the Mexican cochineal is found in a crimson passementary thread as well as in a crimson brocading weft from the same textile.

Laccaic acid A, the characteristic dye component of lac dye (*Kerria lacca* Kerr) was only found in 5 of the Ottoman velvets. Indian lac, originally coming from India, was imported to Asia Minor since the 15th century, although already known in West-Asia as well as in Europe much earlier. During the middle ages, lac dye was imported to Europe by the port of Venice[8]. The presence of lac dye could suggest that these velvets were produced in Bursa[9].

Vegetable red

Madder (*Rubia tinctorum* L.) was found frequently in the series of velvets (21/25 velvets), while it was only detected in 4 out of 15 *lampas*. There, it was used to obtain a scarlet shade, or, in combination with other dye sources, to produce yellow and blue colours.

Red wood (*Caesalpinia* sp.) was found in 4/25 velvets and in 4/15 *lampas*. Although the less light fastness of this red dyestuff, it has been used since ancient times. The red wood species called sappan wood (*Caesalpinia sappan*) was imported from East-India to Asia and Europe, while since the 16th century, another species, called brasil wood (*Caesalpinia brasiliensis*) was imported from South-America to Europe[10].

In 6 samples belonging to only two textiles (velvet IS.Tx.1226 and IS.Tx.1229), traces of henna (*Lawsonia* sp.) were detected, always together with madder for reddish foundation and binding wefts, and together with madder and Armenian cochineal for the red pile warp of IS.Tx.1229. However, it is not unlikely that the traces of henna are due to the manipulation of the textiles by man.

A type of 'rhubarb' (*Rumex* or *Rheum* sp.) was detected in 5 green to mustard coloured samples of three *lampas* with inscriptions (IS.Tx.1217, IS.Tx.1218 and IS.Tx.1219). Probable dye sources are Chinese rhubarb (*Rheum palmatum* L.), curled dock (*Rumex crispus* L.) or alder bucktorn (*Rhamnus frangula* L.). The green shade was performed by a combination with an indigoid dye source and traces of weld. It was only detected in the foundation warps and wefts of the *lampas*. Traces of rhubarb were also detected in three velvets: twice in the yellow core of a gold thread (IS.Tx.1200 and 1201) and twice in the foundation warp (yellow) and weft (ivory) of velvet IS.Tx.1231.

Nor kermes (*Kermes vermilio* Planchon) nor safflower (*Carthamus tinctorius* L.), the latter which would refer to a rather Persian origin of the textiles according to Böhmer[11] and Golikov[12], are detected, neither in the velvets nor in the *lampas* series.

3.3. Blue and green dyeing

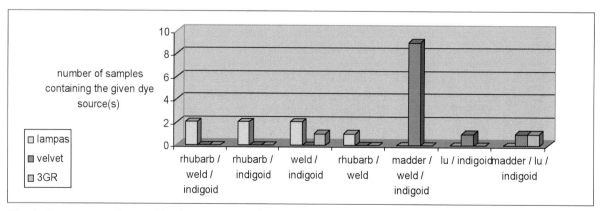

Fig. 4. Dye sources detected in the green samples.

Green shades

The green dyed samples of the three groups of textiles are compared in fig. 4. In the group of the *lampas*, 6 green foundation warps or wefts and one pattern weft were analysed, while the velvets contain 8 green pile warps, two selvage warps and a brocading weft.

A remarkable difference is to be noticed in the selection of the dye sources. Apart from the indigoid dye source (indigo or woad), which is the blue component in all samples, weld and rhubarb seemed to be used to perform the green dyeing in the series of *lampas*. This is in contrast to the velvets, where no rhubarb is detected. There, the green shade is mainly realised by a combination of the indigoid dye, madder and weld. Mixtures of the indigoid dye with a not identified luteolin based yellow dyestuff (and madder) are detected as well within this series.

Blue shades

The 4 blue pile warps of the velvets, were dyed with a combination of the indigoid dyestuff and madder, two times together with a trace of cochineal. On the other hand, only the indigoid dye source is detected in the two blue pattern wefts analysed in the *lampas* series.

Both results of the green and blue shades suggest a difference in the production process. Blue dyeing of yarns for *lampas* seemed to be done with the pure indigoid dye source, while for green dyeing, weld and/or rhubarb were added. The blue dyeing in the velvet series was performed with a combination of indigoid and madder, while for green shades weld or another luteolin based dye source was added.

3.4. Yellow silk core of silver and gold threads

Table 6. Dye sources of the yellow silk cores of the gold and silver threads.

YELLOW dye source(s)			other
Lampas	Colour core		
IS.Tx.1257	yellow	weld & young fustic	tannin
IS.Tx.1261	yellow	weld & young fustic	
IS.Tx.1280	yellow	young fustic & a luteolin based yellow	
Velvets			
IS.Tx.785	yellow	weld & young fustic	
IS.Tx.1229	yellow	weld & young fustic	madder
IS.Tx.450	ivory	young fustic & bastard hemp	madder & tannin
IS.Tx.806	yellow	weld	
IS.Tx.806	yellow	weld	
IS.Tx.1201	yellow	young fustic	rhubarb
IS.Tx.1200	yellow	young fustic	rhubarb
IS.Tx.1205	yellow	weld, young fustic & yellow berries	
IS. Tx. 1205	ivory		
IS.Tx.1208	yellow	young fustic & bastard hemp	tannin
IS.Tx.1212	yellow		tannin
IS.Tx.1213	yellow		
IS.Tx.1231	yellow	weld & young fustic	
IS.Tx.1232	white	weld & young fustic	tannin
IS.Tx.1232	yellow		
IS.Tx.792	yellow	weld & young fustic	
IS.Tx.1209	yellow	weld & young fustic	
IS.Tx.1209	ivory		madder, red wood & tannin
IS.Tx.664	orange	young fustic	madder & tannin
IS.Tx.664	orange	young fustic & bastard hemp	
IS.Tx 664	ivory		madder

The majority of the Ottoman textiles are abundantly enriched by using 'gold' and/or silver threads. These consist of a gilded silver ('golden') or silver metal strip wrapped around a silk core. Table 6 shows the results of the natural dye analysis of the dyed silk cores. The principal dye sources are young fustic (dyer's sumach) and weld, mainly used in combination. In three other samples (velvets IS.Tx.450, 664 and 1208), young fustic is combined to bastard hemp. More orange shades are realised by adding madder or red wood.

4. Discussion

The expensive insect dyes are clearly preserved for well-defined purposes. In the series of velvets, they are almost exclusively used for the dyeing of the red pile warps, while for the other coloured pile warps and for the foundation weaves (fwa and fwe), mainly a combination of madder and a yellow and/or blue dye source were used. Only two velvets don't have an insect dyed red pile warp (IS.Tx.1206 and 1232).

The series of red samples of the *lampas* shows very clearly that the choice of using an insect or vegetable red dye source is directly connected to the shade: insect dyes are preserved for crimson red, while scarlet red is mainly realised with the madder dye source. In this series, cochineal is mainly (in 9 out of 13 samples) found in the red foundation warps, which are clearly visible on the front side of the *lampas*.

Very typical to the series of the velvets is the frequent combination of two or more red or yellow dye sources together in one analysis, as shown in table 7. Within the velvets, two to three red dye sources were detected in 17 samples as well as 16 samples containing two or three yellow dye sources. Not only the number of samples with this phenomenon is remarkable, but even more the number of different combinations that were detected. Madder was found in five different mixtures, together with cochineal, lac dye, henna, red wood or rhubarb, while cochineal was detected together with madder, red wood or even lac dye. Young fustic was found in 4 different combinations in the velvet samples (together with weld, yellow berries, bastard hemp, and weld and yellow berries together). The series of the *lampas* shows much less variation in combinations of the red and yellow dye sources compared to the velvets.

The combinations of an insect red (cochineal or lac dye) with madder was also detected in other analysis of Turkmen textiles in our laboratory[13].

Table 7. Combination of multiple red or yellow dye sources together in one sample (dyed core yarns of gold and silver threads included; *: type of cochineal not identified; (): number of samples containing the given combination).

VELVETS	LAMPAS
cochineal / lac dye (1) cochineal / madder (2) Armenian cochineal / madder / henna (1) Mexican cochineal / red wood (1) Mexican cochineal / madder (1) lac dye / madder (2) madder / henna (5) Armenian cochineal / madder (1) madder / red wood (2) madder / rhubarb (1)	cochineal / madder (1) Mexican cochineal / red wood (1) madder / red wood (2)
Young fustic / weld (10) Young fustic / yellow berries (1) Young fustic / bastard hemp (4) Young fustic / weld / yellow berries (1)	Young fustic / weld (6) Young fustic / luteolin based yellow (1)

IS.Tx.1207: In the light and dark brown coloured pile warps from velvet IS.Tx.1207, neither natural dye components, nor synthetic dyes were detected by HPLC-PDA. Possible explanations of the lack of dyes detected on these clearly coloured yarns are, the presence of dyes which are not detectable by our method or are less probably following visual observation, a state of degradation of the dyes, which makes it impossible to identify them. Hence, the natural dye analysis cannot contribute to a more precise datation of this controversial fabric (see cat. V.1.4).

5. Conclusion

Table 8. Comparison of the biological dye sources between the selection of Ottoman velvets and *lampas*.

VELVETS	LAMPAS
Red hues: scarlet / crimson / orange	
COCHINEAL (Armenian & Mexican) Lac dye MADDER Red wood Henna	COCHINEAL (Armenian & Mexican) - MADDER Red wood -
Yellow hues	
WELD YOUNG FUSTIC Bastard hemp Yellow berries + mainly together with madder	WELD YOUNG FUSTIC - - luteolin based yellow
Blue hues	
INDIGOID + MADDER	INDIGOID
Green hues	
blue dyeing + weld or luteolin based yellow	blue dyeing + weld and/or rhubarb

An overview of the biological dye sources in the Ottoman *lampas* and velvets is made in table 8.

The principal red, yellow and blue dye sources (in capital letters) are identical for both groups. However, some remarkable differences are to be noticed: a broader range of dye sources was used for the dyeing of the Ottoman velvets and, as described above, the dyeing technique for blue and green colours shows significant differences.

The biological dye sources detected in both groups of velvets and *lampas* are conforming to former analysis of Ottoman textiles performed by Böhmer and Golikov. However, the use of the HPLC-PDA technique makes it possible not only to detect the principal dye source, but also to identify all the present dye sources in one sample, even if only traces of dye components were found, as well as to specify the type of cochineal.

As the same dye sources were identified in the two textiles (banner and extended tabby) of the third group, there is no indication, based on the natural dye analysis, to confirm the estimation of the difference in origin of those textiles.

Notes

1. WOUTERS J., VERHECKEN A. 'The Coccid Insect Dyes: HPLC and computerized diode-array analysis of dyed yarns', *Studies in conservation* 34, 1989, p. 189-200.
2. WOUTERS J., Kleurstofanalyse van Florentijnse boorden uit de verzameling van de Koninklijke Musea voor Kunst en Geschiedenis te Brussel, *Bulletin van de Vlaamse Vereniging voor Oud en Hedendaags Textiel*, 1995, p. 11-16.
3. *Idem*; BRUNELLO F., *The art of dyeing in the history of mankind*, Neri Pozza (ed.), Vicenza, 1973, p. 162-164.
4. SCHWEPPE H., *Handbuch der Naturfarbstoffe*, Landsberg/Lech: Ecomed, 1992.

5. BÖHMER H., KARADAG R., Dye Analyses of Ottoman Brocades and Velvets from the Topkapı Museum, Istanbul, and other silk textiles, *7. Internationale Konferenz für Orienttepiche*. Vorträge 1993, p. 69-78.
6. VERHECKEN A., WOUTERS J., The Coccid Insect Dyes, historical, geographical and technical data, *Bulletin van het Koninklijk Instituut voor het Kunstpatrimonium*, 1988-1989, p. 224-225.
7. BÖHMER H., KARADAG R., *op. cit.*
8. SCHWEPPE H., *op. cit.*
9. BÖHMER H., KARADAG R., *op. cit.*
10. CARDON D., DU CHATENET G., *Guide des teintures naturelles*, Delachaux & Niestlé, Paris, 1990.

11. BÖHMER H., KARADAG R., *op. cit.*
12. GOLIKOV V.P., VISHNEVSKAYA I.I., *A comparative study of dyeing technology in 16-17th century Persian and Turkish textiles from Moscow Kremlin collection*, ICOM, 1990, vol. I, p. 294-298.
13. Unpublished report on Turkmen textiles, laboratory for materials and techniques of the Royal Institute for the Cultural Heritage, 2003.

6. Conservation treatment

Vera Vereecken

The interdisciplinary research on the historical, material and technological value of the collection of Ottoman textiles helps us assess the degree of interventions applied during the conservation treatment. We always try to limit these interventions to protect authenticity and to assure the textile a sound conservation for the future. Damage can be caused by original use, reuse or by later additions and often reveals the cultural and material history of these fabrics. It is the conservator's task to ensure that the history of the object is preserved.

Conservation treatment

Each treatment is preceded by an extensive documentation phase and a thorough analysis. Only earlier restorations that disturb the readability, cause tensions or accelerate further degradation are re-established partially or complete after research and consultation. *Cleaning* is usually the basis of the conservation process. First particles of dust are mechanically removed with care, if possible along both the front and back of the textile. Often we will limit ourselves to dusting the textile, moulding it into shape with the help of an ultrasonic moisturiser.

As a wet cleaning is irreversible and not without risk for old and weakened fibres, the choice of cleaning treatment is carefully considered. Water may well be the best means to recover reversible tensions and pleats and it is also the best solvent for dirt and other stains, but on the other hand it causes swelling and weighting of the fibres, which makes them break much faster when manipulated. The reaction of fibre to water, when local moisturising takes place, is closely watched under a binocular-microscope, and the degree of dye stability is tested.

Weak and damaged textiles are placed between a fine cambric silk on a slightly hypotenuse underground, covered with a polyester layer (melinex), so the textile is entirely supported while manipulating it. The textile is rinsed by pulverising demineralised water and dries flat at room temperature.

For *consolidation*, we use a sewing technique that attaches the textile to a linen support. Linen is a natural fibre that offers a sufficient amount of resistance to tensions without deforming. The stitches are made with natural silk threads and are expected to break first whenever tension occurs. The conservation materials are dyed in harmony with the original colours, with pre-metallised and lightfast dyes. The textile is attached to the linen with transferred rows of running stitches; the weak places are supported by the quincunx placement of laid and couched stitches. The stitches are placed in a supple way and disappear into the original. Floating metal threads are attached in the direction of the torsion of the lamella.

The linen support is fastened at a distance of maximum 1 cm of the textile by the selvage, at 3 cm when the textile seems to be incomplete.

With textiles composed of multiple fragments, whose pattern or scenery was disturbed during earlier interventions, we attempt to recover readability. Sometimes this process can be guided by the results of a technological analysis of the recurring weaving errors. The original construction can be recovered with certainty through these errors. When there are no weaving

errors, a study is made of the construction of the pattern. Based on these results, the fragments are arranged on the supporting linen and fixed.

To achieve an optimal condition during manipulation, preservation and exhibition, the textile is displayed on a firm underground. For this, a polycarbonate (plastic without softener) is used. The perforated board is supplied with a layer of non-hydrophilic wadding and dyed linen.

Historical textile is usually composed of fibres with a natural origin. Not only the nature of the fibre, but also the dyes, the mordant and other materials, among them metal threads, are very sensitive to the conditions of the environment such as: light, air, heat and humidity. A stable climate, without rude fluctuation, and the relative humidity (RH) are important elements for a good conservation. Therefore textile is preserved best at a temperature of 18°C and RH of 50% to 55%. Light has a harmful effect on fibres and dyes. Artificial illumination is kept as low as possible. The maximum allowable is 50 LUX, UV is to be excluded and daylight should be avoided.

Treated textiles

VELVETS

Inv. IS.Tx.785 **(cat. V.1.1)**
Condition: Very worn out, the pile of the velvet partially disappeared. The gold thread is worn out, so the yellow core is visible. Local deformations and pleats, disturbing restoration stitches. The fragments were sewed together with only partial respect for the pattern.
Treatment: Unfastening and removing of the seams and disturbing restorations. Dust mechanically with an adapted vacuum cleaner. Recovering of the deformations and flattening of the seams with cold steam (ultrasonic moisturiser).
A study concerning the pattern's construction.
The revised composition considers:
- The technological analysis of the two larger fragments; the analysis shows that these fragments have the same irregularity in their structure. This confirms that these fragments where woven next to each other.
- The scenery of the two narrow fragments, no irregularities could be determined in the structure. Consolidation on supporting linen with laid and couched stitches.

Inv. IS.Tx.792 **(cat. V.3.23)**
Condition: Very bad, heavily worn out, fractures and lacunas are integrally spread over the entire surface. The selvages are incomplete. The cotton lining is locally glued. (Fig. 3).
Treatment: The lining was removed; the locally glued parts (animal glue) were slightly moisturised with cold steam during the unfastening. Disturbing restorations were removed. Dusted mechanically with an adapted vacuum cleaner. Recovery of deformations and the pile of the velvet with the help of cold steam. Consolidation on supporting linen with laid and couched stitches. (Fig. 4)

Inv. IS.Tx.1208 1 & 2 **(cat. V.2.15)**
Condition: Preserved in good condition. The selvages are slightly deformed because they were folded for a long time. On the back there are traces of glue and remains of threads from previous restorations. Local imprints of thumbnails.
Treatment: Removal of loose ends of threads (they are kept in the file). Mechanical dusting.
Mechanical removal of the traces of glue (synthetic glue). Recovering of the imprints and flattening of the deformed selvages with cold steam. Consolidation on a supporting linen with transferred rows of running stitches.

Inv. IS.Tx.1209 **(cat. V.2.16)**

Condition: Severely damaged. There are only a few traces left of the gilded lamella (oxidation); this makes the beige and yellow core visible. The non-aesthetic darning causes tensions. The fragments were assembled in the opposite direction without taking the pattern into account.

Treatment: The darning was removed, mostly because it creates tensions. Badly composed fragments were unfastened. Mechanical dusting. A light treatment with cold steam. During the rearrangement of the fragments, only the direction of the pattern was considered. The correct distance between both fragments is 54 cm. For esthetical reasons, this distance was not respected, which also explains the loss of the quincunx placement. A small distance between the fragments is an indication for the lacuna.

Inv. IS.Tx.1262 **(cat. V.1.8)**

Condition: As the metal threads are strongly affected, the uncoloured and yellow cores are visible. Damaged parts show a great loss of pile of the velvet. A tear that runs over the entire length of the textile was glued with synthetic glue (protein and polysaccharide) on a red taffeta. Local restorations, re-sewing of the top and the bottom. At the left side, the selvage is folded.

Treatment: The glues were mechanically removed under a binocular microscope. After performing tests with paraxylene, the above option was chosen. Paraxylene causes the glue to dissolve, but the process takes too long and is not without risk for the fibres. Removal of restoration stitches. Mechanical dusting at the front and back of the textile with an adapted vacuum cleaner. Recovery of the pile of the velvet and flattening of the selvage with cold steam. Consolidation on supporting linen.

LAMPAS FABRICS

Inv. IS.Tx.681 (cat. L.1.1)

Condition: The textile is very dirty and severely damaged with a great amount of material loss. Unattractive restorations in the ground (red darning) and in the Arabic text include very disturbing embroidery stitches.

Treatment: After carefully removing the restoration stitches, the textile was dusted on the front and back with an adapted vacuum cleaner. The fragile textile was cleaned with demineralised water and non-ionic detergent on a slightly hypotenuse underground; the textile dried at room temperature. Consolidation on supporting linen.

Inv. IS.Tx.758 (cat. L.2.8)

Condition: The two fragments were joined by a glued strip of linen, which has a sooty colour. Preserved in good condition. (Fig. 1)

Treatment: Mechanical dusting. Tested for dye stability. Glue residues were soaked locally in water and removed with a spatula while looking through a binocular microscope. Cleaning of the textile and multiple rinsing with demineralised water. For the consolidation on supporting linen, the same setting remained as it was before treatment with transferred rows of running stitches. (Fig. 2)

Inv. IS.Tx.807 (cat. L.2.9)

Condition: Preserved in good condition. The left selvage and the starting edge at the bottom of the textile are present. The right and upper sides are cut; these borders are finished with sewing stitches. A blue marking of a stamp, that forms an inventory number, is found at the back. In the middle, a little to the right, is a lacuna.

Treatment: Mechanical dusting. The dying material and the blue stamp were tested to determine colourfastness. The test results confirmed that the colours would not run; cleaning with water and non-ionic detergent. Consolidation of the textile on supporting linen.

Inv. IS.Tx.809 (cat. L.2.11)

Condition: The fragment was in good condition. It felt rather stiff because of glue residues (animal glue) found on the back.

Treatment: After dusting, the glue was locally soaked in water and removed with a spatula. Cleaning with water and non-ionic detergent. Consolidation on supporting linen.

Inv. IS.Tx.811 (cat. L.2.12)

Condition: In reasonably good condition, although dusty and dirty. The textile was composed lengthways. The seam was reinforced at the back with a narrow strip of fabric. In the front, over the seam, the pattern is completely embroidered in ochre silk.

Treatment: Mechanical dusting with an adapted vacuum cleaner. Testing of the used colorants in the restored parts. Removal of a non-colourfast restoration. Cleaning with water and non-ionic detergent. Consolidation on linen with laid and couched stitches and stitches in the direction of the torsion to fix the metal threads.

The intensive embroidery on the seam creates tension between the two fragments. This could get worse when there are fluctuations in the temperature.

Inv. IS.Tx.1280 (cat. L.2.16)

Condition: Poor condition with considerable loss of red warps.

Treatment: Mechanical dusting. Removal of the red darning. Floating threads are locally placed back in to the right direction with cold steam. Consolidation on linen with laid and couched stitches and stitches in the direction of the torsion.

Conservation treatment: Chantal Carpentier, Juliette De boeck, Michelle De Brueker, Peter De Groof, Annie Geyssens, Kathryn Housiaux, Rosetta Turco, Greta Bocqué: dyeing of conservation materials, Vera Vereecken: Head of Conservation Workshop

Laboratory analysis: Marie-Christine Maquoi, Ina Vandenberghe, Marina Van Bos, Jozef Vynckier, Jan Wouters: Head of Section

Technological analysis of the velvet: Daniël De Jonghe

Translated from Dutch: Griet Kockelkoren and Peter De Groof

Illustrations

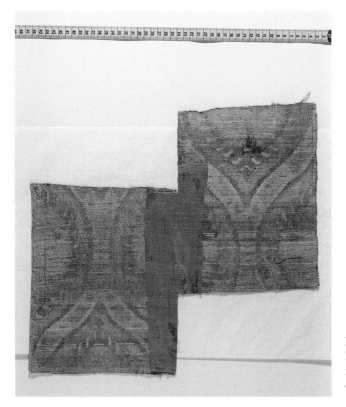

Fig. 1. IS.Tx.758 - KN 2253 KIKIRPA, Brussels. Back side before treatment: an example of a glued restoration that should be avoided, the glue dehydrates the fibres and attracts dust.

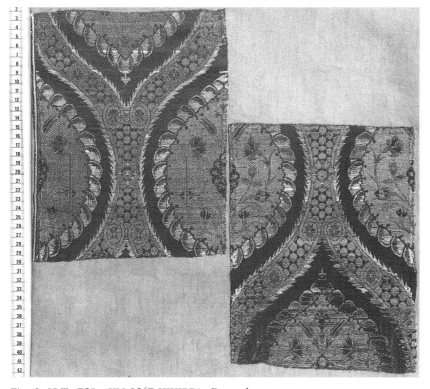

Fig. 2. IS.Tx.758 - KN 2567 KIKIRPA, Brussels
After conservation treatment.

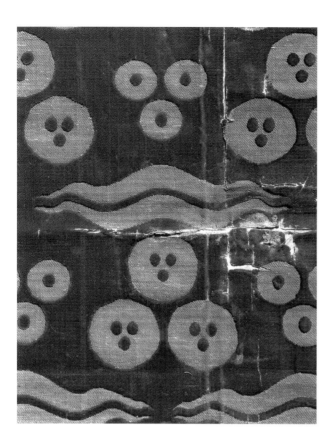

Fig. 3. IS.Tx.792 - KLE 605 KIKIRPA, Brussels
Detail of a damaged zone before treatment.

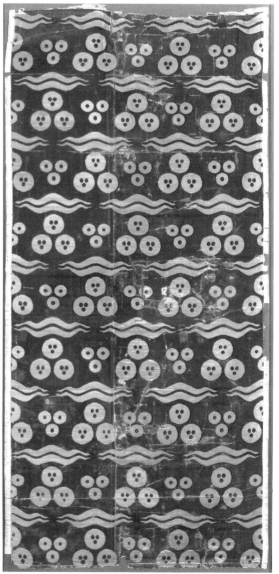

Fig. 4. IS.Tx.792 - KN 1840 KIKIRPA, Brussels
After consolidation.

Conservation treatment

CATALOGUE

I. Velvets

With one pattern repeat (cat. V.1.1.-V.1.8)

V.1.1.
Four fragments from length with intertwining ogival lattices

Date: First half of the 16th century

Dimensions: 1/4: 96 x 19 cm; 2/4: 96 x 20 cm; 3/4: 96 x 9 cm; 4/4: 96 x 9 cm

Inv. IS.Tx.785

Acquisition: Purchased by I. Errera from S. Baron in Paris in 1897 and donated to the museum.

Bibliography: ERRERA 1927, cat. 220, p. 201 (defined as "*travail oriental ou italien du XVIe siècle*" with the comment: "*Lessing croit ce tissu oriental, d'après un dessin européen*").

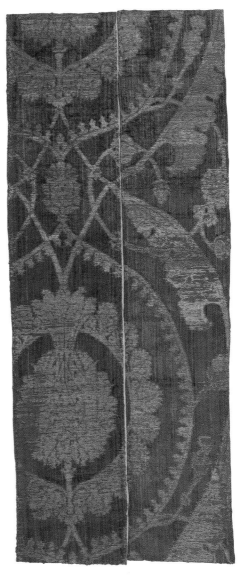

cat. V.1.1

On a green ground with a deep red undertone, two loom-width ogival lattices in gilded silver thread intertwine. They are composed by large split-palmette leaves overlaying vine motifs and enclosing double concentric ogival medallions with a pomegranate motif in the centre. Small versions of this pomegranate link the ogival lattices at their top and bottom.

The loom-width multi-level design of large split leaves, tendrils with palmettes and floral motifs on a velvet ground, is typical for a group of high-quality velvets attributed to Bursa and dated to the end of the 15th or to the first half of the 16th century. This design is executed in three technically different variants.

Similar pieces to this one are to be found in the Topkapı Palace Museum in Istanbul, dated to the end of the 16th century[1], in the Deutsches Textilmuseum Krefeld, dated to the 16th century[2] and in the Metropolitan Museum of Art in New York, dated circa 1500[3].

In the second variant within this group, not represented in this collection, the vines on the background are formed by linear voided parts leaving the foundation fabric visible. Two of these are datable to the 15th century or to the very early 16th century[4]. Examples with a pattern similar to the one on our textile are to be found in the Deutsches Textilmuseum Krefeld, dated to the end of the 15th century[5] and in the Cooper-Hewitt National Design Museum, Smithsonian Institution, New York, dated to the early 16th century[6].

The third variant has linear voiding and extra brocaded coloured silk wefts. The collection contains three of these (cat. V.1.6, 3 and 7). Analogue velvets are preserved in the Metropolitan Museum of Art in New York, dated with probability to the first half of the 16th century[7] and in the Bargello Museum of Florence, dated to the late 16th century[8].

All show an Islamic decorative vocabulary, but their complex design and the technique of using voided parts as a decoration element are thought to be of Italian origin. This group illustrates the mutual influences between Italian and Ottoman silks, which parallel their intense commercial contacts[9].

Technical analysis:

Pattern repeat: Measurements: height: 74 cm; Width: > 61 cm. Construction: vertical point repeat.

Technical denomination: brocaded cut velvet

Warp: Material and count: Foundation warp: red Z-spun silk; 75/cm. Pile warp: green very light S-spun/S-plied silk; 12.5/cm. Proportion: 6 foundation warps to 1 pile warp thread. Step: 1 tuft. *Weft*: Material and count: A. Foundation weft: red S-spun schappe silk; 19/cm. B. Squeezing weft: red Z-spun cotton; 9.5/cm. C. Supporting weft: red Z-spun cotton; 9.5/cm. D. Brocading weft: wrapped gold metal thread; on both sides gilded silver strip wrapped S (*riant*) around a yellow Z-spun/S-plied silk core; 19/cm. E. Pile rods: 9.5/cm. Proportion: 2 foundation picks to 2 brocading picks to 1 squeezing pick to 1 supporting pick. Sequence: 1 squeezing pick - 1 pile rod - 1 foundation pick - 1 supporting pick - 1 foundation pick (= 1 pass), and in the brocading areas: 1 squeezing pick - 1 pile rod - 2 brocading picks - 1 foundation pick - 1 supporting pick - 1 foundation pick (= 1 pass). Step: 1 pass. *Weave* (cf. article 3, fig. 5 and 6): Foundation fabric: 5-end satin warp face, décochement 3, on the schappe silk foundation weft. Weave of the squeezing weft: 4.1 twill S warp face. The squeezing pick is entered before the pile rod. Weave of the supporting weft: 4.1 twill S warp face, with all of the foundation warp threads. Weave of the brocading weft: 4.1 twill S weft face, with 1/3 of the foundation warp threads. Weave of the pile warp: under all the foundation, the squeezing and the brocading picks and above all the supporting picks. In the pile effect: above the pile rod. In the brocaded and the voided effect: under the pile rod.

Composition of the pattern: Ground: green cut pile. Pattern: brocaded effect of the gold metal weft. *Selvages*: none.

Natural dye analysis: cf. article 5, table 3.

Conservation treatment: cf. article 6.

V.1.2.

One complete and one pieced length, sewn together, with an ogival lattice linked by crowns and containing thistle flowers

Date: Second half of the 16th century

Dimensions: The two pieces are composed of several fragments sewn together. Piece IS.Tx.1200 1/2: 171 x 65 cm (both selvages included); Fragment 1/2: 90.5 x 65 cm (both selvages included); Fragment 2/2: 90 x 65 cm (both selvages included). Piece IS.Tx.1200 2/2: 172.5 x 39 cm (right selvage included); Fragment 1/4: 58 x 38.5 cm (right selvage included); Fragment 2/4: 58 x 39 cm (right selvage included); Fragment 3a/4: 54.5 x 18.5 cm (right selvage included); Fragment 3b/4: 55 x 18,5 cm (no selvage); Fragments 3a/4 and 3b/4 are posi-

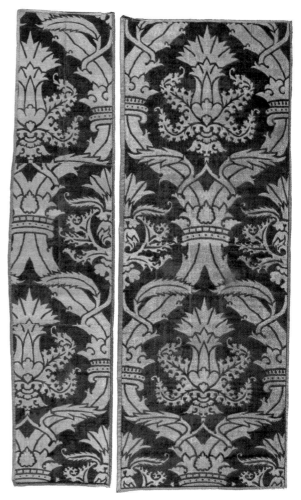

cat. V.1.2

tioned side by side. Fragments 1/4, 2/4 and 3/4 are positioned one above the other.

Inv. IS.Tx.1200

Acquisition: Purchased by I. Errera from Benguiat in London in 1894 and donated to the museum. Transferred to the Islamic collection in 1992.

Bibliography: ERRERA 1927, cat. 222, p. 205 (defined as "*travail Italien d'inspiration orientale du XVI^e siècle*"). ATASOY 2001, plate 89, technical analysis on p. 337-338 (dated to the second half of the 16th century).

On a crimson velvet ground, a loom-width ogival lattice in gilded silver thread is composed of double stems with tendrils bearing leaves and linked by crowns. It encloses bold thistle flowers slightly different from one row to the other.

The crown linking the ogival stems and the thistle motifs are derived from the patterns of Italian silk textiles but are treated in a more flattened way in the Ottoman velvets (see also cat. V.1.5). A velvet with an identical design is published by Otto von Falke and called an "*Osmanische Umbildung eines Italienischen*

Granatmusters, Anfang 16. Jabrb."[10]. The author specifies that the presentation of "the grenade", half as a tulip and half as a carnation –along with the wrong interpretation of the crown– betray the hand of an oriental artist who copies foreign forms. Another identical piece is situated by David King at the end of the 16th century[11] and the author points also to the mutual influences between Italian and Ottoman design. On these bases and given the presence of Mexican cochineal dye, this velvet can be dated to the second half of the 16th century.

Technical analysis:

 There are 2 pieces IS.Tx.1200. One piece, IS.Tx.1200 1/2 consists of two fragments and IS.Tx.1200 2/2 is composed of four fragments. Silk lining covering the selvages on the front side.

 Pattern repeat: Measurements: 91 x 62 cm. Construction: vertical point repeat.

 Technical denomination: brocaded cut velvet

 Warp: Material and count: Foundation warp: ivory S-spun silk; 72/cm. Pile warp: crimson light S-spun/S-plied silk; 12/cm. Proportion: 6 foundation warp threads to 1 pile warp thread. Step: 1 tuft. *Weft*: Material and count: A. Foundation weft: paired undyed Z-spun cotton; 20/cm. B. Squeezing weft: thin ivory silk without apparent twist; 10/cm. C. Supporting weft: thin ivory silk without apparent twist; 10/cm. D. Brocading weft: wrapped gold metal thread; on both sides gilded silver strip wrapped Z (*couvert*) around a multiple light yellow S-spun/S-plied silk core; 20/cm. E. Pile rods: 10/cm. Proportion: 2 foundation picks to 2 brocading picks to 1 squeezing pick to 1 supporting pick. Sequence: 1 squeezing pick - 1 pile rod - 1 foundation pick - 1 supporting pick - 1 foundation pick (= 1 pass), and in the brocading areas: 1 squeezing pick - 1 pile rod - 2 brocading picks - 1 foundation pick - 1 supporting pick - 1 foundation pick (= 1 pass). Step: 1 pass. *Weave* (cf. article 3, fig. 1 and 2): Foundation fabric: 5-end satin warp face, décochement 3, on the paired foundation picks. Weave of the squeezing weft: 4.1 twill S warp face. Each pick of the squeezing weft is entered before the pile rod in the same satin shed as the foundation pick, which is behind the pile rod. Weave of the supporting weft: 4.1 twill S warp face, with all of the foundation warp threads. Weave of the brocading weft: 4.1 twill S weft face, with 1/3 of the foundation warp threads. Weave of the pile warp: under all the foundation, the squeezing and the brocading picks and above all the supporting picks. In the pile effect: above the pile rod. In the brocaded effect: under the pile rod.

 Composition of the pattern: Ground: crimson cut pile. Pattern: brocaded effect of the gold metal weft.

 Selvages: Composition: Piece IS.Tx.1200 1/2. Fragments 1/2 and 2/2, both selvages 15 coarse ivory silk threads, 15-25 coarse green silk threads, 10 thin yellow silk threads. Piece IS.Tx.1200 2/2. Fragments 1/4, 2/4 and 3a/4, only the right selvage 40 coarse green silk threads, 10 thin yellow silk threads. Width: IS.1200 1/2: 1.2 cm; IS.1200 2/2: 0.8 cm. Weave: as the foundation weave, 5-end satin warp face (foundation picks doubled alternately with a squeezing pick and a supporting pick).

Natural dye analysis: cf. article 5, table 3.

Condition: One length is fragmentary, but the general condition of the velvet is good. A green silk lining covers the selvages on the front side.

V.1.3.
Piece of length with intertwining ogival lattices

Date: 16th century

Dimensions: 154 x 63.8 cm (selvages included)

Inv. IS.Tx.1206

Bibliography: ERRERA 1927, cat. 220 D, p. 202-203 (defined as "*travail oriental du XVIᵉ siècle*" and said to come from the "*Fond des Musées*").

Colour plate on p. 131.

 On a red velvet ground, heavy stems form ogival medallions linked on their top and bottom by stylised pomegranate motifs and containing a lobed pomegranate with a crescent in its centre. Two smaller symmetrical stems run behind the heavy ones, and end on their turn in smaller pomegranates with a crescent. The stems and pomegranates are rendered by brocaded silver threads wrapped around a yellow silk core, while the crescents are formed by brocaded silver threads with a white core. Small eight petalled rosettes, alternately in brocaded silver thread with a white core and in yellowish green silk thread, light up the field between the two concentric ogivals. Finally, ivory voided parts form tendrils and curved serrated leaves filling the background.

 This textile belongs to the group of velvets with loom-width multileveled ogival pattern, with linear voiding and supplementary brightly coloured silk wefts (see cat. V.1.1). It is similar to the one under cat. V.1.7 and related to the length under cat. V.1.6.

Technical analysis:

 Pattern repeat: Measurements: height: > 154 cm; Width: 61.5 cm. Construction: vertical point repeat.

 Technical denomination: brocaded voided cut velvet.

 Warp: Material and count: Foundation warp: ivory Z-spun silk; 72/cm. Pile warp: red S-spun silk; 12/cm. Proportion: 6 foundation warp threads to 1 pile warp thread. Step: 1 tuft. *Weft*: Material and count: A. Foundation weft: fourfold dark ochre Z-spun cot-

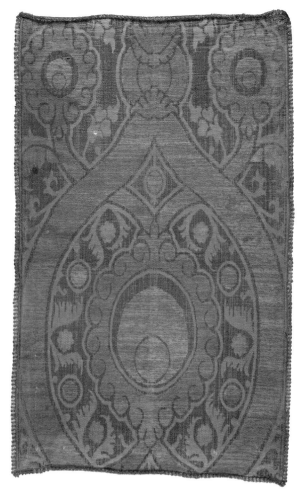

cat. V.1.3

cading weft: 4.1 twill S weft face, with 1/3 of the foundation warp threads. Weave of the pile warp: under all the foundation, the squeezing and the brocading picks and above all the supporting picks. In the pile effect: above the pile rod. In the brocaded effect: under the pile rod.

Composition of the pattern: Ground: red cut pile. Pattern: 1. Ivory voided foundation fabric. 2. Brocaded effect of the silver metal weft (white core). 3. Brocaded effect of the silver metal weft. (yellow core). 4. Brocaded effect of the yellowish green weft.

Selvages: both selvages preserved. Composition: ivory Z-spun silk. Width: 1, 2 and 1.1 cm. *Weave*: as the foundation weft, 5-end satin warp face (foundation picks doubled alternately with a squeezing pick and a supporting pick).

Passementerie: Galloon in silver and gold threads. Width: 2.1 cm, pattern repeat heigth: 0.8 cm. Main warp and supplementary warp in white filé gold thread with a lamella wound in S-direction over a white silk core. The main weft is a treble similar but finer filé thread. A supplementary loop weft (filé silver thread irregularly wound over a visible white silk core) has been flattened in order to render it more lustrous. The main weft works in plain weave with part of the warp. The supplementary warp floats over 3 and 5 wefts. The loop weft binds with the supplementary warp only. This narrow edging is hard to date. A Turkish provenance can not be ruled out, but the structure gives no conclusive evidence[12].

Natural dye analysis: cf. article 5, table 3.

Condition: Very poor. The velvet pile is worn.

V.1.4.
Cushion cover (*yastık yüzü*) with central sunburst medallion

Date: 17th century (?)

Dimensions: 108.5 x 64.3 cm

Inv. IS.Tx.1207

Acquisition: Purchased by I. Errera from Chiodella in Cremona and donated in 1894.

Bibliography: Errera 1927, cat. 270, p. 244 (defined as "*travail oriental du XVIe siècle*").

This cushion cover shows a central sunburst medallion, the rays ending in tulips with small rosettes between them. Quarters of similar sunburst medallions occupy the corners, while the field between them is filled with vigorous tendrils bearing leaves, tulips, carnations and rosettes, all rendered by the ivory brocaded voided parts, the brown velvet pile and the brocaded gilded silver weft, on a mustard-green ground. The six lappets at each end contain stylised flowers under a lobed arch.

ton; 11/cm. B. Squeezing weft: thin ivory silk without apparent twist; 5.5/cm. C. Supporting weft: thin ivory silk without apparent twist; 5.5/cm. D. Brocading weft: wrapped silver metal thread; silver strip wrapped S (*riant*) around a white very light S-spun/S-plied silk core; 11/cm. Wrapped silver metal thread; silver strip wrapped S (*riant*) around a yellow very light S-spun/S-plied silk core; 11/cm. Yellowish green silk without apparent twist. E. Pile rods: 5.5/cm. Proportion: 2 foundation picks to 2 brocading picks to 1 squeezing pick to 1 supporting pick. Sequence: 1 squeezing pick - 1 pile rod - 1 foundation pick - 1 supporting pick - 1 foundation pick (= 1 pass), and in the brocading areas: 1 squeezing pick - 1 pile rod - 2 brocading picks - 1 foundation pick - 1 supporting pick - 1 foundation pick (= 1 pass). Step: 1 pass. *Weave* (cf. article 3, fig. 1 and 2, with fourfold foundation weft): Foundation fabric: 5-end satin warp face, décochement 3, on the fourfold foundation picks. Weave of the squeezing weft: 4.1 twill S warp face. Each pick of the squeezing weft is entered before the pile rod in the same satin shed as the foundation pick, which is behind the pile rod. Weave of the supporting weft: 4.1 twill S warp face, with all of the foundation warp threads. Weave of the bro-

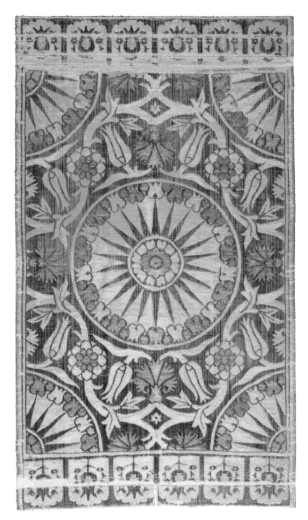

cat. V.1.4

count: A. Foundation weft: paired undyed Z-spun cotton; 20/cm. B. Squeezing weft: thin ivory silk without apparent twist; 10/cm. C. Supporting weft: thin ivory silk without apparent twist; 10/cm. D. Brocading weft: wrapped gold metal thread; on both sides gilt silver strip wrapped S (*riant*) around an ivory S-spun silk core; 20/cm. E. Pile rods: 10/cm. Proportion: 2 paired foundation picks to 2 brocading picks to 1 squeezing pick to 1 supporting pick. Sequence: 1 squeezing pick - 1 pile rod - 1 foundation pick - 1 supporting pick - 1 foundation pick (= 1 pass), and in the brocading areas: 1 squeezing pick - 1 pile rod - 2 brocading picks - 1 foundation pick - 1 supporting pick - 1 foundation pick (= 1 pass). Step: 1 pass. *Weave* (cf. article 3, fig. 1 and 2): Foundation fabric: 5-end satin warp face, décochement 3, on the paired foundation picks. Weave of the squeezing weft: 4.1 twill S warp face. Each pick of the squeezing weft is entered before the pile rod in the same satin shed as the foundation pick, which is behind the pile rod. Weave of the supporting weft: 4.1 twill S warp face, with all of the foundation warp threads. Weave of the brocading weft: 4.1 twill S weft face, with 1/3 of the foundation warp threads. Weave of the pile warp: under all the foundation, the squeezing and the brocading picks and above all the supporting picks. In the pile effect: above the pile rod. In the brocaded and the voided effect: under the pile rod.

Composition of the pattern: Ground: brown cut pile. Pattern: 1. Ivory voided foundation fabric. 2. Brown cut pile. 3. Brocaded effect of the gold metal weft.

Selvages: Warp: brown silk S-spun. Width: 1 cm. Weave: as the foundation weave. 5-end satin warp face (foundation picks alternately doubled with a squeezing and a supporting pick).

Natural dye analysis: cf. article 5, table 3.

Condition: Worn on the upper and under borders. Treated by the Royal Institute for the Cultural Heritage in 1972.

V.1.5.
Fragment of length with an ogival lattice linked by crowns and containing palmettes

Date: Second half of the 16th or first half of the 17th century

Dimensions: 40 x 57.5 cm

Inv. IS.Tx.1213

Acquisition: Donated by Baron Guilio Francetti of Florence to his niece I. Errera, and donated to the museum. Transferred to the Islamic collection in 1996.

Bibliography: Errera 1927, cat. 278, p. 250 (defined as "*travail d'inspiration orientale du XVIe siècle*").

Colour plate on p. 132.

Although there exist a number of other cushion covers with a similar iconography and although the weaving technique is totally conform with the one determined in other velvets of Ottoman origin, there is doubt about the authenticity of this piece. In fact, neither natural nor synthetic dye components have been detected in the ochre-brown pile (see article 5, table 3). This is an aspect we cannot explain at this moment, but we hope that future research will elucidate this question.

Technical analysis:

Measurement: Between the horizontal borders: 84.5 cm; borders: 12 cm.

Pattern repeat: Measurements: 84.5 x 60 cm; borders: 12 x 10 cm. Construction: horizontal and vertical point repeat.

Technical denomination: brocaded voided cut velvet

Warp: Material and count: Foundation warp: ivory S-spun silk; 72/cm. Pile warp: brown striped S-spun silk; 12/cm. Proportion: 6 foundation warp threads to 1 pile warp thread. Step: 1 tuft. *Weft*: Material and

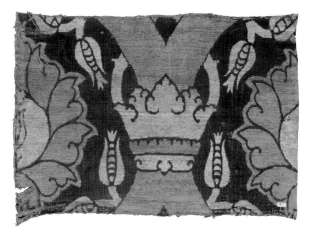

cat. V.1.5

On a red velvet ground, the pattern is rendered in silver and gilded silver metal thread, outlined by red velvet pile. This fragment comes from a length with a large-scale ogival lattice, formed by stems from which tulips grow, bound by crowns and containing large lobed palmettes.

The crown, palmettes and tulips on this fabric are similar to those found on a velvet kaftan preserved in the Topkapı Palace Museum in Istanbul, one of the only two preserved imperial kaftans made out of Ottoman velvet, dated to the first half of the 17th century[13].

This fragment is of a high quality: the design is finely drawn, the colours are bright, Indian lac being used for the deep red parts.

Technical analysis:
 Pattern repeat: Measurements: height: > 40 cm. Half the width: 30 cm. Construction: vertical point repeat.
 Technical denomination: brocaded cut velvet.
 Warp. Material and count: Foundation warp: yellow Z-spun silk; 75/cm. Pile warp: red very light S-spun/ S-plied silk; 12.5/cm. Proportion: 6 foundation warp threads to 1 pile warp thread. Step: 1 tuft. *Weft*: Material and count: A. Foundation weft: paired undyed Z-spun cotton; 13/cm. B. Squeezing weft: thin ivory silk without apparent twist; 6.5/cm. C. Supporting weft: thin ivory silk without apparent twist; 6.5/cm. D. Brocading wefts: wrapped gold metal thread; on both sides gilded silver strip wrapped S (*riant*) around a yellow S-spun silk core; 13/cm. Wrapped silver metal thread; silver strip wrapped S (*riant*) around an ivory S-spun silk core; 13/cm. E. Pile rods: 6.5/cm. Proportion: 2 foundation picks to 2 brocading picks to 1 squeezing pick to 1 supporting pick. Sequence: 1 squeezing pick - 1 pile rod - 1 foundation pick - 1 supporting pick - 1 foundation pick (= 1 pass), and in the brocading areas: 1 squeezing pick - 1 pile rod - 2 brocading picks - 1 foundation pick - 1 supporting pick - 1 foundation pick

(= 1 pass). Step: 1 pass. *Weave* (cf. article 3, fig. 1 and 2): Foundation fabric: 5-end satin warp face, décochement 3, on the paired foundation picks. Weave of the squeezing weft: 4.1 twill S warp face. Each pick of the squeezing weft is entered before the pile rod in the same satin shed as the foundation pick, which is behind the pile rod. Weave of the supporting weft: 4.1 twill S warp face, with all of the foundation warp threads. Weave of the brocading weft: 4.1 twill S weft face, with 1/3 of the foundation warp threads. Weave of the pile warp: under all the foundation, the squeezing and the brocading picks and above all the supporting picks. In the pile effect: above the pile rod. In the brocaded effect: under the pile rod.

Composition of the pattern: Ground: red cut velvet. Pattern: 1. Red cut velvet. 2. Brocaded effect of the gold metal weft. 3. Brocaded effect of the silver metal weft.

Selvages: none.

Natural dye analysis: cf. article 5, table 3.

Condition: Excellent.

V.1.6.
Length with intertwining ogival lattices

Date: 16th century

Dimensions: 179 x 64 cm (selvages included)

Inv. IS.Tx.1229

Acquisition: Purchased by I. Errera at the Somzée Auction in 1904, lent to the museum and finally bequeathed in 1929.

Bibliography: ERRERA 1927, cat. 220 A, p. 201 (defined as "*travail oriental du XVIᵉ siècle*").

Colour plate on p. 133.

On a crimson velvet ground, linear voided parts in red form finely drawn arabesques, but this pattern is overlaid by two intertwining gilded metal thread lattices. The largest one is formed by great curling leaves, surrounding a circular medallion with a pomegranate in the centre and is linked on its interstices by smaller versions of similar medallions. A second and more discrete ogival lattice intertwines with the greater one. Both wear stems with leaves and tulips. The central pomegranates are surrounded by light blue and yellow rosettes in extra brocaded silk weft.

For the pattern of intertwining ogival lattices with linear voided arabesques and with details picked out in pale coloured brocaded silk weft, see under cat. V.1.1. A similar piece to this one is to be found in the Bargello Museum in Florence, dated to the late 16th century[14]. Another analogue one is preserved in the Metropolitan Museum of Art in New York, dated with probability to the first half of the 16th century[15].

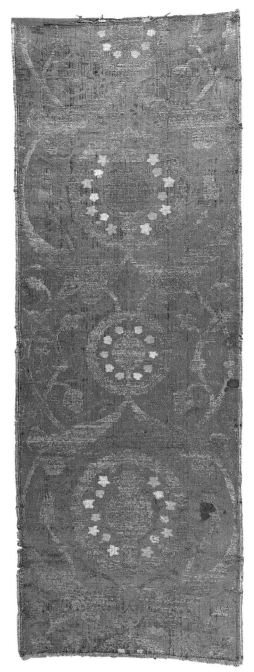

cat. V.1.6

Large curved serrated leaves like those on this textile, called *saz*-leaves, dominate the Ottoman design in the second quarter of the 16th century[16]. Typical for the *saz*-style is a sophisticated three-dimensionality, with different levels intertwining with each other.

Technical analysis:

Pattern repeat: Measurements: 87.5 x 62.5 cm. Construction: vertical point repeat.

Technical denomination: brocaded voided cut velvet.

Warp: Material and count: Foundation warp: red Z-spun silk; 72/cm. Pile warp: crimson very light S-spun/S-plied silk; 12/cm. Proportion: 6 foundation warp threads to 1 pile warp thread. Step: 1 tuft. *Weft*: Material and count: A. Foundation weft: paired brown-red S-spun bourrette silk; 18/cm. B. Squeezing weft: red silk without apparent twist: 9/cm. C. Supporting weft: red silk without apparent twist; 9/cm. D. Brocading weft: wrapped gold metal thread; on both sides gilded silver strip wrapped S (*riant*) around a yellow Z-spun/S-plied silk core; 18/cm. Light blue silk without apparent twist; 18/cm. Yellow silk without apparent twist; 18/cm. E. Pile rods: 9/cm. Proportion: 2 foundation picks to 2 brocading picks to 1 squeezing pick to 1 supporting pick. Sequence: 1 squeezing pick - 1 pile rod - 1 foundation pick - 1 supporting pick - 1 foundation pick (= 1 pass), and in the brocading areas: 1 squeezing pick - 1 pile rod - 2 brocading picks - 1 foundation pick - 1 supporting pick - 1 foundation pick (= 1 pass). Step: 1 pass. *Weave* (cf. article 3, fig. 1 and 2): Foundation fabric: 5-end satin warp face, décochement 3, on the paired foundation picks. Weave of the squeezing weft: 4.1 twill S warp face. Each pick of the squeezing weft is entered before the pile rod in the same satin shed as the foundation pick, which is behind the pile rod. Weave of the supporting weft: 4.1 twill S warp face, with all of the foundation warp threads. Weave of the brocading weft: 4.1 twill S weft face, with 1/3 of the foundation warp threads. Weave of the pile warp: under all the foundation, the squeezing and the brocading picks and above all the supporting picks. In the pile effect: above the pile rod. In the brocaded and the voided effect: under the pile rod.

Composition of the pattern: Ground: crimson cut velvet (very worn out). Pattern: 1. The brocaded effect of the gold metal weft. 2. Brocaded effect of the light-blue silk weft. 3. Brocaded effect of the yellow silk weft. 4. The red voided foundation fabric (very worn out).

Selvages: Composition: 46 paired yellow silk threads; Width: 0.8-0.9 cm. Weave: as the foundation weave, 5-end satin warp face (foundation picks doubled alternately with a squeezing pick and a supporting pick).

Natural dye analysis: cf. article 5, table 3.

Condition: Very worn and with stains.

V.1.7.
Piece of length with intertwining ogival lattices

Date: 16th century

Dimensions: 134.5 x 60.5 cm (selvages included)

Inv. IS.Tx.1232

Acquisition: Purchased by I. Errera from Bacri in Paris in 1901, lent to the museum and bequeathed in 1929.

Bibliography: ERRERA 1927, cat. 220 B, p. 201-202 (defined as "*travail oriental du XVIe siècle*").

Very similar to cat. V.1.3, this piece has also a red velvet ground, voided parts as decoration element, brocaded wefts in silver thread with yellow or white core, and extra brocaded wefts of coloured silk thread here in yellowish green. The pattern is slightly different though, in the sense that the main ogival is formed here by lobed stems and that, instead of a crescent motif in the centre, a pomegranate is drawn.

Technical analysis:
 Pattern repeat: Measurements: 102 x 58 cm. Construction: vertical point repeat.
 Technical denomination: brocaded voided cut velvet.
 Warp: Material and count: Foundation warp: light yellow Z-spun/Z-plied silk; 72/cm. Pile warp: red very light S-spun/S-plied silk; 12/cm. Proportion: 6 foundation warp threads to 1 pile warp thread. Step: 1 tuft. *Weft*: Material and count: A. Foundation weft: paired undyed Z-spun cotton; 12/cm. B. Squeezing weft: thin ivory silk without apparent twist; 6/cm. C. Supporting weft: thin ivory silk without apparent twist; 6/cm. D. Brocading wefts: wrapped silver metal thread; silver strip wrapped S (*riant*) around a yellow S-spun/S-plied silk core; 12/cm; wrapped silver metal thread; silver strip wrapped S (*riant*) around a white S-spun/S-plied silk core; 12/cm; Green (different shades) fourfold Z-spun silk; 12/cm. E. Pile rods: 6/cm. Proportion: 2 foundation picks to 2 brocading picks to 1 squeezing pick to 1 supporting pick. Sequence: 1 squeezing pick - 1 pile rod - 1 foundation pick - 1 supporting pick - 1 foundation pick (= 1 pass), and in the brocading areas: 1 squeezing pick - 1 pile rod - 2 brocading picks - 1 foundation pick - 1 supporting pick - 1 foundation pick (= 1 pass). Step: 1 pass. *Weave* (cf. article, fig. 1 and 2): Foundation fabric: 5-end satin warp face, décochement 3, on the paired foundation picks. Weave of the squeezing weft: 4.1 twill S warp face. Each pick of the squeezing weft is entered before the pile rod in the same satin shed as the foundation pick, which is behind the pile rod. Weave of the supporting weft: 4.1 twill S warp face, with all of the foundation warp threads. Weave of the brocading weft: 4.1 twill S weft face, with 1/3 of the foundation warp threads. Weave of the pile warp: under all the foundation, the squeezing and the brocading picks and above all the supporting picks. In the pile effect: above the

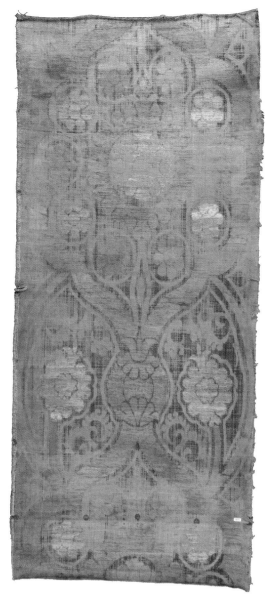

cat. V.1.7

pile rod. In the brocaded and the voided effect: under the pile rod.
 Composition of the pattern: Ground: red cut velvet. Pattern: 1. Brocaded effect of the silver metal weft (yellow silk core). 2. Brocaded effect of the silver metal weft (white silk core). 3. Brocaded effect of green silk weft. 4. The light yellow voided foundation fabric.
 Selvages: only one complete selvage. Composition: silk; the 40 last threads are paired silk threads; Width: 1.25 cm. Weave: as the foundation weave, 5-end satin warp face (foundation picks doubled alternately with a squeezing pick and a supporting pick).

Natural dye analysis: cf. article 5, table 3.

Condition: Poor. Very worn.

V.1.8.
Length with intertwining ogival lattices

Date: End of the 16th or first half of the 17th century

Dimensions: 177 x 63 cm (one selvage included)

Inv. IS.Tx.1262

Acquisition: Bequeathed by G. Vermeersch in 1911.

Bibliography: ERRERA 1927, cat. 220 E, p. 203 (defined as "*travail oriental du XVIe siècle*"); LAFONTAINE-DOSOGNE 1983, fig. 21 b (dated to the 16th or 17th century); ATASOY 2001, plate 90 (dated to the first half of the 17th century).

Colour plate on p. 134.

On a crimson velvet ground, the pattern of two intertwining ogival lattices is rendered in gilded metal and silver threads. The main lattice has a triple stem, the middle one decorated with a garland, and is bounded by pine cone motifs. It contains lobed pomegranates resting on stems formed by the second lattice. Carnations and triple dots –those in the main lattice affect the form of crescents directed towards each other– fill in the empty spaces.

This is another variant of the velvets inspired by Italian silks, with loom-width double intertwining ogival lattices. The motifs resembling carnations and triple dots are, however, of Turkish origin.

Technical analysis:

Pattern repeat: Measurements: 81 x 62 cm. Construction: vertical point repeat.

Technical denomination: brocaded cut velvet.

Warp: Material and count: Foundation warp: yellow Z-spun silk; 72/cm. Pile warp: crimson very light S-spun/S-plied silk; 12/cm. Proportion: 6 foundation warp threads to 1 pile warp thread. Step: 1 tuft. *Weft*: Material and count: A. Foundation weft: fourfold orange red S-spun schappe silk; 20/cm. B. Squeezing weft: red silk without apparent twist; 10/cm. C. Supporting weft: red silk without apparent twist; 10/cm. D. Brocading wefts: wrapped gold metal thread; on both sides gilded silver strip wrapped S (*riant*) around an ivory silk core S; 20/cm; Wrapped silver metal thread; silver strip wrapped S (*riant*) around an ivory very light S-spun/S-plied silk core; 20/cm. E. Pile rods: 10/cm. Proportion: 2 foundation picks to 2 brocading picks to 1 squeezing pick to 1 supporting pick. Sequence: 1 squeezing pick - 1 pile rod - 1 foundation pick - 1 supporting pick - 1 foundation pick (= 1 pass), and in the brocading areas: 1 squeezing pick - 1 pile rod - 2 brocading picks - 1 foundation pick - 1 supporting pick - 1 foundation pick (= 1 pass). Step: 1 pass. *Weave* (cf. article 3, fig. 1 and 2): Foundation fabric: 5-end satin warp face, décochement 3, on the fourfold foundation picks. Weave of the squeezing weft: 4.1 twill S warp face. Each pick of the squeezing weft is entered before the pile rod in the same satin shed as the foundation pick, which is behind the pile rod. Weave of the supporting

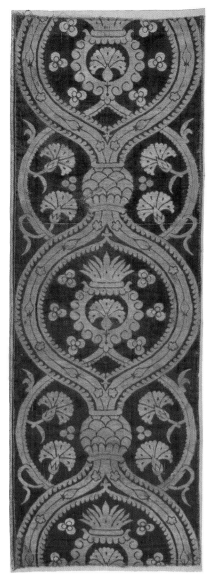

cat. V.1.8

weft: 4.1 twill S warp face, with all of the foundation warp threads. Weave of the brocading weft: 4.1 twill S weft face, with 1/3 of the foundation warp threads. Weave of the pile warp: under all the foundation, the squeezing and the brocading picks and above all the supporting picks. In the pile effect: above the pile rod. In the brocaded effect: under the pile rod.

Composition of the pattern: Ground: crimson cut velvet. Pattern: 1. Brocaded effect of the gold metal weft. 2. Brocaded effect of the silver metal weft.

Selvages: only one complete selvage. Composition: silk; 70 paired silk threads; Width: 1 cm. Weave: as the foundation weave, 5-end satin warp face (foundation picks doubled alternately with a squeezing pick and a supporting pick).

Natural dye analysis: cf. article 5, table 3.

Conservation treatment: cf. article 6.

With two pattern repeats (cat. V.2.9-V.2.19)

V.2.9.
Three fragments from length with lobed medallions on ogival stems

Date: 16th century

Dimensions: Three fragments. 1/3: 48 x 23 cm; 2/3: 25 x 22 cm; 3/3: 24 x 12.5 cm

Inv. IS.Tx.450

Acquisition: Purchased by I. Errera from Ricard in Frankfurt am Main in 1912, lent to the museum and bequeathed in 1929. Transferred to the Islamic collection in 1996.

Bibliography: ERRERA 1927, cat. 130 F, p. 138-139 (defined as "*travail italien du XV^e siècle*"). .

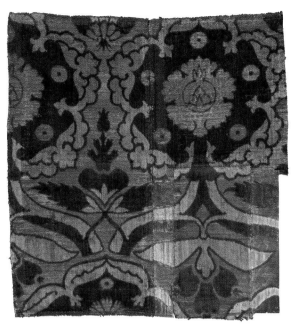

cat. V.2.9

The three fragments of deep red and greenish yellow velvet on a ground of gilt-metal thread, come from a length with staggered rows of poly-lobed medallions connected by curvilinear ogival stems, from which leaves and flower motifs sprout. Each medallion contains in its turn a serrated medallion with a pomegranate and five dotted circles.

The so-called horizontal layout with lobed medallions inspired by Italian models[17] suggests a date in the beginning of the 16th century. The use of Mexican cochineal however, situates the origin of this velvet at least after ca. 1525 and rather probably in the second half of the 16th century when this dye was available in Turkey (see article 5, table 3). Moreover, the presence of Indian lac in the pile warp confirms the presumed high quality of the silk velvet, probably woven in Bursa, since the lac dye, *kerria lacca,* was mentioned in the judicial enquiry of the Bursa silk industry of 1502 as being expensive and used to colour the weft of a *kadife* or velvet[18].

The fragments show analogue technical and stylistic features as velvet cat. V.2.19, but in the latter no Mexican cochineal has been detected.

Technical analysis:
Pattern repeat: Measurements: Height: > 48 cm; Width: 32.2 cm. Construction: vertical point repeat. *Technical denomination*: brocaded cut velvet. *Warp*: Material and count: Foundation warp: red Z-spun silk; 72/cm. Pile warp a: red S-spun silk; 12/cm. Pile warp b: greenish-yellow S-spun silk; 12/cm. Proportion: 4 foundation warp threads to 1 pile warp thread a to 2 foundation warp threads to 1 pile warp thread b. Step: 1 tuft by the pile warp. *Weft*: Material and count: A. Foundation weft: red paired S-spun schappe silk; 23 paired picks/cm. B. Squeezing weft: red silk without apparent twist; 11.5/cm. C. Supporting weft: red silk without apparent twist; 11.5/cm. D. Brocading weft: wrapped gold metal thread; on both sides gilded silver strip wrapped S (*riant*) around an ivory S-spun silk core; 23/cm. E. Pile rods: 11.5/cm.

Remark: On some horizontal sections the material of the squeezing weft and the supporting weft are simultaneously substituted by paired schappe silk S-spun. This means that the material of the squeezing weft and the supporting weft are the same, and that the two wefts came from the same shuttle. Proportion: 2 foundation picks to 2 brocading picks to 1 squeezing pick to 1 supporting pick. Sequence: 1 squeezing pick - 1 pile rod - 1 foundation pick - 1 supporting pick - 1 foundation pick (= 1 pass), and in the brocading areas: 1 squeezing pick - 1 pile rod - 2 brocading picks - 1 foundation pick - 1 supporting pick - 1 foundation pick (= 1 pass). Step: 1 pass. *Weave* (cf. article 3, fig. 1 and 2): Foundation fabric: 5-end satin warp face, décochement 3, on the paired foundation picks. Weave of the squeezing weft:4.1 twill S warp face with all of the foundation warp threads. The squeezing pick is entered before the pile rod. Weave of the supporting weft: 4.1 twill S warp face, with all of the foundation warp threads. Weave of the brocading weft: 4.1 twill S weft face, with 1/3 of the foundation warp threads. Weave of the pile warps: under all the foundation, the squeezing and the brocading picks and above all the supporting picks. In the red pile effect: red pile warp above the rod, greenish-yellow pile warp under the pile rod. In the greenish-yellow pile effect: greenish-yellow pile warp above the rod, red pile warp under the pile rod. In the brocaded effect: under the pile rod.

Composition of the pattern: Ground: brocaded effect of the gold metal weft. Pattern: 1. red cut pile; 2. greenish-yellow cut pile.
Selvages: none.

Natural dye analysis: cf. article 5, table 3.

Condition: The three fragments are cleaved to cardboard and the motifs are partially (two small rectangles in the right bottom quarter) completed with paint.

V.2.10.
Cushion cover (*yastık yüzü*) with ogival medallions in staggered rows

Date: 17th century

Dimensions: 109 x 61 cm

Inv. IS.Tx.820

Acquisition: Bequeathed by G. Vermeersch, 1911.

Bibliography: ERRERA 1927, cat. 220 F, p. 203 (defined as "*travail oriental du XVIe siècle*").

On a pistachio green velvet ground, the pattern stands out in the ivory voided foundation fabric with inner motifs in brocaded gilded metal wefts and green velvet pile. In the main field, ogival medallions with serrated edges and arranged in staggered rows, rest on a calyx affecting the form of a reversed palmette and end on their top in a palm tree. Each medallion contains a crescent and three groups of three linked dots. The six lappets at each end contain stylised flowers under a lobed arch.

The collection comprises three sofa cushion covers. Cat. V.2.25 and this one both have a repeating pattern, the first in three pattern repeats, the latter in two pattern repeats The third exemplar, cat. V.1.2, although not absolutely reliable, has a symmetrical design with a central sunburst medallion.

On the reverse of this velvet, a circular ink stamp occurs, barely discernible.

Technical analysis:
Pattern repeat: Measurements: field: 50.5 x 32 cm; borders: 10.67 x 13 cm. Construction: vertical point repeat and in quincunxes.
Technical denomination: brocaded voided cut velvet
Warp: Material and count: Foundation warp: ivory S-spun silk; 84/cm. Pile warp: green very light S-spun/S-plied silk; 14/cm. Proportion: 6 foundation warp threads to 1 pile warp thread. Step: 1 tuft. *Weft*: Material and count: A. Foundation weft: paired undyed Z-spun cotton; 21/cm. B. Squeezing weft:

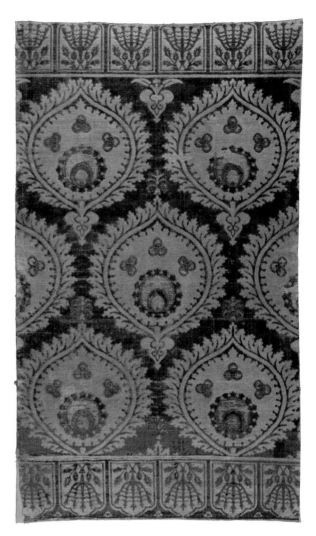

cat. V.2.10

thin ivory silk without apparent twist; 10.5/cm. C. Supporting weft: thin ivory silk without apparent twist; 10.5/cm. D. Brocading weft: wrapped gold metal thread; on both sides gilded silver strip wrapped S (*riant*) around an ivory S-spun silk core; 21/cm. E. Pile rods: 10.5/cm. Proportion: 2 foundation picks to 2 brocading picks to 1 squeezing pick to 1 supporting pick. Sequence: 1 squeezing pick - 1 pile rod - 1 foundation pick - 1 supporting pick - 1 foundation pick (= 1 pass), and in the brocading areas: 1 squeezing pick - 1 pile rod - 2 brocading picks - 1 foundation pick - 1 supporting pick - 1 foundation pick (= 1 pass). Step: 1 pass. *Weave* (cf. article 3, fig. 1 and 2): Foundation fabric: 5-end satin warp face, décochement 3, on the paired cotton foundation picks. Weave of the squeezing weft: 4.1 twill S warp face. Each pick of the squeezing weft is entered before the pile rod in the same satin shed as the foundation pick, which is behind the pile rod. Weave of the supporting weft: 4.1 twill S warp face, with all of the foundation warp threads. Weave of the brocading weft: 4.1 twill S weft face, with 1/3 of the foundation warp threads. Weave of the pile warp:

under all the foundation, the squeezing and the brocading picks and above all the supporting picks. In the pile effect: above the pile rod. In the brocaded and the voided effect: under the pile rod.

Composition of the pattern: Ground: green cut pile. Pattern: 1. Ivory voided foundation fabric. 2. Green cut pile. 3. Brocaded effect of the gold metal weft.

Selvages: none

Natural dye analysis: cf. article 5, table 3.

Condition: Worn, especially on the lower part. Treated by the Royal Institute for the Cultural Heritage in Brussels, in 1979.

V.2.11.
Fragmentary two-loom-width cover with roundels in staggered rows

Date: 17th century

Dimensions: 159 x 125.5 cm

Inv. IS.Tx.1201

Acquisition: Purchased by I. Errera from Delaunay in Amsterdam and donated to the museum.

Bibliography: ERRERA 1927, cat. 266 A, p. 242 (defined as "*travail oriental du XVIe siècle*"); LAFONTAINE-DOSOGNE 1983, fig. 22 (dated to the 16th century); LAFONTAINE-DOSOGNE J., Art islamique, in *Musea nostra, Musées royaux d'Art et d'Histoire Bruxelles. Amérique, Asie, Océanie*, 1992, p. 18 (dated to the 16th century).

Colour plate on p. 135.

On a crimson velvet ground, roundels in staggered rows are rendered by the brocaded silver thread wefts with details in crimson velvet pile. A double lined frame overlays the pattern and separates the central field from the border (see article 3). The slightly oval shaped and dentate roundels affect the form of crescents, flanked by hyacinths and other flower motifs. These crescents enclose smaller ones in their turn with a dot touching the outline, thus creating the impression of an eye.

Decorated roundels in staggered rows form a popular pattern in 17th century Bursa furnishing velvets, often in the form of crescents evoking eyes. This eye-like motif may be mingled with the one of the dots in the *çintamani*-motif, discussed under cat. V.3.23.

Technical analysis:
Dimensions: Of the five fragments: 1/5: 112 x 45 cm (left selvage included); 2/5: 112 x 19.2 cm (right selvage included); 3/5: 112 x 64 cm (both selvages included); 4/5: 47 x 64 cm (both selvages included); 5/5: 47 x 64 cm (both selvages included). At the upper edge of the fragments 1/5, 2/5, 3/5 and at the lower edge of the fragments 4/5 and 5/5 there is a 2 mm strip of foundation fabric. Fragments 1/5, 2/5 and 3/5 are sewn together

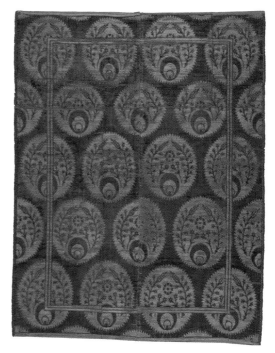

cat. V.2.11

side by side, so too are fragments 4/5 and 5/5. Fragments 4/5, 5/5 are positioned above fragments 1/5, 2/5 and 3/5.

Round the piece is a small border, ± 3.5 cm wide, 15 cm from the selvages and 10.5 cm from the upper and lower edges of the piece. The border overlies the repeats suppressing the pattern (see: 2. The execution of small borders in some Ottoman velvets).

Pattern repeat: Measurements: 62 x 30.5 cm. Construction: vertical point repeat and in quincunxes.

Technical denomination: brocaded cut velvet.

Warp: Material and count: Foundation warp: ivory silk without apparent twist; 72/cm. Pile warp: crimson light S-spun/S-plied silk; 12/cm. Proportion: 6 foundation warp threads to 1 pile warp thread. Step: 1 tuft. *Weft*: Material and count: A. Foundation weft: paired undyed Z-spun cotton; 16/cm. B. Squeezing weft: thin ivory silk without apparent twist; 8/cm. C. Supporting weft: thin ivory silk without apparent twist; 8/cm. D. Brocading weft: wrapped silver metal thread; silver strip wrapped S (*riant*) around a yellow S-spun silk core; 16/cm. E. Pile rods: 8/cm. Proportion: 2 foundation picks to 2 brocading picks to 1 squeezing pick to 1 supporting pick. Sequence: 1 squeezing pick - 1 pile rod - 1 foundation pick - 1 supporting pick - 1 foundation pick (= 1 pass), and in the brocading areas: 1 squeezing pick - 1 pile rod - 2 brocading picks - 1 foundation pick - 1 supporting pick - 1 foundation pick (= 1 pass). Step: 1 pass. *Weave* (cf. article 3, fig. 1 and 2): Foundation fabric: 5-end satin warp face, décochement 3, on the paired foundation picks. Weave of the squeezing weft: 4.1 twill S warp face. Each pick of the squeezing weft is entered before the pile rod in the same satin shed as the foundation pick, which is behind the pile rod. Weave of the supporting

weft: 4.1 twill S warp face, with all of the foundation warp threads. Weave of the brocading weft: 4.1 twill S weft face, with 1/3 of the foundation warp threads. Weave of the pile warp: under all the foundation, the squeezing and the brocading picks and above all the supporting picks. In the pile effect: above the pile rod. In the brocaded effect: under the pile rod.

Composition of the pattern: Ground: crimson cut pile. Pattern: 1. Crimson cut pile. 2. Brocaded effect of the silver metal weft.

Selvages: Composition: all the selvages have ± 50 red silk S-spun threads. Width: 1.5 cm. Weave: as the foundation weave, 5-end satin warp face (foundation picks doubled alternately with a squeezing pick and a supporting pick).

Natural dye analysis: cf. article 5, table 3.

Condition: Composed of five fragments of the same textile, sewn together. At about three thirds of the height, there is a horizontal split, masked by the sewing.

V.2.12.
Pieced length with roundels in staggered rows

Date: Late 16th or 17th century

Dimensions: 123.5 x 65 cm

Inv. IS.Tx. 1202

Acquisition Purchased by I. Errera in Istanbul in 1895 and donated to the museum.

Bibliography: ERRERA 1927, cat. 269, p. 244 (defined as *"travail oriental du XVI^e siècle"*).

Colour plate on p. 136.

On a crimson velvet ground, roundels in staggered rows are rendered by the brocaded silver thread wefts with details in crimson and blue velvet pile. The roundels contain a sunburst motif with concentric circles of pointed rays and have a palm tree on their top and bottom. A vertical double line goes through the pattern, probably a frame border, but here a second one is preserved on the left edge (see article 3).

An identical velvet is used for the fragmentary double-loom-width cover in this collection, cat. V.2.14. An identical pattern, also realised with two pile colours but with gilded metal thread instead of silver thread, is found on a velvet preserved in the Museum für Kunst und Gewerbe in Hamburg and is dated to the 16th century[19]. A complete two-loom-width cover with the same pattern is preserved in the Metropolitan Museum of Art in New York[20]. A similar pattern, although with three dots replacing the palm tree in the field and with a different colour combination, is conserved in the Mevlana Museum in Konya where it is dated to the late 16th or early 17th century.[21]

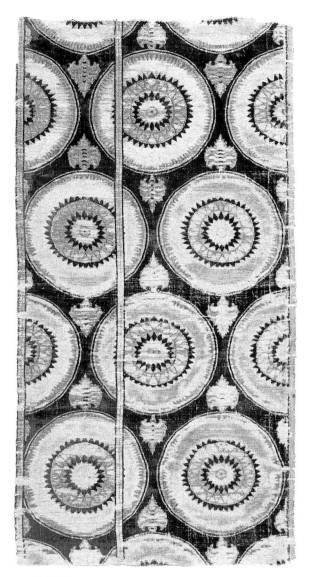

cat. V.2.12

Technical analysis:

Pattern repeat: Measurements: 54 x 32 cm. Construction: horizontal and vertical point repeat and symmetry point. *Remark:* at a distance of about 38.8 cm from the selvage there is a vertical unfigured border with a width of ca. 2 cm. This border overlies the repeats suppressing the pattern. At a distance of about 23 cm from this border occurs a second identical vertical border on the edge of the piece. This edge is not a selvage. (see: 2. The execution of small borders in some Ottoman velvets).

Technical denomination: brocaded cut velvet

Warp: Material and count: Foundation warp: ivory S-spun silk; 78/cm. Pilewarp a: crimson S-spun silk; 14/cm. Pilewarp b: blue S-spun silk; 14/cm. Proportion: 4 foundation warp threads to 1 pile warp thread a to 2 foundation warp threads to 1 pile warp thread b. Step: 1 tuft by the pile warp. *Weft*: Material and count: A. Foundation weft: paired undyed Z-spun

cotton; 22/cm. B. Squeezing weft: ivory silk without apparent twist; 11/cm. C. Supporting weft: ivory silk without apparent twist; 11/cm. D. Brocading weft: wrapped silver metal thread; silver strip wrapped S (*riant*) around a light yellow 3S-spun/S-plied silk core; 22/cm. E. Pile rods: 11/cm. Proportion: 2 foundation picks to 2 brocading picks to 1 squeezing pick to 1 supporting pick. Sequence: 1 squeezing pick - 1 pile rod - 1 foundation pick - 1 supporting pick - 1 foundation pick (= 1 pass), and in the brocading areas: 1 squeezing pick - 1 pile rod - 2 brocading picks - 1 foundation pick - 1 supporting pick - 1 foundation pick (= 1 pass). Step: 1 pass. *Weave* (cf. article 3, fig. 3 and 4): Foundation fabric: 5-end satin warp face, décochement 3, on the paired foundation picks. Weave of the squeezing weft: 4.1 twill S warp face. Each pick of the squeezing weft is entered before the pile rod in the same satin shed as the foundation pick, which is behind the pile rod. Weave of the supporting weft: 4.1 twill S warp face, with all of the foundation warp threads. Weave of the brocading weft: 4.1 twill S weft face, with 1/3 of the foundation warp threads. Weave of the pile warps: under all the foundation, the squeezing and the brocading picks and above all the supporting picks. In the crimson pile effect: crimson pile warp above the rod, blue pile warp under the pile rod. In the blue pile effect: blue pile warp above the rod, crimson pile warp under the pile rod. In the brocaded effect: under the pile rod.

Composition of the pattern: Ground: crimson cut pile. Pattern: 1. Crimson cut pile. 2. Blue cut pile. 3. Brocaded effect of the silver metal weft.

Selvages: Only the right selvage is preserved. Composition: 55-60 treble green silk S-spun; blue selvage cord: coarse silk S-spun. Width: 1.5 cm. Weave: as the foundation weave. 5-end satin warp face (foundation picks doubled alternately with a squeezing pick and a supporting pick). *Remark*: some green warp threads of the left selvage are still present. Then the original width of the piece includes 65+1.5=66.5 cm.

Natural dye analysis: cf. article 5, table 3.

Condition: Rather poor.

V.2.13.
Two fragments of cover, sewn together, with roundels in staggered rows

Date: Late 16th or first half of the 17th century

Dimensions: 86.5 x 56 cm (1/2: 86.5 x 42-44.5 cm; 2/2: 86.5 x 14-11.5 cm)

Inv. IS.Tx.1203

Acquisition: Purchased by I. Errera from Benguiat in London in 1894 and donated to the museum.

Bibliography: ERRERA 1927, cat. 267, p. 242-243 (defined as "*travail oriental du XVIe siècle*").

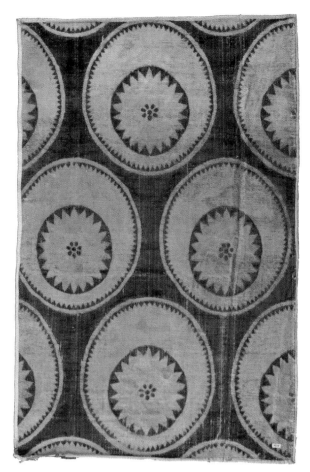

cat. V.2.13

On a plain crimson velvet ground, slightly oval shaped roundels in staggered rows are rendered by the brocaded silver thread wefts, with details in crimson velvet pile. The roundels affect the form of dentate crescents and contain a sun motif with a seven-petalled rosette in its middle.

A complete loom-width cover with a similar pattern, although with palm trees filling the ground, is to be found in the David Collection in Copenhagen, dated here to the second half of the 16th or first half of the 17th century[22].

Technical analysis:
Two fragments: Lining yellow silk covering both edges about 0.5 cm.
Pattern repeat: Measurements: 54.5 x 30.5 cm. Construction: vertical point repeat and in quincunxes.
Technical denomination: brocaded cut velvet
Warp: Material and count: Foundation warp: ivory S-spun silk; 78/cm. Pile warp: crimson S-spun silk; 13/cm. Proportion: 6 foundation warp threads to 1 pile warp thread. Step: 1 tuft. *Weft*: Material and count: A. Foundation weft: paired undyed Z-spun cotton; 18/cm. B. Squeezing weft: ivory silk without apparent twist; 9/cm. C. Supporting weft: ivory silk without apparent twist; 9/cm. D. Brocading weft:

wrapped silver metal thread; silver strip wrapped S (*couvert*) around an ivory S-spun silk core; 18/cm. E. Pile rods: 9/cm. *Remark*: on this velvet the weaving direction has been identified by means of a broken warp thread. The velvet has been woven in the opposite direction to that of the tufts, and the squeezing picks have been entered before the pile rod. Proportion: 2 foundation picks to 2 brocading picks to 1 squeezing pick to 1 supporting pick. Sequence: 1 squeezing pick - 1 pile rod - 1 foundation pick - 1 supporting pick - 1 foundation pick (= 1 pass), and in the brocading areas: 1 squeezing pick - 1 pile rod - 2 brocading picks - 1 foundation pick - 1 supporting pick - 1 foundation pick (= 1 pass). Step: 1 pass. *Weave* (cf. article 3, fig. 1 and 2): Foundation fabric: 5-end satin warp face, décochement 3, on the paired foundation picks. Weave of the squeezing weft: 4.1 twill S warp face. Each pick of the squeezing weft is entered before the pile rod in the same satin shed as the foundation pick, which is behind the pile rod. Weave of the supporting weft: 4.1 twill S warp face, with all of the foundation warp threads. Weave of the brocading weft: 4.1 twill S weft face, with 1/3 of the foundation warp threads. Weave of the pile warp: under all the foundation, the squeezing and the brocading picks and above all the supporting picks. In the pile effect: above the pile rod. In the brocaded effect: under the pile rod. *Weave direction*: The direction in which this velvet has been woven is the same as the direction of the pattern. In two places a broken thread of the foundation warp has not been repaired. These threads are present in the lower part of the velvet and have disappeared from the upper part of the velvet. This means that this velvet was woven from the bottom to the top of the pattern.

Composition of the pattern: Ground: crimson cut pile. Pattern: crimson cut pile. 1. Brocaded effect of the silver metal weft.

Selvages: none.

Natural dye analysis: cf. article 5, table 3.

Condition: Worn.

V.2.14.
Two large fragments of cover, sewn together, with roundels in staggered rows

Date: Late 16th or first half of the 17th century

Dimensions: 1/2: 159 x 41 cm; 2/2: 159 x 58 cm

Inv. IS.Tx.1204

Acquisition: Purchased by I. Errera from Kevan-Isparian in Istanbul, in 1895 and donated to the museum.

Bibliography: ERRERA 1927, cat. 268, p. 243-244 (defined as "*travail oriental du XVIe siècle*").

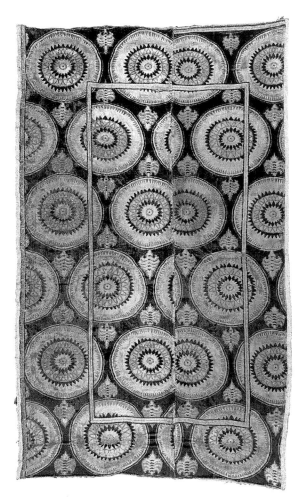

cat. V.2.14

The textile has the same pattern and technical features as cat. V.2.12.

Technical analysis:

The piece is composed of two fragments. Round the piece is a small border, 2 cm wide, about 26 cm from the right edge, 15 cm from the left edge, 22 from the upper edge and 20 cm from the lower edge of the piece. The border overlies the repeats suppressing the pattern (see also: 2. The execution of small borders in some Ottoman velvets). At the upper edge of the right fragment there is a small border of foundation fabric with a height of 12 mm, similar to the other small borders.

Pattern repeat: IS.Tx.1204 has the same pattern as IS.Tx.1202. Measurements: 51 x 31.5 cm. Construction: horizontal and vertical point repeat and symmetry point. *Remark*: despite this construction of the pattern, it is proved by selection faults that the second half in the height is not realised by pulling the lashes from the first part in the opposite direction.

Technical denomination: brocaded cut velvet.

Warp: Material and count: Foundation warp: ivory S-spun silk; 72/cm. Pile warp a: crimson S-spun silk; 12/cm. Pile warp b: blue S-spun silk;

12/cm. Proportion: 4 foundation warp threads to 1 pile warp thread a to 2 foundation warp threads to 1 pile warp thread b. Step: 1 tuft by the pile warp. *Weft*: Material and count: A. Foundation weft: paired undyed Z-spun cotton; 24/cm. B. Squeezing weft: ivory silk without apparent twist; 12/cm. C. Supporting weft: ivory silk without apparent twist; 12/cm. D. Brocading weft: silver strip wrapped S (*riant*) around a light yellow S-spun/S-plied silk core; 24/cm. E. Pile rods: 12/cm. Proportion: 2 foundation picks to 2 brocading picks to 1 squeezing pick to 1 supporting pick. Sequence: 1 squeezing pick - 1 pile rod - 1 foundation pick - 1 supporting pick - 1 foundation pick (= 1 pass), and in the brocading areas: 1 squeezing pick - 1 pile rod - 2 brocading picks - 1 foundation pick - 1 supporting pick - 1 foundation pick (= 1 pass). Step: 1 pass. *Weave* (cf. article 3, fig. 3 and 4): Foundation fabric: 5-end satin warp face, décochement 3, on the paired foundation picks. Weave of the squeezing weft: 4.1 twill S warp face. Each pick of the squeezing weft is entered before the pile rod in the same satin shed as the foundation pick, which is behind the pile rod. Weave of the supporting weft: 4.1 twill S warp face, with all of the foundation warp threads. Weave of the brocading weft: 4.1 twill S weft face, with 1/3 of the foundation warp threads. Weave of the pile warps: under all the foundation, the squeezing and the brocading picks and above all the supporting picks. In the crimson pile effect: crimson pile warp above the rod, blue pile warp under the pile rod. In the blue pile effect: blue pile warp above the rod, crimson pile warp under the pile rod. In the brocaded effect: under the pile rod.

Composition of the pattern: Ground: crimson cut pile. Pattern: 1. Crimson cut pile. 2. Blue cut pile. 3. Brocaded effect of the silver metal weft.

Selvages: none.

Natural dye analysis: cf. article 5, table 3.

Condition: The two fragments have been badly sewn together.

V.2.15.
Two lengths with serrated palmettes in staggered rows

Date: First half of the 17th century

Dimensions: 1/2: 172 x 66 cm; 2/2: 168 x 66 cm (selvages included)

Inv. IS.Tx.1208

Acquisition: Purchased by I. Errera from Osman-bey in Istanbul, in 1895 and donated to the museum. Colour plate on p. 137.

Bibliography: ERRERA 1927, cat. 272, p. 245-246 (defined as "*travail oriental du XVIe siècle*"); LAFONTAINE-DOSOGNE 1983, fig. 21 a (dated to the 17th century).

Colour plate on p. 137.

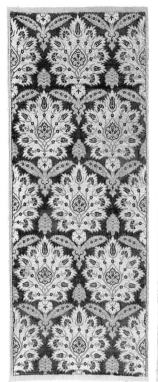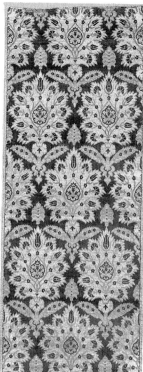

cat. V.2.15

On a crimson velvet ground, serrated palmettes in staggered rows are rendered in silver thread and decorated with bouquets of carnations and tulips on elegant stems in pistachio green and crimson velvet pile. These encircle a pomegranate in gilded metal thread, in its turn containing a bunch of three hyacinths in velvet pile. The palmettes rest on a decorated stem flanked by two leaves with a garland and their top ends in a palm tree, all rendered in gilded metal thread.

The serrated palmette is a popular motif in the 17th century Bursa velvet production, several examples of which have been preserved in Russia[23]. A similar version to the one under consideration, is preserved in the Topkapı Palace Museum in Istanbul, dated to the first two thirds of the 17th century[24]. The ground is equally densely filled, the coloration of pistachio-green and crimson velvet pile and voided areas brocaded with silver thread is identical and the palmettes are similar, although with a finial in the form of three tulips and a slightly different central motif in the piece kept in Istanbul.

Technical analysis:
Pattern repeat: Measurements: 70 x 32 cm. Construction: vertical point repeat and in quincunxes.
Technical denomination: brocaded cut velvet.
Warp: Material and count: Foundation warp: ivory S-spun silk; 80/cm. Pile warp a: crimson light S-spun/S-plied silk; 13.3/cm. Pile warp b: green light S-spun/S-plied silk; 13.3/cm. Proportion: 4 foundation

warp threads to 1 pile warp thread a to 2 foundation warp threads to 1 pile warp thread b. Step: 1 tuft by the pile warp. *Weft*: Material and count: A. Foundation weft: paired undyed Z-spun cotton; 18/cm. B. Squeezing weft: ivory silk without apparent twist; 9/cm. C. Supporting weft: ivory silk without apparent twist; 9/cm. D. Brocading weft: wrapped silver metal thread; silver strip wrapped S (*riant*) around an ivory light S-spun/S plied silk core; 18/cm. Wrapped gold metal thread; on both sides gilded silver strip wrapped S (*riant*) around a light yellow S-spun silk core; 18/cm. E. Pile rods: 9/cm. Proportion: 2 foundation picks to 2 brocading picks to 1 squeezing pick to 1 supporting pick. Sequence: 1 squeezing pick - 1 pile rod - 1 foundation pick - 1 supporting pick - 1 foundation pick (= 1 pass), and in the brocading areas: 1 squeezing pick - 1 pile rod - 2 brocading picks - 1 foundation pick - 1 supporting pick - 1 foundation pick (= 1 pass). Step: 1 pass. *Weave* (cf. article 3, fig. 3 and 4): Foundation fabric: 5-end satin warp face, décochement 3, on the paired foundation picks. Weave of the squeezing weft: 4.1 twill S warp face. Each pick of the squeezing weft is entered before the pile rod in the same satin shed as the foundation pick, which is behind the pile rod. Weave of the supporting weft: 4.1 twill S warp face, with all of the foundation warp threads. Weave of the brocading weft: 4.1 twill S weft face, with 1/3 of the foundation warp threads. Weave of the pile warps: under all the foundation, the squeezing and the brocading picks and above all the supporting picks. In the crimson pile effect: crimson pile warp above the rod, green pile warp under the pile rod. In the green pile effect: green pile warp above the rod, crimson pile warp under the pile rod. In the brocaded and the voided effect: under the pile rod.

Composition of the pattern: Ground: crimson cut pile. Pattern: 1. Crimson cut pile. 2. Green cut pile. 3. Brocaded effect of the gold metal weft. 4. Brocaded effect of the silver metal weft.

Selvages: Composition: ± 40 z-spun/s-plied silk. Width: 1.2 cm. Weave: as the foundation weave, 5-end satin warp face (foundation picks doubled alternately with a squeezing pick and a supporting pick).

Natural dye analysis: cf. article 5, table 3.

Conservation treatment: cf. article 6.

V.2.16.
Two fragments of length with carnations in staggered rows

Date: Early 17th century

Dimensions: 1/2: 80 x 61 cm; 2/2: 18 x 61 cm

Inv. IS.Tx.1209

Acquisition: Purchased by I. Errera from Benguiat in London in 1894 and donated to the museum.

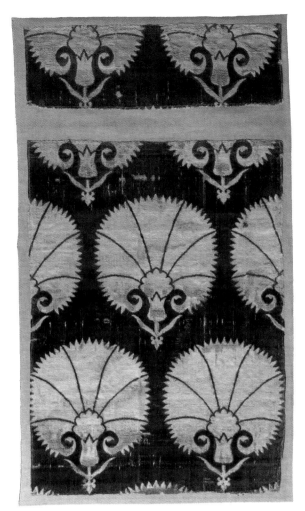

cat. V.2.16

Bibliography: ERRERA 1927, cat. 274, p. 247-248 (defined as "*travail oriental du XVI^e siècle*"); LAFONTAINE-DOSOGNE 1983, fig. 20 (dated to the 17th century).

On a plain crimson velvet ground, large dentate but further undecorated carnations in staggered rows are rendered in gilded metal thread, the curvilinear lines separating the seven petals rendered in crimson velvet pile. The flowers with symmetrical volutes at their base, rest on a stylised tulip, growing from a stem flanked by pointed leaves and resting in a small palmette-like base.

Variations on the large carnation flowers *(karanfil)* are numerous in furnishing velvets of the 16th and especially 17th centuries[25]. These range from simple undecorated and widely spaced flowers on a plain ground, as is the case with this specimen, to more elaborated and densely placed examples. The pattern is very similar to the one found on a two loom-width cover in the Mevlana Museum of Konya, dated circa 1600[26].

Technical analysis:
Pattern repeat: Measurements: 65.5 x 32 cm. Construction: vertical point repeat and in quincunxes.
Technical denomination: brocaded cut velvet
Warp: Material and count: Foundation warp: ivory S-spun silk; 84/cm. Pile warp: crimson light S-spun silk; 14/cm. Proportion: 6 foundation warp threads to 1 pile warp thread. Step: 1 tuft. *Weft*: Material and count: A. Foundation weft: paired undyed strong S-spun cotton; 22/cm. B. Squeezing weft: ivory silk without apparent twist; 11/cm. C. Supporting weft: ivory silk without apparent twist; 11/cm. D. Brocading weft: In piece 1/2: wrapped gold metal thread; on both sides gilded silver strip wrapped S (*riant*) around an ivory S-spun silk core; 22/cm. In piece 2/2: wrapped gold metal thread; on both sides gilded silver strip wrapped S (*riant*) around an ivory S-spun silk core; 22/cm. Wrapped gold metal thread; on both sides gilded silver strip wrapped S (*riant*) around a yellow S-spun silk core; 22/cm. E. Pile rods: 10/cm. Proportion: 2 foundation picks to 2 brocading picks to 1 squeezing pick to 1 supporting pick. Sequence: 1 squeezing pick - 1 pile rod - 1 foundation pick - 1 supporting pick - 1 foundation pick (= 1 pass), and in the brocading areas: 1 squeezing pick - 1 pile rod - 2 brocading picks - 1 foundation pick - 1 supporting pick - 1 foundation pick (= 1 pass). Step: 1 pass. *Weave* (cf. article 3, fig. 1 and 2): Foundation fabric: 5-end satin warp face, décochement 3, on the paired foundation picks. Weave of the squeezing weft: 4.1 twill S warp face. Each pick of the squeezing weft is entered before the pile rod in the same satin shed as the foundation pick, which is behind the pile rod. Weave of the supporting weft: 4.1 twill S warp face, with all of the foundation warp threads. Weave of the brocading weft: 4.1 twill S weft face, with 1/3 of the foundation warp threads. Weave of the pile warp: under all the foundation, the squeezing and the brocading picks and above all the supporting picks. In the pile effect: above the pile rod. In the brocaded effect: under the pile rod.
Composition of the pattern: Ground: crimson cut pile. Pattern: In piece 1/2: brocaded effect of the gold metal weft with the ivory core. In piece 2/2: brocaded effect of the gold metal weft with the ivory core. Brocaded effect of the gold metal weft with the yellow core.
Selvages: none.

Natural dye analysis: cf. article 5, table 3.

Conservation treatment: cf. article 6.

V.2.17.
Two fragments of length with carnations in staggered rows

Date: First half of the 17th century

Dimensions: 56 x 103.5 cm (1/2: 56 x 45 cm; 2/2: 56 x 58.5 cm)

Inv. IS.Tx.1210

Acquisition: Purchased by I. Errera from Benguiat in London, in 1894 and donated to the museum.

Bibliography: ERRERA 1927, cat. 273, p. 246-247 (defined as "*travail oriental du XVIe siècle*").

Colour plate on p. 138.

On a crimson velvet ground, large dentate seven-petalled carnations in staggered rows are rendered in silver thread, with outlines in pistachio green velvet pile. The flowers have symmetrical volutes at their base and rest on a stylised tulip, growing from a stem flanked by leaves containing a garland. In contrast with the plain flower petals, the base from which they grow and their leaves are furthermore decorated with flower motifs in crimson and pistachio velvet pile. Similarly, is the finial in the form of a pomegranate containing three hyacinths.

This is the second velvet in the collection with carnations in staggered rows[27]. Here, the ground is densely filled, and the details of the decoration are rendered in two colours. Moreover, Indian lac dye has been detected in the crimson pile warp, which betrays that this was an expensive velvet. No identical piece could be found, but the nearest one is preserved in the Deutsches Textilmuseum Krefeld, dated to the end of the 16th or first half of the 17th century[28]. Two-loom-width covers with similar design are to be found in the Mevlana Museum in Konya[29] and in the National Museum in Krakov[30], both dated to the first half of the 17th century. One is preserved in the Calouste Gulbenkian Collection in Lisbon, here dated to the 17th century[31]. The carnations on these four variants show a lobed inner element with three flowers and their finials are palm trees.

Technical analysis:
Pattern repeat: Measurements: 61 x 31.5 cm. Construction: vertical point repeat and in quincunxes.

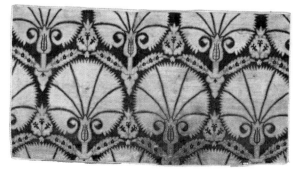

cat. V.2.17

Technical denomination: brocaded cut velvet

Warp. Material and count: Foundation warp: ivory S-spun silk; 84/cm. Pile warp a: crimson S-spun silk; 14/cm. Pile warp b: pistachio green S-spun silk; 14/cm. Proportion: 4 foundation warp threads to 1 pile warp thread a to 2 foundation warp threads to 1 pile warp thread b. Step: 1 tuft by the pile warp. *Weft*: Material and count: A. Foundation weft: paired undyed Z-spun cotton; 20/cm. B. Squeezing weft: ivory silk without apparent twist; 10/cm. C. Supporting weft: ivory silk without apparent twist; 10/cm. D. Brocading weft: wrapped silver metal thread; silver strip wrapped S (*riant*) around an ivory S-spun silk core; 20/cm. E. Pile rods: 10/cm. Proportion: 2 foundation picks to 2 brocading picks to 1 squeezing pick to 1 supporting pick. Sequence: 1 squeezing pick - 1 pile rod - 1 foundation pick - 1 supporting pick - 1 foundation pick (= 1 pass), and in the brocading areas: 1 squeezing pick - 1 pile rod - 2 brocading picks - 1 foundation pick - 1 supporting pick - 1 foundation pick (= 1 pass). Step: 1 pass. *Weave* (cf. article 3, fig. 3 and 4): Foundation fabric: 5-end satin warp face, décochement 3, on the paired foundation picks. Weave of the squeezing weft: 4.1 twill S warp face. Each pick of the squeezing weft is entered before the pile rod in the same satin shed as the foundation pick, which is behind the pile rod. Weave of the supporting weft: 4.1 twill S warp face, with all of the foundation warp threads. Weave of the brocading weft: 4.1 twill S weft face, with 1/3 of the foundation warp threads. Weave of the pile warps: under all the foundation, the squeezing and the brocading picks and above all the supporting picks. In the crimson pile effect: crimson pile warp above the rod, pistachio green pile warp under the pile rod. In the pistachio green pile effect: pistachio green pile warp above the rod, crimson pile warp under the pile rod. In the brocaded effect: under the pile rod.

Composition of the pattern: Ground: crimson cut pile. Pattern: 1. Pistachio green cut pile. 2. Crimson cut pile. 3. Brocaded effect of the silver metal weft.

Selvages: none

Natural dye analysis: cf. article 5, table 3.

Condition: The two fragments are sewn together and lined.

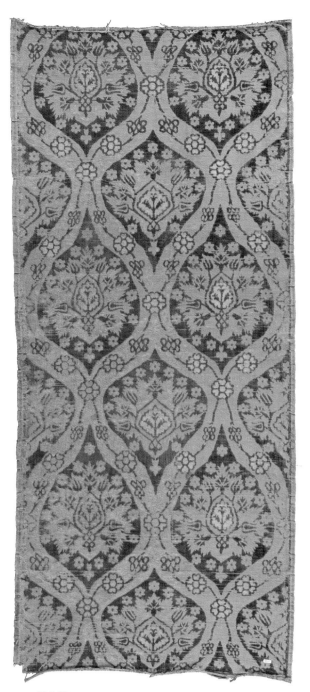

cat. V.2.18

V.2.18.
Length with an ogival lattice and flowers

Date: Second half of the 16th or 17th century

Dimensions: 140 x 62.5 cm (selvages included)

Inv. IS.Tx.1211

Acquisition: Purchased by I. Errera in Istanbul, in 1895 and donated to the museum. Transferred to the Islamic collection in 1996.

Bibliography: ERRERA 1927, cat. 276, p. 249 (defined as "*travail oriental du XVIe siècle*").

On a crimson velvet ground, an ogival lattice is rendered by the voided cream parts decorated with a garland in crimson pile and six-petalled rosettes in silver thread. Each ogival encompasses a serrated leaf, also in cream and surrounded by cream rosettes on a crimson field. The leaves contain a crimson bunch of tulips and carnations around a pomegranate in silver thread with a flower motif in its centre.

An analogue pattern can be found on a length in the Museo Nationale del Bargello in Florence, dated

to the second half of the 16[32] century[32]. Here, a border line runs through the ogival lattice which indicates that the length was part of a sofa cushion or floor cover. Another analogue piece is a length in the Topkapı Palace Museum in Istanbul, dated to the first half of the 17[33] century[33].

The style of these velvets with elegant bunches of finely drawn flowers was introduced by the court workshop, *nakkaçhane,* in the middle of the 16th century. Combined with ogival lattices, it became the most common decoration of silk textiles in the second half of the 16th century, especially of the *lampas* fabrics. Preserved examples prove, moreover, that the style remained popular in the 17th century.

Technical analysis:
 Pattern repeat: Measurements: 46.5 - 48 x 29.5 cm. Construction: vertical point repeat.
 Technical denomination: brocaded voided cut velvet.
 Warp: Material and count: Foundation warp: light yellow S-spun silk; 75/cm. Pile warp: crimson S-spun silk; 12.5/cm. Proportion: 6 foundation warp threads to 1 pile warp thread. Step: 1 tuft. *Weft*: Material and count: A. Foundation weft: paired undyed S-spun cotton; 18/cm. B. Squeezing weft: thin ivory silk without apparent twist; 9/cm. C. Supporting weft: thin ivory silk without apparent twist; 9/cm. D. Brocading weft: wrapped silver metal thread; silver strip wrapped Z (*riant*) around a fourfold white Z-spun silk core; 18/cm. E. Pile rods: 9/cm. Proportion: 2 foundation picks to 2 brocading picks to 1 squeezing pick to 1 supporting pick. Sequence: 1 squeezing pick - 1 pile rod - 1 foundation pick - 1 supporting pick - 1 foundation pick (= 1 pass), and in the brocading areas: 1 squeezing pick - 1 pile rod - 2 brocading picks - 1 foundation pick - 1 supporting pick - 1 foundation pick (= 1 pass). Step: 1 pass. *Weave* (cf. article 3, fig. 1 and 2): Foundation fabric: 5-end satin warp face, décochement 3, on the paired foundation picks. Weave of the squeezing weft: 4.1 twill S warp face. Each pick of the squeezing weft is entered before the pile rod in the same satin shed as the foundation pick, which is behind the pile rod. Weave of the supporting weft: 4.1 twill S warp face, with all of the foundation warp threads. Weave of the brocading weft: 4.1 twill S weft face, with 1/3 of the foundation warp threads. Weave of the pile warp: under all the foundation, the squeezing and the brocading picks and above all the supporting picks. In the pile effect: above the pile rod. In the brocaded and the voided effect: under the pile rod.
 Composition of the pattern: Ground: crimson cut velvet. Pattern: 1. Brocaded effect of the silver metal weft. 2. Cream voided foundation fabric. 3. Crimson cut velvet.
 Selvages: Composition: coarse yellow silk S threads and a few red silk S threads. Width: 1.1 cm. Weave: as the foundation weave, 5-end satin warp

face (foundation picks doubled alternately with a squeezing pick and a supporting pick).

Natural dye analysis: cf. article 5, table 3.

Condition: Poor.

V.2.19.
Length with lobed medallions on ogival stems

Date: First half of the 16th century

Dimensions: 153 x 62 cm (selvages included)

Inv. IS.Tx.1231

Acquisition: Donated by Baron Giulio Francetti of Florence to his niece I. Errera in 1901, lent to the museum and bequeathed in 1929.

Bibliography: ERRERA 1927, cat. 220 C, p. 202 (defined as "*travail oriental du XVIe siècle*"); LAFONTAINE-DOSOGNE 1983, fig. 19 (dated to the 16th century); ATASOY 2001, plate 74 (dated to the first half of the 16th century).

Colour plate on p. 139.

On a ground of brocaded gilded silver thread, lobed medallions are connected by curvilinear ogival stems, all in turquoise green and red velvet pile. The medallions contain either a tulip or a pomegranate in their lobes. From the stems, pomegranates with a palmette in their centre and heart-shaped leaves grow in opposite directions.

An identical piece is preserved in the Museo Nazionale del Bargello in Florence, dated to the end of the 16th or to the 17th century[34], while the same design, but in a different colour combination is found on a length in the Victoria & Albert Museum, dated to the first half of the 16th century[35]. In the latter, the locations of the pile and the metal thread are also switched[36].

This velvet can be compared to the specimen under cat. V.2.9, which also has an Italianate "horizontal" layout, lobed medallions and Indian lac dye. Mexican cochineal is not found here.

Bottom right, an ink stamp mark is visible.

Technical analysis:
 Pattern repeat: Measurements: 110 x 31 cm. Construction: vertical and horizontal point repeat.
 Technical denomination: brocaded cut velvet.
 Warp: Material and count: Foundation warp: light yellow Z-spun silk; 72/cm. Pile warp a: crimson very light S-spun/S-plied silk; 12/cm. Pile warp b: green very light S-spun/S-plied silk; 12/cm. Proportion: 4 foundation warp threads to 1 pile warp thread a to 2 foundation warp threads to 1 pile warp thread b.

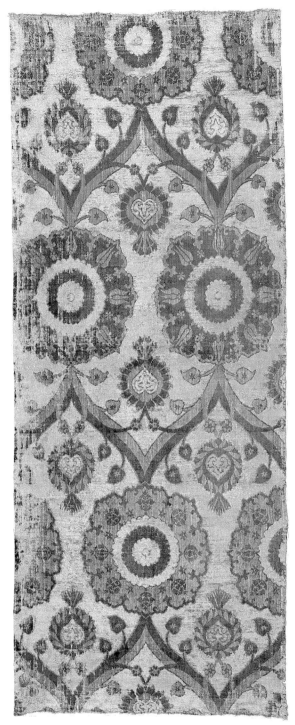

cat. V.2.19

pick. Sequence: 1 squeezing pick - 1 pile rod - 1 foundation pick - 1 supporting pick - 1 foundation pick (= 1 pass), and in the brocading areas: 1 squeezing pick - 1 pile rod - 2 brocading picks - 1 foundation pick - 1 supporting pick - 1 foundation pick (= 1 pass). Step: 1 pass. *Weave* (cf. article 3, fig. 3 and 4): Foundation fabric: 5-end satin warp face, décochement 3, on the paired foundation picks. Weave of the squeezing weft: 4.1 twill S warp face. Each pick of the squeezing weft is entered before the pile rod in the same satin shed as the foundation pick, which is behind the pile rod. Weave of the supporting weft: 4.1 twill S warp face, with all of the foundation warp threads. Weave of the brocading weft: 4.1 twill S weft face, with 1/3 of the foundation warp threads. Weave of the pile warps: under all the foundation, the squeezing and the brocading picks and above all the supporting picks. In the crimson pile effect: crimson pile warp above the rod, green pile warp under the pile rod. In the green pile effect: green pile warp above the rod, crimson pile warp under the pile rod. In the brocaded effect: under the pile rod.

Composition of the pattern: Ground: brocaded effect of the gold metal weft; Pattern: 1. Green cut pile; 2. Red cut pile.

Selvages: Composition: ± 30 paired silk threads. Width: 1 cm. Weave: as the foundation weave, 5-end satin warp face (foundation picks doubled alternately with a squeezing pick and a supporting pick).

Natural dye analysis: cf. article 5, table 3.

Condition: Worn areas. Treated by the Royal Institute for the Cultural Heritage.

Step: 1 red tuft and 1 green tuft. *Weft*: Material and count: A. Foundation weft: paired ivory S-spun schappe silk; 20/cm. B. Squeezing weft: thin ivory silk without apparent twist; 10/cm. C. Supporting weft: thin ivory silk without apparent twist; 10/cm. D. Brocading weft: wrapped gold metal thread; on both sides gilded silver strip wrapped S (*riant*) around a light yellow S-spun silk core; 20/cm. E. Pile rods: 10/cm. Proportion: 2 foundation picks to 2 brocading picks to 1 squeezing pick to 1 supporting

cat. V.2.19 (detail with stamp mark)

With two pattern repeats and with borders (cat. V.2.20-V.2.21)

V.2.20.
Fragmentary two-loom-width cover with date-palms in an ogival lattice and border of star-medallions

Date: 17th century

Dimensions: 1/2 and 2/2: 115 x 65.5 cm (selvages included)

Inv. IS.Tx.1212

Acquisition: Purchased by I. Errera in Istanbul, in 1895 and donated to the museum.

Bibliography: ERRERA 1927, cat. 275, p. 248-249 (defined as "travail oriental du XVIᵉ siècle").

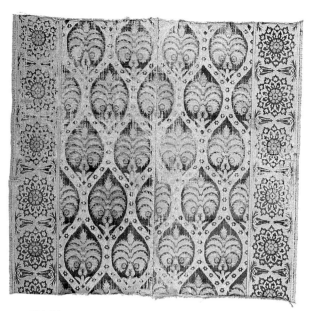

cat. V.2.20

The ogival lattice is rendered by ivory voided parts which also form the ground for the star-medallions in the border. The pattern is further rendered in crimson pile and in silver thread, wrapped around an ivory or a light yellow core. The lattice is decorated with a garland and encompasses stylised palm trees with a trunk resting on a base and a suggestion of fruits in the symmetrical volutes flanking it. Two double vertical lines separate the field from the borders, which show a row of twelve pointed star-medallions separated by two tulips directed towards each other.

An identical pattern in field and borders is to be found in a private collection, dated to the mid-17th century[37]. Similar patterns are otherwise preserved in large numbers, for example in a complete two-loom-width cover dated to the 17th century[38] and confirming the supposed function of our fragments. The design of date-palms within an ogival lattice occurs moreover on two Ottoman silk textiles, sewn respectively to a dalmatic and cope for the Russian Orthodox Church and dateable before 1674[39]. This shows that the design was largely appreciated around that time, even outside the Empire, with the quality of the production depending on the intended function.

Technical analysis:
 Pattern repeat: Measurements: 43.5 x 20.5 cm; borders: 21.75 x 22 cm. Construction: vertical point repeat and in quincunxes; borders: horizontal and vertical point repeat.
 Technical denomination: brocaded voided cut velvet
 Warp: Material and count: Foundation warp: thin ivory silk S-spun; 72/cm. Pile warp: crimson silk S-spun; 12/cm. Proportion: 6 foundation warp threads to 1 pile warp thread. Step: 1 tuft. *Weft*: Material and count: A. Foundation weft: paired undyed Z-spun cotton; 18/cm. B. squeezing weft: ivory thin silk without apparent twist; 9/cm. C. Supporting weft:

ivory thin silk without apparent twist; 9/cm. D. Brocading wefts: wrapped silver metal thread; silver strip wrapped Z (*riant*) around a light yellow silk core without apparent twist; 18/cm. Wrapped silver metal thread; silver strip wrapped Z (*riant*) around an ivory silk core without apparent twist; 18/cm. E. Pile rods: 9/cm. Proportion: 2 foundation picks to 2 brocading picks to 1 squeezing pick to 1 supporting pick. Sequence: 1 squeezing pick - 1 pile rod - 1 foundation pick - 1 supporting pick - 1 foundation pick (= 1 pass), and in the brocading areas: 1 squeezing pick - 1 pile rod - 2 brocading picks - 1 foundation pick - 1 supporting pick - 1 foundation pick (= 1 pass). Step: 1 pass. *Weave* (cf. article 3, fig. 1 and 2): Foundation fabric: 5-end satin warp face, décochement 3, on the paired foundation picks. Weave of the squeezing weft: 4.1 twill S warp face. Each pick of the squeezing weft is entered before the pile rod in the same satin shed as the foundation pick, which is behind the pile rod. Weave of the supporting weft: 4.1 twill S warp face, with all of the foundation warp threads. Weave of the brocading weft: 4.1 twill S weft face, with 1/3 of the foundation warp threads. Weave of the pile warp: under all the foundation, the squeezing and the brocading picks and above all the supporting picks. In the pile effect: above the pile rod. In the brocaded and the voided effect: under the pile rod.

Composition of the pattern: Ground: ivory voided foundation fabric. Pattern: 1. Crimson cut velvet. 2. Brocaded effect of the silver metal weft (light yellow silk core). 3. Brocaded effect of the silver metal weft (ivory silk core).

Selvages: Composition: z-spun/s-plied silk threads. Width: 1.25 cm. Weave: as the foundation weave, 5-end satin warp face (foundation picks doubled alternately with a squeezing pick and a supporting pick).

Natural dye analysis: cf. article 5, table 3.

Condition: Worn.

V.2.21.
Pieced two-loom-width cover with a field of flower sprays and a border of eight-pointed stars

Date: 17th or 18th century

Dimensions: 123 x 105 cm [1/2: 123 x 43 cm (right selvage included); 2/2: 123 x 62 cm (both selvages included)]

Inv. IS.Tx.1215

Acquisition: Purchased by I. Errera in Istanbul in 1900 and donated to the museum.

Bibliography: ERRERA 1927, cat. 320, p. 277 (defined as "*travail oriental du XVIe-XVIIe siècle*").

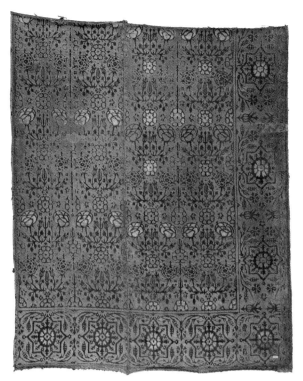
cat. V.2.21

On a yellow ground formed by the voided foundation fabric, the pattern is rendered by the crimson velvet pile with details in brocaded silver thread. The field is filled with rows of stylised flower sprays, only separated by straight vertical stems with eight-lobed rosettes at regular distances. A double line cuts off this field and forms the border with eight-pointed stars and flower motifs.

The flowers on this cover are extremely stylised, often distorted, while their positioning has, as far as is known, no parallels.

Technical analysis:
Measurements: The piece consists of 2 fragments: Piece: 123 x 102 cm. Fragment 1/2: 123 x 43 cm with only one selvage. This fragment has no vertical border. Fragment 2/2: 123 x 62 cm (two selvages included); 41 cm between selvage and vertical border; border: 21.5 cm (selvage included). Between the horizontal border and the end of the fragment: 102.5 cm; border: 20.5 cm. The two fragments are sewn together selvage to selvage, each characterised by 2 green-blue warp threads.
Pattern repeat: Measurements; the repeats of the horizontal borders and of the field are the same in both fragments. However the measurements of the repeats differ somewhat. Horizontal border (left fragment: 2 repeats; right fragment 3 repeats): 20.5 x 20.5 cm. Vertical border (right fragment): 36 x 20.5 cm. Field: (each fragment: 2 repeats in the width and almost 3 repeats in the height): 36 x 20.5 cm. Construction: field: vertical point repeat; borders: vertical and horizontal point repeat.

Technical denomination: brocaded voided cut velvet.

Warp: Material and count: Foundation warp: yellow S-spun silk; 78/cm. Pile warp: crimson S-spun silk; 13/cm. Proportion: 6 foundation warp threads to 1 pile warp thread. Step: 1 tufts. *Weft*: Material and count: A. Foundation weft: paired undyed Z-spun cotton; 16/cm. B. Squeezing weft: thin ivory silk without apparent twist; 8/cm. C. Supporting weft: thin ivory silk without apparent twist; 8/cm. D. Brocading weft: wrapped silver metal thread; silver strip wrapped Z (*riant*) around an ivory silk core without apparent twist; 16/cm. E. Pile rods: 8/cm. Proportion: 2 foundation picks to 2 brocading picks to 1 squeezing pick to 1 supporting pick. Sequence: 1 foundation pick - 1 pile rod - 1 squeezing pick - 1 supporting pick - 1 foundation pick (= 1 pass), and in the brocading areas: 1 foundation pick - 1 pile rod - 2 brocading picks - 1 squeezing pick - 1 supporting pick - 1 foundation pick (= 1 pass). Step: 1 pass. *Remark*: in contrast to the other velvets, the squeezing pick (B) and the foundation pick (A) in this velvet have switched their positions. The squeezing pick is entered after the tufts. *Weave* (cf. article 3, fig. 1 and 2): Foundation fabric: 5-end satin warp face, décochement 3, on the paired foundation picks. Weave of the squeezing weft: 4.1 twill S warp face. Each pick of the squeezing weft is entered after the pile rod in the same satin shed as the foundation pick which is before the pile rod. Weave of the supporting

weft: 4.1 twill S warp face, with all of the foundation warp threads. Weave of the brocading weft: 4.1 twill S weft face, with 1/3 of the foundation warp threads. Weave of the pile warp: under all the foundation, the squeezing and the brocading picks and above all the supporting picks. In the pile effect: above the pile rod. In the brocaded and the voided effect: under the pile rod.

Composition of the pattern: Ground: yellow voided foundation fabric. Pattern: 1. Crimson cut velvet. 2. Brocaded effect of the silver metal weft.

Selvages: Composition: The two selvages sewn together: two green-blue z-spun/s-plied silk threads and a number of coarse ivory z-spun/s-plied silk threads. The other selvage has no green-blue threads. Width: 1 cm. Weave: as the foundation weave, 5-end satin warp face (foundation picks doubled alternately with a squeezing pick and a supporting pick).

Remark about the execution of the fabric on the loom: It may be supposed that originally the left piece had also a border as the right piece. If this was

so the two pieces could be woven one after the other. For weaving the second part, the lashes had to be pulled in the opposite direction. In this way the repeats were inverted. By sewing together the two selvages with green-blue warp threads (on the loom the right selvage), the repeats of the second half are seen in the right direction. Since the pattern of the piece without a border (left piece) has the same direction as the weave direction (the direction of the tufts is opposite to the direction of the pattern) it may be supposed that this piece was woven first. And the piece with the border (right piece; the direction of the tufts is the same as the direction of the pattern) was woven on the same warp by pulling the lashes in the opposite direction (see also: Weave direction, direction of the tufts and location of the squeezing weft, cf. article 3).

Natural dye analysis: cf. article 5, table 3.

Condition: Poor.

With three pattern repeats (cat. V.3.22-V.3.25)

V.3.22.
Two panels of a chasuble with finely drawn tendrils and flowers

Date: Early 16th century

Dimensions: 1/2 and 2/2: 105 x 24 cm

Inv. IS.Tx.664

Acquisition: Exchanged by I. Errera with G. Vermeersch in Brussels and donated to the museum.

Bibliography: ERRERA, 1927, cat. 120, p. 125 (defined as "*travail italien du XVe siècle*").

The two symmetrical panels are shaped like the front of a 16th century chasuble of the so-called Spanish and French type. This type of chasuble was associated with the term *fiddle-back shape,* a reference to the shape of the front panel. The orphrey band is missing here. In the Spanish type it appears both in the back and the front as a mere column or pillar. In the French type only the front is decorated with a column while the back has an orphrey cross[40].

On the fabric, finely drawn tendrils are rendered by the voided crimson foundation fabric and stand out on the deep blue velvet ground. They bear leaves, rosettes and lotus-palmettes, either in silver or gold threads, or in mustard yellow or orange silk threads, brocaded into the fabric.

The delicate vines, flowers and palmettes on this rare velvet fit with those found in the 'international style', a court style with arabesques, lotus flowers and other motifs of Chinese origin which appears also in ceramic tiles, book bindings and illuminations of the 15th century[41]. The Ottoman origin is further confirmed by technical features (see below). Finally, the use of Indian lac dye points to a high-quality velvet.

Technical analysis:

Pattern repeat: Measurements: 24.5 x 20.5 cm. Construction: vertical point repeat.

Technical denomination: brocaded voided cut velvet.

Warp: Material and count: Foundation warp: crimson Z-spun silk; 75/cm. Pile warp: deep blue z-spun/s-plied silk; 12.5/cm. Proportion: 6 foundation warp threads to 1 pile warp thread. Step: 1 tuft.

Weft: Material and count: A. Foundation weft: red silk without apparent twist; 24/cm. B. Squeezing weft: as foundation weft; 12/cm. C. Supporting weft: as foundation weft; 12/cm. D. Brocading weft: wrapped gold metal thread; on both sides gilded silver strip wrapped S (*riant*) around an orange S-spun silk core; 24/cm. Wrapped silver metal thread; silver strip wrapped S (*riant*) around an ivory S-spun silk core; 24/cm. Mustard-yellow silk without apparent twist; 24/cm. White silk without apparent twist; 24/cm. E. Pile rods: 12/cm. Proportion: 2 foundation picks to 2 brocading picks to 1 squeezing pick to 1 supporting pick. Sequence: 1 squeezing pick - 1 pile

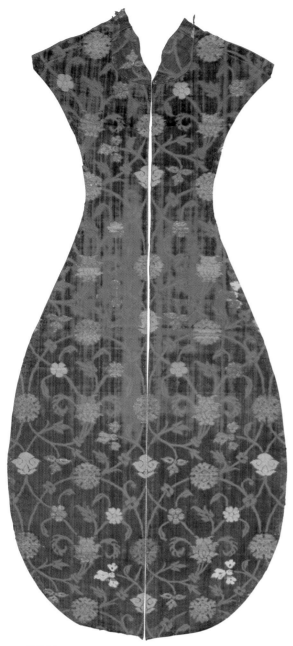

cat. V.3.22

supporting picks. In the pile effect: above the pile rod. In the brocaded and the voided effect: under the pile rod.

Composition of the pattern: Ground: deep-blue cut pile. Pattern: 1. Crimson voided foundation fabric. 2. Brocaded effect of the gold metal weft. 3. Brocaded effect of the silver metal weft. 4. Brocaded effect of the mustard-yellow silk weft. 5. Brocaded effect of the orange silk weft.

Selvages: none.

Natural dye analysis: cf. article 5, table 3.

Condition: Worn areas at the level of the armholes.

V.3.23.
Length with *çintamani* pattern

Date: Second half of the 15th century

Dimensions: 138.5 x 67.6 cm

Inv. IS.Tx.792

Acquisition: Bought by I. Errera from Hakky Bey in Paris in 1897 and donated to the museum.

Bibliography: ERRERA 1927, cat. 137, p. 144 (defined as "*travail oriental du XVe-XVIe, peut-être du XVIIe siècle*"); *Les arts de la soie,* exhibition catalogue, Musées royaux d'Art et d'Histoire, Brussels, 1955, pl. 29 (defined as "*velours d'Asie Mineure. XVIIe siècle*"); LAFONTAINE-DOSOGNE 1983, fig. 18 (dated to the end of the 15th century); ATASOY 2001, fig. 286, p. 298 (dated to the second half of the 15th century).

Colour plate on p. 140.

On a deep crimson velvet ground, only the effect of the brocaded gilded silver thread wefts forms the pattern. This consists of two horizontal rows of staggering motifs: one row with two plain wavy lines, the second with groups of three dots forming a triangle and containing three small red points, alternating with groups of three smaller dots comprising but one point. The force of this almost abstract pattern lies in the balance between the continuing wavy lines and the dots, in alternating size and position.

While there are many variants on the pattern, few are identical[42]. A number of velvets show similar motifs but in a different combination[43]. Often only parts of the pattern occur in isolation[44]. Visually strong designs, such as the one in the Brussels piece –moreover using an exceptionally advanced weaving technique– point to the high quality production for imperial use dated to the second half of the 15th century. This velvet may be linked to those listed in a document of 1483 under the name of *Bursa'nın altınlı benekli çatması*, Bursa fabric with gold dots[45], which at least indicates that dots were woven into velvets with brocaded gold threads in the second half of the 15th century. The use of Armenian cochineal as dye for the crimson velvet ground supports the early dating.

rod - 1 foundation pick - 1 supporting pick - 1 foundation pick (= 1 pass), and in the brocading areas: 1 squeezing pick - 1 pile rod - 2 brocading picks - 1 foundation pick - 1 supporting pick - 1 foundation pick (= 1 pass). Step: 1 pass. *Weave*: Foundation fabric: 5-end satin warp face, décochement 3. Weave of the squeezing weft: 4.1 twill S warp face with all of the foundation warp threads. The squeezing weft and the foundation weft are of the same material. They are entered one in front of the pile rod and the other behind the pile rod. Weave of the supporting weft: 4.1 twill S warp face, with all of the foundation warp threads. Weave of the brocading weft: 4.1 twill S weft face, with 1/3 of the foundation warp threads. Weave of the pile warp: under all the foundation, the squeezing and the brocading picks and above all the

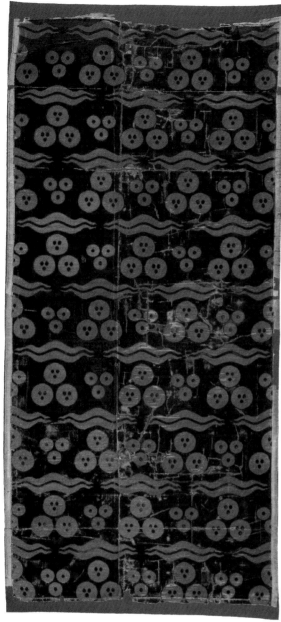

cat. V.3.23

The origin and symbolism of the pattern are far from clear. The motifs are thought to go back to Buddhist China, but there seems to be no real evidence for this assumption[46]. The pair of wavy vines could, however, be associated with tiger stripes[47] and the dots with leopard spots. The pattern may then be interpreted as a sign of power and strength, and its name –literally *auspicious jewel*[48]– shows moreover that it was a token of good luck. These elements explain the popularity of the pattern, not only in textiles but also in ceramic tiles made for public use.

Finally, it is perhaps useful to mention the existence of a small fragment of 15th century Turkish velvet with a *çintamani* pattern in the Gruuthuse-museum of Bruges[49].

Technical analysis:

Pattern repeat: Measurements: 31 x 21.83 cm. Construction: vertical point repeat and in quincunxes.

Technical denomination: brocaded cut velvet

Warp: Material and count: Foundation warp: yellow Z-spun/S-plied silk; 85.5/cm. Pile warp: crimson Z-spun/S-plied silk; 28.5/cm. Proportion: 4 foundation warp threads to 1 pile warp thread to 2 foundation warp threads to 1 pile warp thread = 1 warp unit. Step: 2 tufts. *Weft*: Material and count: A. Foundation weft: ivory silk without apparent twist; 24.8/cm. B. Squeezing weft: as the foundation weft; 12.4/cm. C. Supporting weft: as the foundation weft; 12.4/cm. D. Brocading weft: wrapped gold metal thread; on both sides gilded silver strip wrapped S (*couvert*) around a light yellow Z-spun/S-plied core; 24.8/cm. E. Pile rods: 12.4/cm. *Remark*: the foundation weft appears to be the same material as the squeezing and the supporting weft. But they were not entered by means of only one shuttle. The foundation weft was entered by one shuttle and the squeezing and supporting weft by a second shuttle. Proportion: 2 foundation picks to 2 brocading picks to 1 squeezing pick to 1 supporting pick. Sequence: 1 squeezing pick - 1 pile rod - 1 foundation pick - 1 supporting pick - 1 foundation pick (= 1 pass), and in the brocading areas: 1 squeezing pick - 1 pile rod - 2 brocading picks - 1 foundation pick - 1 supporting pick - 1 foundation pick (= 1 pass). Step: 1 pass. *Weave* (cf. article 3, fig. 7): Foundation fabric: 5-end satin warp face, décochement 3. Weave of the squeezing weft: 4.1 twill S warp face. Each pick of the squeezing weft is entered before the pile rod in the same satin shed as the foundation pick, which is behind the pile rod. Weave of the supporting weft: 4.1 twill S warp face, with all of the foundation warp threads. Weave of the brocading weft: 4.1 twill S weft face, with 1/3 of the foundation warp threads. Weave of the pile warp: under all the foundation, the squeezing and the brocading picks and above all the supporting picks. In the pile effect: above the pile rod. In the brocaded effect: under the pile rod.

Composition of the pattern: Ground: crimson cut pile. Pattern: brocaded effect of the gold metal weft.

Selvages: Composition: 82 paired silk threads. Width: 1.5 cm. Weave: as the foundation weave, 5-end satin warp face (foundation picks doubled alternately with a squeezing pick and a supporting pick).

Remark: The foundation warp count is 12 to 15% higher as the foundation warp count of the velvets with a paired cotton foundation weft. But particularly the count of the tufts is noticeably greater: about 100% in the weft direction en 30% in the warp direction. This piece is a very high quality velvet.

Natural dye analysis: cf. article 5, table 3.

Conservation treatment: cf. article 6.

V.3.24.
Two fragments of a cover with eight-lobed rosettes

Date: 17th century

Dimensions: The two fragments sewn together: 82.5 x 25 cm. 1/2 (border): 22 x 21.5 cm; 2/2: 60.5 x 21.5 cm

Inv. IS.Tx. 806

Acquisition: Purchased by I. Errera from Bacri in Paris in 1901, lent to the museum and bequeathed in 1929.

Bibliography: ERRERA 1927, cat. 271 A, p. 245 (defined as "*travail oriental du XVI^e siècle*" with a reference to MIGEON G., *La collection Kelekian. Étoffes et Tapis d'Orient et de Venise,* Paris, s.d., pl. XCII).

On a crimson velvet ground, the pattern is rendered by the ivory voided foundation fabric with details in blue velvet pile and silver thread in the field, while the border shows an opposite combination. The motifs are similar though, and consist of rows of eight-lobed rosettes with an inner design of carnations, stylised tulips and/or hyacinths and palmettes, radiating around a rosette and with a lobed lozenge between them. A double stripe separated the border from the field.

These fragments come probably from a double-width cover, like the complete one preserved in a private collection[50], possibly even from a four-loom-width cover as the one preserved in the Detroit Museum of Arts[51]. The weaving is of good quality, counting the same comber unit as our *çintamani* velvet. Velvets with similar design were used as altar covers[52] and sewn into copes by the Orthodox Church in Russia[53].

Technical analysis:
Pattern repeat: Measurements: 20.3 x 21.25 cm. Construction: vertical and horizontal point repeat.
Remark: the ground of the half rosette near the selvage is not brocaded.
Technical denomination: brocaded voided cut velvet
Warp: Material and count: Foundation warp: ivory S-spun silk; 90/cm. Pile warp a: crimson S-spun silk; 15/cm. Pile warp b: blue-green S-spun silk; 15/cm. Proportion: 4 foundation warp threads to 1 pile warp thread a to 2 foundation warp threads to 1 pile warp thread b. Step: 1 tuft by the pile warp. *Weft*: Material and count: A. Foundation weft: paired undyed Z-spun cotton; 22/cm. B. Squeezing weft: thin ivory silk without apparent twist; 11/cm. C. Supporting weft: thin ivory silk without apparent twist; 11/cm. D. Brocading weft: wrapped gold metal thread; on both sides gilded silver strip wrapped S (*riant*) around a yellow z-spun/s-plied silk core; 22/cm. Wrapped gold metal thread; on both sides gilded silver strip wrapped S (*riant*) around a light yellow S-spun silk core; 22/cm. E. Pile rods: 11/cm. Proportion: 2 foundation picks to 2 brocading picks to 1 squeezing pick to 1 supporting

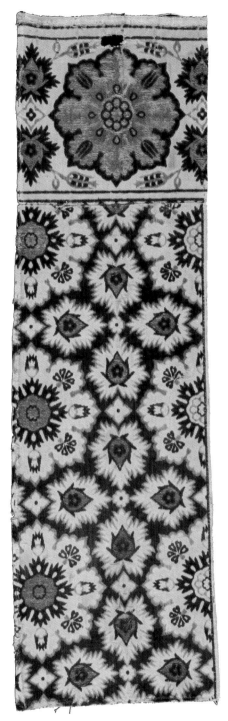

cat. V.3.24

pick. Sequence: 1 squeezing pick - 1 pile rod - 1 foundation pick - 1 supporting pick - 1 foundation pick (= 1 pass), and in the brocading areas: 1 squeezing pick - 1 pile rod - 2 brocading picks - 1 foundation pick - 1 supporting pick - 1 foundation pick (= 1 pass). Step: 1 pass. *Weave* (cf. article 3, fig. 3 and 4): Foundation fabric: 5-end satin warp face, décochement 3, on the paired foundation picks. Weave of the squeezing weft: 4.1 twill S warp face. Each pick of the squeezing weft is entered before the pile rod in the same satin shed

as the foundation pick, which is behind the pile rod. Weave of the supporting weft: 4.1 twill S warp face, with all of the foundation warp threads. Weave of the brocading weft: 4.1 twill S weft face, with 1/3 of the foundation warp threads. Weave of the pile warps: under all the foundation, the squeezing and the brocading picks and above all the supporting picks. In the crimson pile effect: crimson pile warp above the rod, blue-green pile warp under the pile rod. In the blue-green pile effect: blue-green pile warp above the rod, crimson pile warp under the pile rod. In the brocaded and the voided effect: the two pile warps under the pile rod.

Composition of the pattern: Ground: crimson cut pile. Pattern: 1. Ivory voided foundation fabric. 2. Blue-green cut pile. 3. Brocaded effect of the gold metal weft (yellow silk core). 4. Brocaded effect of the gold metal weft (light yellow silk core).

Selvages: fragmentary right selvage. Weave: as the foundation weave, 5-end satin warp face (foundation picks doubled alternately with a squeezing pick and a supporting pick).

Natural dye analysis: cf. article 5, table 3.

Condition: The two fragments are sewn together and in rather good condition.

V.3.25.
Cushion cover (*yastıc yüzü*) with eight-lobed medallions

Date: 17th century

Dimensions: 117.5 x 62.5 cm

Inv. IS.Tx.1205

Acquisition: Purchased by I. Errera in Istanbul in 1900 and donated to the museum.

Bibliography: ERRERA 1927, cat. 271, p. 245 (defined as "*travail oriental du XVIe siècle*").

On a ground of gilded silver thread, four rows of three widely spaced eight-lobed rosettes are rendered in crimson and pistachio green velvet pile. They are decorated with tulips and hyacinths. Between them, carnations are radiantly posed around a rosette. The six lappets at each end contain stylised flowers under a lobed arch.

This cushion cover with a vertical and horizontal symmetry must have been of a good quality with the two-coloured velvet pile and the brocaded gold thread wound either on a yellow or on an ivory silk core.

Technical analysis:
Measurements: between the horizontal borders: 95.5 cm; borders: 10.5 cm. On some places the crimson worn out pile is over painted.

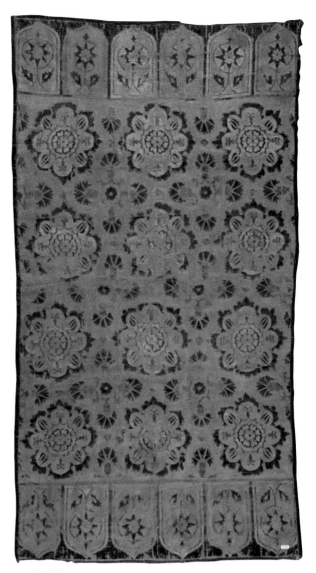

cat. V.3.25

Pattern repeat: Measurements: 21 x 21-21.5 cm; borders: 10.5 x 17 cm. Construction: horizontal and vertical point repeat.

Technical denomination: brocaded cut velvet

Warp: Material and count: Foundation warp: ivory S-spun silk; 84/cm. Pile warp a: crimson light S-spun silk; 14/cm. Pile warp b: green light S-spun silk; 14/cm. Proportion: 4 foundation warp threads to 1 pile warp thread a to 2 foundation warp threads to 1 pile warp thread b. Step: 1 tuft by the pile warp. *Weft*: Material and count: A. Foundation weft: paired undyed Z-spun cotton; 24/cm. B. Squeezing weft: ivory silk without apparent twist; 12/cm. B. Supporting weft: ivory silk without apparent twist; 12/cm. C. Brocading weft: wrapped gold metal thread; on both sides gilded silver strip wrapped S (*riant*) around an ivory S-spun silk core; 24/cm. Wrapped gold metal thread; on both sides gilded silver strip wrapped S (*riant*) around a yellow S-spun

silk core; 24/cm. D. Pile rods: 12/cm. Proportion: 2 foundation picks to 2 brocading picks to 1 squeezing pick to 1 supporting pick. Sequence: 1 squeezing pick - 1 pile rod - 1 foundation pick - 1 supporting pick - 1 foundation pick (= 1 pass), and in the brocading areas: 1 squeezing pick - 1 pile rod - 2 brocading picks - 1 foundation pick - 1 supporting pick - 1 foundation pick (= 1 pass). Step: 1 pass. *Weave* (cf. article 3, fig. 3 and 4): Foundation fabric: 5-end satin warp face, décochement 3, on the paired foundation picks. Weave of the squeezing weft: 4.1 twill S warp face. Each pick of the squeezing weft is entered before the pile rod in the same satin shed as the foundation pick, which is behind the pile rod. Weave of the supporting weft: 4.1 twill S warp face, with all of the foundation warp threads. Weave of the brocading weft: 4.1 twill S weft face, with 1/3 of the foundation warp threads. Weave of the pile warps: under all the foundation, the squeezing and the brocading picks and above all the supporting picks. In the crimson pile effect: crimson pile warp above the rod, green pile warp under the pile rod. In the green pile effect: green pile warp above the rod, red pile warp under the pile rod. In the brocaded effect: under the pile rod.

Composition of the pattern: Ground: brocaded effect of the gold metal weft (yellow silk core). Pattern: 1. Crimson cut pile. 2. Green cut pile. 3. Brocaded effect of the gold metal weft (ivory silk core).

Selvages: no selvages.

Natural dye analysis: cf. article 5, table 3.

Condition: Very poor and machine overstitched. Double lining.

II. *Lampas* fabrics

With inscriptions (cat. L.1.1-L.1.6)

L.1.1.
Fragment of a cenotaph cover

Date: 17th-18th century

Dimensions: 22-25 x 67.5 cm (selvages included)

Inv. IS.Tx.681

Acquisition: Purchased by I. Errera from Hakky-bey in Paris in 1901, lent to the museum and bequeathed in 1929.

Bibliography: ERRERA 1927, cat. 321 A, p. 280-281 (defined as *"travail oriental du XVI^e-XVII^e siècle"*).

On a crimson ground, alternatingly narrow and broad zigzag bands with inscriptions are rendered in ivory and separated by a double line. The pattern is repeated six times in the width, which results in a densely filled composition.

The top narrow band contains *sura* 108 of the Quran[54]:
Verily, We have given you the "Kausar" (Abundance).
So pray to your Lord! and offer sacrifice.
Verily, your enemy shall be the one cut off (in his progeny).

The broad band contains the *shahada* or profession of faith:
There is no god but Allah, and Muhammad is the prophet of Allah.

The second narrow band contains *sura* 112 of the Quran:

Say: He, God, is One (Alone)
God, the Needless (Independent)
He begets not, nor is He Begotten,
And there is none like Him.

The second broad band is fragmentary. It contained the names of Allah and Muhammad above and under a shield-shaped pendant with "Allah".

Identical texts are found on a fragment of a tomb cover in the Keir Collection, dated to the 17th-18th century[55]. However, the form of the letters is slightly different and the ground colour is green instead of red.

The silk is one of the six *lampas* fabrics in the collection with religious texts inscribed in zigzag bands. Fabrics of this type have a funeral function: they cover the coffin when carried to the grave and may be placed on the cenotaph. The inscribed texts do not provide the name of the deceased, nor a date[56], but Quranic verses and pious invocations. Some of these are popular and are combined in different ways, but the *shahada* seems always to be inscribed in the main broad band. The script is in an elegant *thuluth*, although it may be slightly angular like in the smaller bands of this textile, or a bit clumsy and coarser like in the smaller band of the one under cat. L.1.6.

There must have been a specialised production of cenotaph covers, running over a long period of time (from the 16th to the 19th centuries), realised in large

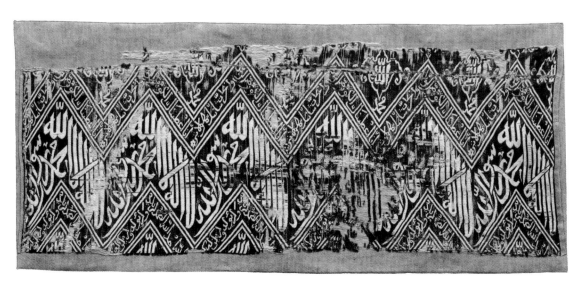

cat. L.1.1

quantities (many have been preserved in western collections) and in diverse qualities (among the six examples studied here, five qualities have been discerned according to the number of colours used and to the weaving technology). At this moment, it is not known where these textiles have been woven.

The use of Armenian cochineal as dye stuff and the irregularity of the weave in this piece points to an early date, possibly even earlier than the 17th-18th century, but further study should confirm this assumption.

Technical analysis:

Pattern repeat: Dimension of pattern: height: not complete. Width: 10.5-11.7 cm. Straight repeat of pattern unit in warp direction. Simple cords needed for pattern unit: 11 x 24: 264 (approximately). 6 pattern repeats in the width. Straight arrangement in weft direction.

Weave structure: *Lampas*. *Warp*: 2 warp systems: Foundation warp: crimson silk: I2S-ply. Binding warp: cream silk: I- twist. Proportion Found/Binding: 3-4/1 (warp unit). Warp step: 3-4 foundation ends (between the binding warps). Count per cm: 25-27 warp units. Selvage: Right selvage: 0.7 cm. Foundation warp: cream silk: S2S-ply. Binding warp: cream silk I-twist. Last 0.3 cm: paired threads. Selvage cord: one group of foundation warps. Left selvage: smaller and no selvage cord. *Weft*: 2 weft systems: Foundation weft: yellow silk: 2-4 Z- twist. Supplementary wefts: Pattern weft: ivory silk: 2-3 Z-twist. Proportion: one pattern weft followed by one foundation weft in the pass. Sequence: opposite weft sequence. Weft step: one pass. Count per cm: 17 passes. *Weaves*: *Lampas* structure. Foundation weave: warp-faced 5-end satin weave, interruption of 2, formed by the ends of the foundation warp and the foundation weft. The latter is also bound in 1/3 Z-twill by the binding warp. Supplementary weave: the pattern weft is bound by the binding warp in 1/3 Z-twill weave and is on the surface as required by the pattern. Selvage: *lampas* structure. The foundation weave is on the surface. Only the foundation weft turns around the selvage cord. The pattern weft is hold by the foundation weft when turning on the edge.

Remarks: a lot of mistakes in the foundation weave. Sometimes 2 to 3 foundation warp threads work together, some are missing.

Natural dye analysis: cf. article 5, table 4.

Condition: Areas of the crimson foundation warp and of the ivory pattern wefts are worn away. Horizontal split on the upper side. Frayed on the upper and lower side, but intact selvages.

Conservation treatment: cf. article 6.

L.1.2.
Two lengths of a cenotaph cover

Date: 18th-19th century

Dimensions: 2 fragments: 1/2: 147 x 69 cm (both selvages included); 2/2: 147 x 69 cm (both selvages included)

Inv. IS.Tx.1216

Acquisition: Purchased by I. Errera in Istanbul in 1894 and donated to the museum.

Bibliography: ERRERA 1927, cat. 321, p. 279-280 (defined as "*travail oriental du XVIe-XVIIe siècle*"). LAFONTAINE-DOSOGNE 1983, fig. 29 (dated to the 18th century).

On a crimson ground, alternatingly narrow and broad zigzag bands with inscriptions are rendered in ivory and separated by two lines of different thickness.

The top narrow border contains the first part of verse 144, *sura* 2, of the Quran:
We see the turning of your face in heaven
so We shall turn you (in prayer) towards a "Qiblah"
you shall be pleased with.
Turn then your face towards the Sacred Mosque.

The top broad band contains the *shahada* or profession of faith:
There is no god but Allah, and Muhammad is the prophet of Allah.

The second narrow border contains the pious invocation:
Praise the Lord and glorify Him
Praise the Lord, the Mighty.

The second broad border contains shield-shaped pendants, alternatingly disposed in the opposite direction and containing the words:
Oh Benefactor. Oh Compassionate.
And in circular medallions:
Oh Praise. Oh Authority.

The Quranic text concerns the *Qiblah*-direction, toward which Muslims turn themselves during their prayers and toward which also the head of the deceased is turned when he is buried.

This version of a cenotaph cover must have been woven in extra large quantities. A number of specimens has been preserved, of which at least four show an identical pattern and are, relying on photographs, in rather good condition. They are dated between the 16th and 18th centuries[57]. Three other specimens, also with an identical pattern, show additional specific features: one piece is very worn[58], two others are seamed[59] and finally one is converted to a (magical?) garment[60].

The technical analysis shows that the fabric under consideration here is very regularly woven and compact. This suggests a late date, possibly even in the

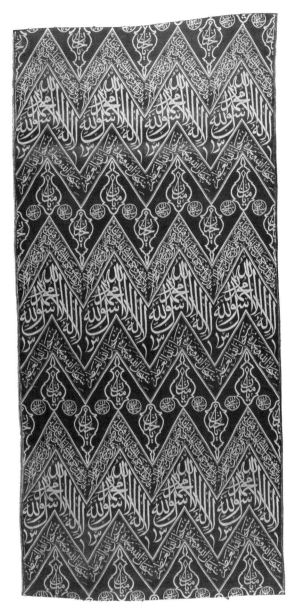
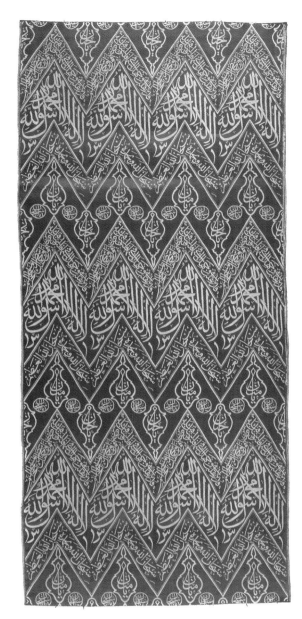

cat. L.1.2

19th century, but future analysis of the other speci-
mens should confirm this assumption.

Technical analysis:

Pattern repeat: Dimension of pattern: height:
48 cm. Width: 17 cm. Straight repeat of pattern unit
in warp direction. Simple cords needed for pattern
unit: 17 x 23: 390 approximately. Counted: 400 warp
units. 4 pattern repeats in the width. Straight arrange-
ment in weft direction.

Weave structure: *Lampas. Warp*: 2 warp systems:
Foundation warp: crimson silk: I2S-ply. Binding
warp: ivory silk: I-twist. Proportion Found/Binding:
5/1 (warp unit). Warp step: 5 foundation ends
(between the binding warp threads). Count per cm:
23 warp units (regular). Selvage: right selvage:
0.7 cm. Foundation warp: 25 crimson silk threads: S-

twist. Binding warp: 5 ivory silk threads: I-twist.
Selvage cords: 2 silk cords: S3Z-ply. Left selvage:
0.9 cm. Foundation warp: 55 crimson silk threads: S-
twist. Binding warp: 11 ivory silk threads: I-twist.
Selvage cords: 2 silk cords: S3Z-ply. *Weft*: 2 weft sys-
tems: Foundation weft: crimson silk: I-twist.
Supplementary wefts: Pattern weft: 1: ivory silk: 3 I-
twist. Proportion: one pattern weft followed by one
foundation weft in the pass. Sequence: opposite weft
sequence. Weft step: one pass. Count per cm: 23
passes. *Weaves*: *Lampas* structure. Foundation weave:
warp-faced 5-end satin weave, interruption of 2,
formed by the ends of the foundation warp and the
foundation weft. The binding warp and the founda-
tion weft are bound in tabby. Supplementary weave:
the binding warp binds the pattern weft in tabby. The
pattern weft is on the surface as required by the pat-

tern. Selvage: *lampas* structure. Foundation weave on the surface.

Remarks: near the selvage the thread count does not change. The selvage has a loose structure probably caused by the use of a temple to maintain a constant width.

Natural dye analysis: cf. article 5, table 4.

Condition: Good. The two lengths were sewn together until 1978 when the pieces were separated and treated in the Royal Institute for the Cultural Heritage in Brussels.

L.1.3.
Fragment of cenotaph cover

Date: 17th-18th century

Dimensions: 79.5 x 75 cm (right selvage preserved)

Inv. IS.Tx.1217

Acquisition: Purchased by I. Errera in Istanbul in 1895 and donated to the museum.

Bibliography: ERRERA 1927, cat. 322, p. 281-282 (defined as *"travail oriental du XVI^e-XVII^e siècle"*).

On a green ground, alternatingly narrow and broad zigzag bands with inscriptions are rendered in ivory and separated by a double line. The pattern is widely spaced and, even if the original width is not known because the left selvage is not preserved, it must have been wide considering the actual size of the fabric.

The top narrow band contains verse 56, *sura* 33 of the Quran:
Verily God and His angels bless the prophet!
Oh you who believe! Send blessings on him
And greet him with salutation worthy of the respect (due to him).

The top broad band contains the pious invocation:
Allah there is none but Allah.

The second narrow band contains the second part of verse 88, *sura* 28, of the Quran:
All things are perishable but He (His face)
He is the Authority, and to Him shall you be returned.

The second broad band contains the prayer:
Oh God, bless and give peace to
Their nobilities all the prophets and missionaries[61].

The third narrow band contains *sura* 112 of the Quran:
Say: "He, God, is One (Alone)
God, the Needless (Independent)
He begets not, nor is He begotten,
And there is none like Him.

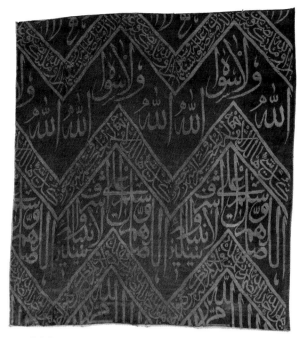

cat. L.1.3

This textile, as well as the one under cat. L.1.4, belongs to a group of white on green cenotaph covers with similar patterns and texts, but in different combinations, all dated to the 17th or 18th century[62]. For the function of these fabrics, see under cat. L.1.1.

Technical analysis:
Pattern repeat: Dimension of pattern: height: not complete. Width: 30-31 cm. Straight repeat of pattern unit in warp direction. Simple cords needed for pattern unit: 30 x 19: 570 approximately. Counted: 560 warp units. Probably 3 pattern repeats in the width (90 cm?). Straight arrangement in weft direction.
Weave structure: *Lampas. Warp:* 2 warp systems: Foundation warp: green silk: I2S-ply. Binding warp: cream silk: 2 S-twist. Proportion Found/Binding: 5/1 (warp unit). Warp step: 5 foundation ends (between 2 binding warp threads). Count per cm: 19 warp units (regular). Selvage: right selvage: 0.6 cm (12 warp units). Foundation warp: green silk: I2S-ply. Binding warp: cream silk: 2 S-twist. Selvage cords: 4 cords. Each cord consists of a group (10-15) of green silk threads. Only 2 out of the 4 cords are visible at the front side. *Weft:* 2 weft systems: Foundation weft: green silk: 2 I-twist (0.3-0.4 mm). Supplementary wefts: Pattern weft: ivory silk: 5 I-twist (0.5-0.6 mm). Proportion: one pattern weft followed by one foundation weft in the pass. Sequence: opposite weft sequence. Weft step: one pass. Count per cm: 12-14 one passes. *Weaves: Lampas* structure. Foundation weave: warp-faced 5-end satin weave, interruption of 2, formed by the ends of the foundation warp and the foundation weft. The latter is also bound in 1/3 S-twill weave by the binding warp. Supplementary weave:

Catalogue

the binding warp binds the pattern weft in 1/3 S-twill weave. The pattern weft is on the surface as required by the pattern. Selvage: *lampas* structure. The foundation weave is on the surface. The 4 selvage cords, acting as binding warp ends, are bound by the foundation weft and the pattern weft in 1/3 S-twill.

Natural dye analysis: cf. article 5, table 4.

Condition: Good. Treated by the Royal Institute for the Cultural Heritage in Brussels in 1979.

L.1.4.
Fragment of cenotaph cover

Date: 17th-18th century

Dimensions: 70 x 67 cm (both selvages included)

Inv. IS.Tx.1218

Acquisition: Purchased by I. Errera in Istanbul in 1895 and donated to the museum.

Bibliography: ERRERA 1927, cat. 323, p. 282 (defined as "*travail oriental du XVIᵉ-XVIIᵉ siècle*").

On a green ground, alternating broad and narrow bands with inscriptions are rendered in ivory and separated by a double line.

The top broad band contains the pious invocation:
Allah there is none but He
Muhammad
Under the name of *Allah: your Master*
Under and above the name of *Muhammad: beloved by Allah.*

The top narrow band contains the prayer:
Oh God, bless and give peace to their nobilities
All the prophets and missionaries.

The second broad band contains the prayer:
Blessing and peace upon you
The prophet of God[63].

The last narrow band contains the prayer:
May God be pleased with Abu Bakr and 'Umar and 'Uthmân
And 'Alî and with all the other companions [of the prophet][64].

This textile belongs to the same group as the one under cat. L.1.3.

Technical analysis:
Pattern repeat: Dimension of pattern: height: 58 cm. Width: 33.3 cm. Straight repeat of pattern unit in warp direction. Simple cords needed for pattern unit: 33.3 x 18: 600 approximately. Counted: 600

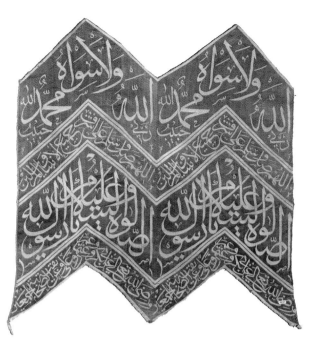

cat. L.1.4

warp units. 2 pattern repeats in the width. Straight arrangement in weft direction.

Weave structure: *Lampas. Warp*: 2 warp systems: Foundation warp: green silk: I2S-ply (0.1 mm). Binding warp: green silk: I-twist. Proportion Found/Binding: 5/1 (warp unit). Warp step: 5 foundation ends (between 2 binding warp threads). Count per cm: 18 warp units (very regular). Selvage: right and left selvage: 0.2 cm. Foundation warp: 15 threads of green silk: I2S-ply. Binding warp: none. Selvage cords: 2 cords of S3Z-ply silk. *Weft*: 2 weft systems: Foundation weft: green silk: 2 I-twist (0.4-0.5 mm). Supplementary wefts: Pattern weft: ivory silk: 3 I-twist (0.5-0.6 mm). Proportion: one pattern weft followed by one foundation weft in the pass. Sequence: opposite weft sequence. Weft step: one pass. Count per cm: 20 passes. *Weaves: Lampas* structure. Foundation weave: warp-faced 5-end satin weave, interruption of 2, formed by the ends of the foundation warp and the foundation weft. The latter is also bound in tabby weave by the binding warp. Supplementary weave: the binding warp binds the pattern weft in tabby weave. The pattern weft is on the surface as required by the pattern. Selvage: warp-faced 5-end satin weave, interruption of 2, formed of 15 foundation warp ends and the foundation weft. The pattern weft threads float under these 15 foundation warp ends and are bound, together with the foundation weft ends, in tabby weave by the 2 selvage cords.

Remarks: the 2 selvage cords are acting as binding warp ends.

Natural dye analysis: cf. article 5, table 4.

Condition: Good, but the cutting out of the pattern is disturbing.

L.1.5.
Fragment of cenotaph cover

Date: 17th century

Dimension: 59 x 73.8 cm (both selvages included)

Inv. IS.Tx.1219

Acquisition: Purchased by I. Errera from S. Baron in Paris in 1901 and donated to the museum.

Bibliography: ERRERA 1927, cat. 265 A, p. 241 (defined as *"travail oriental du XVIᵉ siècle"*).

On a mustard ground, the pattern of alternatingly broad and narrow bands with inscriptions and separated by double lines, is rendered by ivory and crimson silk threads, and by brocaded gilded silver threads wound around a yellow core and accompanied by a yellow brocading weft. There is a hierarchy in the choice of the materials used: the gold threads are reserved for the names of Allah and Muhammad in the main broad band and they are outlined in crimson, the *shabada* in the second broad band is written with ivory letters outlined in crimson, while the texts in the small bands are simply written in ivory.

The top broad band thus contains the *shabada,* the second broad one the names of Allah and Muhammad.

The top small band contains the prayer:
And may God be pleased with Abu Bakr and 'Umar and 'Utbmân
and 'Alî and with all the other companions [of the prophet].

The second small band contains a part of verse 40, *sura* 33, of the Quran:
Muhammad is not the father of any of your men, but A Messenger of God and the Seal of the Prophets.

This silk is similar to the one preserved in the Victoria & Albert Museum, dated to the 17th century[65], concerning both the pattern and the use of more than two colours. The piece in Brussels is of a better quality though, with its gold thread letters and an excellent calligraphy, brightened up by small ivory flowers with a red heart.

These elements and the use of Armenian cochineal as dye stuff for the crimson parts, points to an early date –probably 17th century, possibly even earlier.

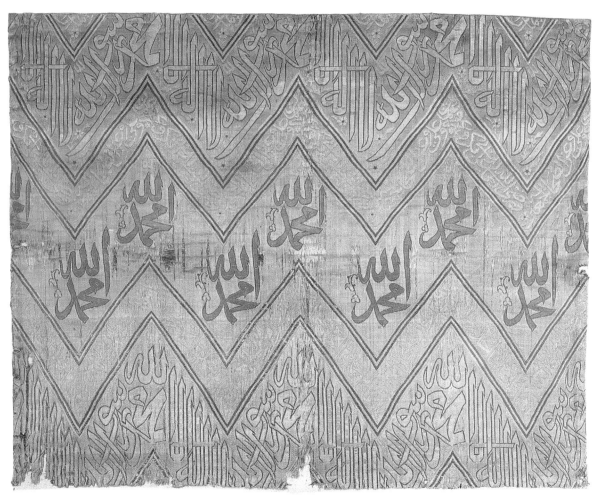

cat. L.1.5

Technical analysis:

Pattern repeat: Dimension of pattern: height: not complete. Width: 19 cm. Straight repeat of pattern unit in warp direction. Simple cords needed for pattern unit: 19 x 22: 418 approximately. Counted: 427 warp units. 4 pattern repeats in the width. Straight arrangement in weft direction.

Weave structure: *Lampas. Warp:* 2 warp systems: Foundation warp: mustard silk: S-twist. Binding warp: cream silk: Z-twist. Proportion Found/Binding: 3-4/1 (warp unit). Warp step: 3-4 foundation ends (between 2 binding warp threads). Count per cm: 22 warp units. Selvages: right (0.8 cm) and left (1 cm) selvage. Foundation warp: mustard silk: S-twist. Binding warp: cream silk: 2 Z-twist. Selvage cords: none. *Weft:* 2 weft systems: Foundation weft: mustard silk: 3 Z-twist. Supplementary wefts: Pattern wefts: Crimson silk: 3-4 Z-twist. Constantly used. Ivory silk: 3-4 Z-twist. Constantly used. Yellow silk: 2 thin Z-twist threads accompany the brocading metal thread. Intermittently used. Brocading weft: metal thread: gilded silver strip loosely wrapped in S around yellow silk core (S-twist). Intermittently used. Proportion: one foundation weft, 3 pattern wefts (one intermittently used) and the brocading metal thread weft make up one weft pass. Sequence: opposite weft sequence. According to the pattern, the first weft in the pass is the intermittent brocading metal thread weft, followed by the accompanying yellow weft, the ivory weft and the crimson weft. The metal thread and the accompanying yellow weft are absent when not needed in the pattern. The final weft in the pass is always the foundation weft. Weft step: one pass. Count per cm: varied. Areas with metal thread and in the middle: 22-26 passes, without metal threads and the lower end: 19 passes. *Weaves: Lampas* structure. Foundation weave: warp-faced 5-end satin weave, interruption of 1, formed by the foundation warp and the foundation weft. The latter is also bound in 1/3 Z-twill weave by the bindingwarp. Supplementary weave: the binding warp binds the supplementary wefts in 1/3 Z-twill. These supplementary wefts are on the surface as required by the pattern. Selvage: *lampas* structure. Foundation weave on the surface.

Natural dye analysis: cf. article 5, table 4.

Condition: The textile is worn, especially in the middle parts, vertically and horizontally. This lets us suppose that it has been folded once. It has been treated by the Royal Institute for the Cultural Heritage in Brussels, in 1979, and fixed on a linen support with the selvages turned down.

L.1.6.
Fragment of a cenotaph cover

Date: 17th century

Dimension: Height right: 79 cm, left: 12.7 cm; Width: 79 cm (both selvages preserved)

Inv. IS.Tx.1228

Acquisition: Purchased by I. Errera from Hakky-bey in Paris in 1899 and donated to the museum.

Bibliography: ERRERA 1927, cat. 265, p. 240-241 (defined as "*travail oriental du XVI*ᵉ *siècle*").

On a green ground, the pattern of alternatingly broad and narrow bands with inscriptions and separated by three lines is rendered by ivory and crimson silk threads and by brocaded paired gilded silver wires accompanied by yellow silk threads. As in the fragment cat. L.1.4, the names of Allah and Muhammad are rendered in gold, the *shahada* in white outlined with crimson and the texts in the small bands simply in ivory.

The top narrow band contains the prayer:
And may God be pleased with Abu Bakr and 'Umar and 'Uthmân
And 'Alî and with all the other companions [of the prophet].

The second small band contains verse 56, *sura* 33 of the Quran:
Verily, God and His angels bless the Prophet!
Oh you who believe! Send blessings on him
And greet him with salutations worthy of respect (due to him).

This textile has a rather coarse appearance and the calligraphy is clumsy and contracted. Armenian

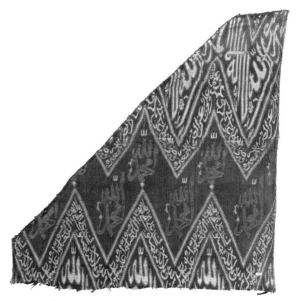

cat. L.1.6

cochineal is used as dye for the crimson parts, which points to an early date, possibly even earlier than the 17th century. The use of gold wire is further unknown in Ottoman textiles, but for the rest this silk is a normal *lampas* like the other ones of this group with inscriptions.

Technical analysis:

Pattern repeat: Dimension of pattern: height: not complete. Width: 20.5 cm. Straight repeat of pattern unit in warp direction. Simple cords needed for pattern unit: 20 x 16: 320 approximately. 4 pattern repeat in the width. Straight arrangement in weft direction.

Weave structure: *Lampas*. *Warp*: 2 warp systems: Foundation warp: green silk: Z-twist (sometimes S-twist), paired. Binding warp: cream silk: Z- and S-twist, paired or plied. Proportion Found/Binding: 3-4/1 (warp unit). Warp step: 3-4 foundation ends (between 2 binding warp ends). Count per cm: 16 warp units. Selvage: right and left selvage: 0.4 cm. Foundation warp: right 10 green silk followed by cream silk 2 Z-twist; left: 2 green silk followed by cream silk 2 Z-twist. Binding warp: paired cream silk Z-twist. Selvage cords: none. *Weft*: 2 weft systems: Foundation weft: green silk: 2 S-twist. Supplementary wefts: Pattern wefts: crimson silk: 5 S-twist. Constantly used; ivory silk: 5 Z-twist. Constantly used;

yellow silk: I2Z-ply thread accompanies the brocading metal thread. Intermittently used. Brocading weft: metal thread: paired gilded silver wire. Intermittently used. Proportion: one foundation weft, 3 pattern wefts (one intermittently used) and the brocading metal thread weft make up one weft pass. Sequence: opposite weft sequence. According to the pattern, the first weft in the pass is the brocading metal thread weft, followed by the accompanying yellow weft, the ivory and the crimson weft. The metal thread and the accompanying yellow weft are intermittent when not needed in the pattern. The final weft in the pass is the foundation weft. Weft step: 1 pass. Count per cm: varied from 7 passes (bottom) to 13 passes (middle). *Weaves*: *Lampas* structure. Foundation weave: warp-faced 5-end satin weave, interruption of 2, formed by the foundation warp and the foundation weft. The latter is also bound in 1/3 S-twill weave by the binding warp. Supplementary weave: the binding warp binds the supplementary wefts in 1/3 S-twill. These supplementary wefts are on the surface as required by the pattern. Selvage: *lampas* structure. Foundation weave on the surface.

Natural dye analysis: cf. article 5, table 4.

Condition: Good but soiled.

With various patterns (cat. L.2.7-L.2.16)

L.2.7.
Fragment with finely drawn tendrils and flowers in an ogival layout

Date: End of the 15th or early 16th century

Dimensions: 36 x 25.5 cm (right selvage preserved)

Inv. IS.Tx.660

Acquisition: Purchased by I. Errera from Ricard in Frankfurt a/Main, in 1912, lent to the museum and bequeathed in 1929.

Bibliography: ERRERA 1927, cat. 102 A, p. 113 (defined as *"travail persan du XVe siècle"*). LAFONTAINE-DOSOGNE 1983, fig. 26 (origin situated in Turkey (?) and dated to the 16th or 17th century).

On a green ground, curved split-palmettes linked at their interstices by rosettes form an ogival lattice which is filled with a palmette surrounded by finely drawn arabesques bearing rosettes and lotus flowers. The ogival lattice, palmettes and rosettes are rendered by brocaded silver thread accompanied with an ivory silk thread, while the tendrils and lotus flowers are in black silk threads. Black silk is also used for outlining the palmettes and flowers.

The small-scale design with arabesques, lotus flowers and palmettes fits in the "international style", in use at the Ottoman court in the late 15th and early 16th centuries. This "international style" shows strong Iranian Timurid influences in addition to Chinese[66]. For this reason the origin of this textile has been situated in Iran in the past, but technical features confirm the Ottoman origin.

Other fragments with this pattern have been labelled Iranian too. One is found in the Metropolitan Museum of Art in New York, dated to the end of the 15th century; one is preserved in the Museum Poldi Pezzoli in Milan, dated here to the second half of the 16th century and one more in the State Hermitage in Leningrad, dated to the first half of the 15th century[67]. In Germany, four fragments with a similar pattern have been preserved, but at least one of them has gold thread instead of silver thread; these are also said to come from Iran and are dated to the end of the 15th or the early 16th century[68].

A similar pattern with finely drawn arabesques exemplifying the "international style" is to be found on a *kiswa* band in the Topkapı Palace Museum in Istanbul, dated to the early 16th century[69].

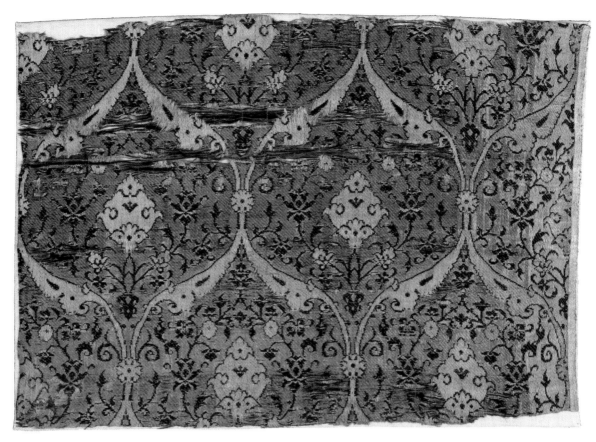

cat. L.2.7

Technical analysis:

Pattern repeat: Dimension of pattern: height: 20 cm. Width: 14.5 cm. Reverse repeat of pattern unit in warp direction. Simple cords needed for pattern unit: 7.25 x 19: 138 approximately. Counted: 135 warp units per pattern unit. Straight arrangement in weft direction.

Weave structure: *Lampas*. *Warp*: 2 warp systems: Foundation warp: pale green silk: Z-twist (0.1-0.13 mm). Binding warp: cream silk: S- or Z-twist (0.2 mm). Proportion Found/Binding: 5/1, sometimes 4/1 and 6/1. Warp step: warps between 2 binding warp ends (4, 5 or 6). Count per cm: variable, 18-20 warp units. Higher density at selvage (30 w. units). Selvage: right selvage: 0.5 cm. Foundation warp: cream silk: Z-twist. Closely packed together. Binding warp: cream silk: 1 Z- and 1 S-twist thread together. Selvage cords: none. *Weft*: 2 weft systems: Foundation weft: pale green or blue-green silk: 3 I-twist (0.5 mm). Supplementary wefts: Pattern wefts: black silk: 2 I-twist (0.5 mm). Constantly used. Ivory silk: Z-twist thread accompanies the brocading metal thread. Constantly used. Brocading weft: metal thread: fine silver strip wrapped in S- around a white silk (2S) core. Constantly used. Proportion: one foundation weft, 2 pattern wefts and the brocading weft make up one pass. Sequence: opposite weft sequence. The brocading metal thread is first in the pass, followed by the ivory weft and the black weft. The foundation weft is the final pick of the pass. Weft step: one pass. Count per cm: 19-22 passes. *Weave*:

Lampas structure. Foundation weave: warp-faced 5-end satin weave, interruption of 2, formed by the foundation warp and the foundation weft. The latter is also bound in 1/3 S-twill weave by the binding warp. Supplementary weave: the pattern wefts and the brocading weft are bound by the binding warp in 1/3 S-twill and appear at the surface as required by the pattern. Selvage: *lampas* structure. The foundation weave is on the surface.

Condition: Worn. Treated by the Royal Institute for the Cultural Heritage in Brussels in 1978.

L.2.8.
Two fragments of length with ogival lattice

Date: Second half of the 16th century

Dimensions: 1/2: 27.8 x 22 cm (left selvage preserved); 2/2: 27 x 21 cm

Inv. IS.Tx.758

Acquisition: Bequeathed by G. Vermeersch, in 1911.

Bibliography: ERRERA 1927, cat. 213 C, p. 196 (defined as *"travail oriental du XV^e-XVI^e siècle*).

On a crimson ground, a decorated ogival lattice containing lobed medallions with a bunch of flowers

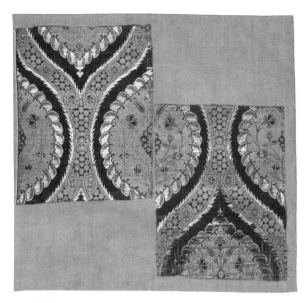

cat. L.2.8

in their centre, is rendered in pale green, blue, white and crimson silk thread and in brocading gilded silver threads prominently present in the lattice and medallions. The gold thread is wrapped around a yellow silk core and accompanied by equally yellow silk threads, which must have originally given a shimmering and golden effect to this silk. Moreover, blue touches on the white lobes of the medallions suggest shade and find their counterbalance in the white dentate edge of the ogivals.

This is a quality *kemha,* a typical example of the production of luxury silks with the new designs standardised in the imperial workshop, *nakkaçhane,* in the middle of the 16th century and flowering in the second half of the 16th century.

Technical analysis:
Pattern repeat: Dimension of pattern: height: not complete. Width: 22 cm. Reverse repeat of pattern unit in warp direction (11x11). Simple cords needed for pattern unit: 11 x 26: 290 (approximately). Straight arrangement in weft direction.
Weave structure: *Lampas. Warp:* 2 warp systems: Foundation warp: crimson silk: I2S-ply. Binding warp: cream silk: I2Z-ply. Proportion Found/Binding: 3-4/1 (warp unit). Warp step: 3-4 foundation ends (between 2 binding warp threads). Count per cm: A: left selvage: 30 warp units and right side: 26 warp units. B: left: 27 warp units and right: 26 warp units. Selvage: Left selvage: 0.3 cm. Foundation warp: crimson S-ply silk followed by 15 warp units of cream and yellow silk: Z-twist. Binding warp: 15 paired silk threads: Z-twist. No selvage cords. *Weft:* 2 weft systems: Foundation weft: scarlet silk: 2 I-twist. Supplementary wefts: Pattern wefts: pale green silk: I-twist. Intermittently used. White silk: 2 I-twist (0.4 mm). Constantly used. Blue silk: 2 I-twist. Constantly used. Yellow silk: thin thread:

S-twist, accompanies the brocading metal thread. Constantly used. Brocading weft: metal thread: gilded silver strip loosely wrapped in S around a yellow silk core (S-twist). Constantly used. Proportion: one foundation weft, 4 pattern wefts, of which one is intermittently used, and the brocading weft makes up one weft pass. Sequence: opposite weft sequence. The brocading metal thread is the first weft in the pass, followed by the yellow accompanying weft, the blue silk weft, the white silk weft and, according to the pattern, the intermittent pale green silk. The final weft in the pass is the foundation weft. Weft step: 1 pass. Count per cm: A and B: 16-17 passes. *Weave: Lampas* structure. Foundation weave: warp-faced 5-end satin weave, interruption of 2, formed by the foundation warp and the foundation weft. The latter is also bound in 1/3 Z- twill weave by the binding warp. Supplementary weave: the pattern wefts and the brocading weft are bound in 1/3 Z- twill weave by the binding warp and are on the surface as required by the pattern. Selvage: *lampas* structure. The foundation weave is on the surface.

Remarks: two vertical red lines in the pattern unit can be seen in piece 1/2. These lines does not appear in piece 2/2.

Natural dye analysis: cf. article 5, table 4.

Conservation treatment: cf. article 6.

L.2.9.
Fragmentary length with leaves on undulating stems

Date: Second half of the 16th or early 17th century

Dimensions: 114.5 x 45 cm (left selvage preserved)

Inv. IS.Tx.807

Acquisition: Lent by I. Errera and bequeathed in 1929.

Bibliography: ERRERA 1927, cat. 277 B, p. 250 (defined as *"travail oriental du XVIe siècle"*). LAFONTAINE-DOSOGNE 1983, fig. 27 b (dated to the 17th century).

Colour plate on p. 141.

On a crimson ground, great serrated leaves on undulating stems are rendered in ivory, turquoise and crimson silk and in brocaded gilded silver threads for the core of the leaves. They are decorated with a garland. From the stems grow tendrils with smaller leaves and flowers.

This is a rather coarse execution of an otherwise beautiful layout with *saz*-leaves on parallel undulating vines creating an impression of motion[70].

Technical analysis:
Pattern repeat: dimension of pattern: height: 69.5 cm. Width: 22.5 cm. Straight repeat of pattern unit in warp direction. Simple cords needed for pat-

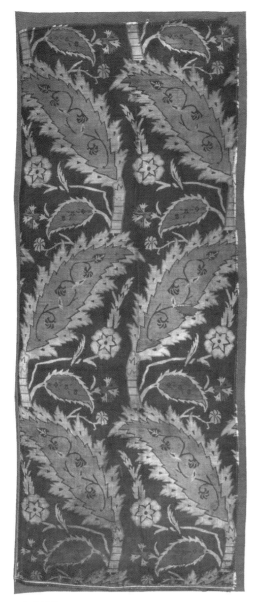

cat. L.2.9

(S2S). Intermittently used. Proportion: one foundation weft, one pattern weft (ivory), one of the latté pattern wefts and the brocading metal weft make up one pass. Sequence: opposite weft sequence. The brocading metal thread is the first weft in the pass, followed by the accompanying yellow weft, the ivory weft and finally the foundation weft. When metal threads are not needed, instead of the yellow weft, the turquoise weft (latté) is the first weft followed by the ivory weft and finally the foundation weft. Weft step: one pass. Count per cm: 17 passes. *Weave*: *Lampas* structure. Foundation weave: warp-face 5-end satin weave, interruption of 2, formed by the foundation warp and the foundation weft. The binding warp binds the foundation weft in 1/3 Z-twill weave. Supplementary weave: the binding warp binds the pattern wefts and the brocading weft in 1/3 Z-twill. The supplementary wefts are on the surface as required by the pattern. Selvage: *lampas* structure. Foundation weave is on the surface.

Remarks: at the bottom of the fabric a red/ivory striped starting (?) border remain. 1. Ivory weft binds the binding warp in 3/1 Z-twill. The foundation warp floats. 2. Crimson weft binds the foundation warp in warp face 5 ends satin. These stripes are repeated 3 times.

Natural dye analysis: cf. article 5, table 4.

Conservation treatment: cf. article 6.

L.2.10.
Parts of a sleeve (?) with decorated ogival lattice and lobed medallions

Date: First half of the 17th century

Inv. IS.Tx.808

Dimensions: 2 parts composed of several fragments. 1/2: 3 pieces: 60 x 14.5 cm (one piece with right selvage); 2/2: 2 pieces: 57 x 16 cm (one piece with left selvage)

Acquisition: Purchased by I. Errera from Bacri in Paris, in 1903, lent and bequeathed to the museum in 1929.

Bibliography: ERRERA 1927, cat. 277 A, p. 250 (defined as *"travail oriental du XVIe siècle"*).

The two parts are on their turn composed of respectively three and two fragments, originating from the same fabric and sewn, probably in order to form the sleeve of a garment. The photograph in the catalogue of I. Errera (1929) shows these two parts sewn together. It is not known when this seam has been undone, the textile has not been treated at least since 1973.

The ground of the fabric is formed by brocaded wefts of gilded silver thread around a yellow silk core and accompanied by an equally yellow silk thread.

tern unit: 22.5 x 11.5: 260 (approximately). Straight arrangement in weft direction.

Weave structure: *Lampas*. *Warp*: 2 warp systems: Foundation warp: crimson silk: I2S-ply. Binding warp: cream silk: I2Z-ply. Proportion Found/Binding: 4/1 (1 warp unit). Warp step: 2 x 4 foundation ends. Count per cm: 23 warp units. Selvage: left selvage: 0.5 cm. Foundation warp: yellow and red silk: S-twist. Last thread: 2 S-twist. Binding warp: cream silk: I2Z-ply. Some paired threads. Selvage cords: none. *Weft*: 2 weft systems: Foundation weft: scarlet silk: 2 Z-twist. Supplementary wefts: Pattern wefts: ivory silk: 2 Z-twist. Constantly used. Latté: turquoise silk: paired of one S- and one Z-twist thread. Yellow silk: 2 Z-twist thread accompanies the brocading metal thread. Brocading weft: metal thread: gilded silver strip densely wrapped in S around a yellow core

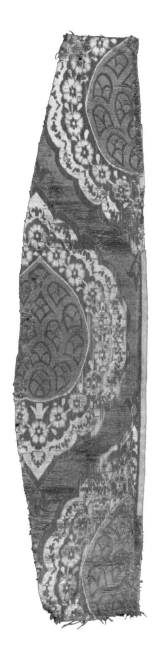
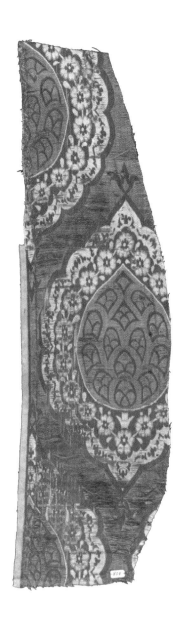

cat. L.2.10

The pattern of lobed medallions in staggered rows, with palmette-like finials on their top and bottom and with a garland around a pine cone in their centre, is rendered in cream and ivory silk threads.

An identic pattern is found on a silk preserved in the Cleveland Museum of Art, dated to the first half of the 17th century[71]. The weave is said to be light and the contours not to be fluid, both features being equally present in our fragments. It is therefore possible that they all come from a same textile, but further examination should confirm this assumption.

Technical analysis:

Pattern repeat: Dimension of pattern: height: not complete. Width: 20 cm. Reverse repeat of pattern units in warp direction. Simple cords needed for pattern unit: 10 x 24: 240 (approximately). Straight arrangement in weft direction.

Weave structure: *Lampas. Warp*: 2 warp systems: Foundation warp: crimson silk: I2S-ply. Binding warp: cream silk: Z-twist. Proportion Found/Binding: 3-4/1 (warp unit). Warp step: 3-4 foundation ends (between 2 binding warp ends). Count per cm: 24 warp units. Selvage: Right and left selvage: 1 cm. Foundation: 35 ends of crimson silk, paired I2S-ply, and cream silk: 2 S-. Binding warp: 7 ends of cream silk: 2 Z-twist. Selvage cords: none. *Weft*: 2 weft systems: Foundation weft: cream silk: I2Z-ply. (0.5-0.6 mm). Supplementary wefts: Pattern wefts: ivory silk: 3 Z-twist (0.5-0.6 mm). Constantly used. Yellow silk: 2 Z-twist threads (0.3-0.4 mm) accompany the brocading metal thread. Constantly used. Brocading weft: metal thread: gilded silver

strip loosely wrapped in S around a yellow silk core S-twist. Constantly used. Proportion: one foundation weft, 2 pattern wefts and the brocading metal thread weft make up one pass. Sequence: opposite weft sequence. The brocading metal thread is the first weft in the pass followed by the yellow weft and the ivory weft. The final weft in the pass is the foundation weft. Weft step: 1 pass. Count per cm: 16 passes. *Weave*: *Lampas* structure. Foundation weave: warp-faced broken 5 Z-twill (1,2,5,3,4) formed by the foundation warp and the foundation weft. The latter is also bound in 1/3 Z-twill weave by the binding warp. Supplementary weave: the binding warp binds the pattern wefts in 1/3 Z-twill. The pattern wefts are on the surface as required by the pattern. Selvage: *lampas* structure. The foundation weave is on the surface.

Remarks: the brocading metal thread and the accompanying yellow weft form the background of the pattern. This yellow weft has also been used for the outline of the figures. At the right selvage the pattern is interrupted 13 warp units after the vertical axis.

Natural dye analysis: cf. article 5, table 4.

Condition: Worn.

L.2.11.
Fragment from length with decorated ogival lattice containing a medallion

Date: Second half of the 16th century

Inv. IS.TX.809

Dimensions: 26 x 21.5 cm (right selvage preserved)

Acquisition: Purchased by I. Errera from Bacri in Paris, in 1903, lent to the museum and bequeathed in 1929.

Bibliography: ERRERA 1927, cat. 213 A, p. 195 (defined as *"travail oriental du XVIᵉ siècle"*). LAFONTAINE-DOSOGNE 1983, fig. 25 (dated to the 16th century).

Colour plate on p. 142.

On a crimson ground, an ogival lattice containing a medallion in the form of an artichoke is rendered in gold thread and decorated with pine cones, pomegranates and groups of three dots in blue, crimson and ivory silk outlined by dark brown silk. The lattice has borders with small triangulars in ivory and crimson. The same geometric pattern decorates also the stem of the artichoke which edge shows moreover lobes inspired by Chinese clouds.

The small-scale geometric pattern is possibly derived from the one found on Mamluk silks[72]. It forms the background of a Turkish kaftan of the first half of the 16th century in the Topkapı Palace Museum in Istanbul[73] the small triangles giving the effect of damask[74]. Similar triangles decorate also a

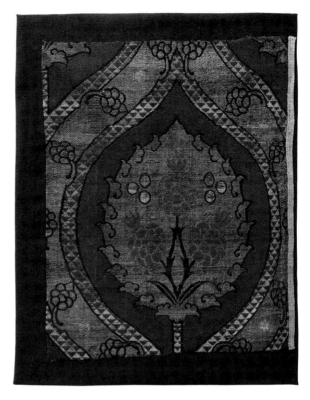

cat. L.2.11

bag in the Topkapı Palace Museum, dated with probability to the later 16th century[75].

Technical analysis:
Pattern repeat: not complete.
Weave structure: *Lampas*. *Warp*: 2 warp systems: Foundation warp: crimson silk: Z-twist. Binding warp: cream silk: Z-twist. Proportion Found/Binding: 3-4/1 (warp unit). Warp step: 3-4 foundation ends (between 2 binding warp ends). Count per cm: 22 warp units and 25 warp units at selvage. Selvage: right selvage: 0.5 cm. Foundation warp: crimson silk: 2 Z-twist and cream silk: 2 Z-twist. Binding warp: cream silk: 2 Z-twist. Selvage cords: none. *Weft*: 2 weft systems: Foundation weft: crimson silk: I-twist. Supplementary wefts: Pattern wefts: blue silk: I-twist. Intermittently used. Ivory silk: I-twist. Constantly used. Dark brown silk: I-twist. Constantly used. Yellow silk: fine, slightly Z-twist thread accompanies the brocading metal thread. Constantly used. Brocading weft: metal thread: gilded silver strip loosely wrapped in S around a core of one yellow and one uncoloured thread: I2S-ply. Constantly used. Proportion: one foundation weft, 4 pattern wefts (one intermittently used) and the brocading metal thread weft make up one pass. Sequence: opposite weft sequence. The first weft in the pass is the brocading metal thread weft followed by the accompanying yellow weft, the dark brown weft, the ivory weft and the intermittent blue weft. The final weft in the pass is the foundation weft. Weft step: one pass. Count per cm: 21-23 passes. *Weave*: *Lampas* structure. Foundation weave: warp-faced 5-

end satin weave, interruption of 1, formed by the foundation warp and the foundation weft. The latter is also bound in 1/3 Z-twill weave by the binding warp. Supplementary weave: the binding warp binds the pattern wefts and brocading weft in 1/3 Z-twill. These supplementary wefts are on the surface as required by the pattern. Selvage: *lampas* structure. The foundation weave is on the surface.

Natural dye analysis: cf. article 5, table 4.

Conservation treatment: cf. article 6.

L.2.12.
Two fragments of the back of a kaftan (?) with crescents on a blue ground

Date: Second half of the 16^th or early 17^th century

Inv. IS.Tx.811

Dimensions: 2 fragments sewn together: 121 x 28.5 cm

Acquisition: Lent by I. Errera and bequeathed to the museum in 1929.

Bibliography: ERRERA 1927, cat. 267 A, p. 243 (defined as *"travail oriental du XVI^e siècle"*). LAFONTAINE-DOSOGNE 1983, fig. 27 a (dated to the 17^th century).

Colour plate on p. 143.

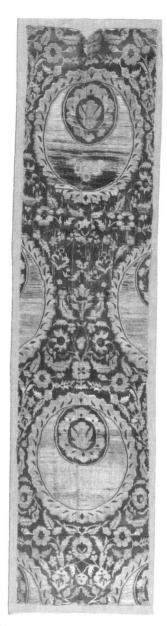

cat. L.2.12

On a blue field strew with small flower motifs, lobed medallions in the form of crescents are placed in staggered rows. They contain a cloud band and encompass a garland and a bouquet. The crescents are rendered in silver thread wrapped around an ivory silk core and accompanied by equally ivory silk threads, while yellow accents brighten up the scene.

These fragments come probably from the back of a garment, possibly a kaftan. Red silk sewing threads are preserved.

Technical analysis:
Pattern repeat: dimension of pattern: height: 67.5 cm. Width: 34 cm. Reverse repeat of pattern unit in warp direction (17 x 17 cm). Simple cords needed for pattern unit: 17 x 12: 204 approximately. Counted: 200 pattern steps (400 warp units). Straight arrangement in weft direction.

Weave structure: *Lampas. Warp:* 2 warp systems: Foundation warp: blue silk: I2S-ply. Binding warp: cream silk: Z-twist. Proportion Found/Binding: 3-4/1 (warp unit). Warp step: 2 x 3-4 foundation ends (between 2 binding warp ends). Count per cm: 23-24 warp units. Selvage: none. *Weft:* 2 weft systems: Foundation weft: light blue silk: I-twist. Supplementary wefts: Pattern wefts: yellow silk: 2 I-twist. Constantly used. Ivory silk: I-twist thread accompanies the brocading metal thread. Constantly used. Brocading weft: metal thread: silver strip loosely wrapped in S around ivory silk core (I3S-ply). Constantly used. Proportion:

one foundation weft, 2 pattern wefts and the brocading metal thread weft make up one pass. Sequence: opposite weft sequence. The brocading metal thread is the first weft in the pass, followed by the ivory weft and the yellow weft. The final weft in the pass is the foundation weft. Weft step: one pass. Count per cm: 17 passes. *Weave: Lampas* structure. Foundation weave: warp-faced 5-end satin weave, interruption of 1, formed by the foundation warp and the foundation weft. The latter is also bound in 1/3 Z-twill weave by the binding warp. Supplementary weave: the supplementary wefts are bound in 1/3 Z-twill by the binding warp and are on the surface as required by the pattern.

Natural dye analysis: cf. article 5, table 4.

Conservation treatment: cf. article 6.

L.2.13.
Length with large tulips on ogival stems

Date: Late 16th or early 17th century

Inv. IS.Tx.1257

Dimensions: 128.5 x 68 cm (both selvages preserved)

Acquisition: Purchased by I. Errera at the Besselièvre Auction in Paris, lent to the museum and bequeathed in 1929.

Bibliography: ERRERA 1927, cat. 382 B, p. 318-319 (defined as *"travail oriental du XVIe-XVIIe siècle"* with a reference to the catalogue *Collection de M. Besselièvre. Étoffes européennes et orientales des XVIe et XVIIe siècles et autres,* Paris, Hôtel Drouot, the second auction on 16 and 17 February 1912 was ment; the textile under cat. 55, p. 10, defined as *"ancien travail de Brousse",* can possibly be identified with this one).

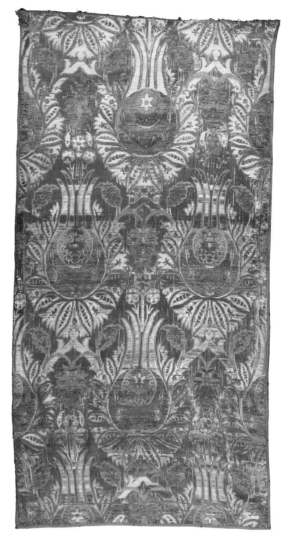

cat. L.2.13

On a scarlet ground, large and heavily decorated tulips rest on curvilinear ogival stems, all rendered in ivory and pale blue silk, and in gilded silver thread on a yellow silk core and accompanied by a yellow silk thread. The tulips ressemble crescents encompassing a star-like flower and ending in four pointed and curved petals from which a bunch of flowers grows. The stems bear tendrils with leaves and flowers drawn alternatingly in opposite directions.

The pattern with large-scale decorated tulips has been woven in different versions, some with typically Ottoman features, some more in Italian style[76]. The layout with horizontal curved stems is inspired by Italian examples, while the tulips and crescents are of Turkish origin. The densely filled ground and the rather loose fabric point to a somewhat later date, possibly in the 17th century.

Technical analysis:
Pattern repeat: Dimension of pattern: height: 71 cm. Width: 34 cm. Reverse repeat of pattern unit in warp direction (17 x 17). Simple cords needed for pattern unit: 17 x 12: 204 approximately. 2 pattern repeats in the width. Straight arrangement in weft direction.
Weave structure: *Lampas. Warp.* 2 warp systems: Foundation warp: scarlet silk: I2S-ply. Binding warp: ivory silk: Z-twist. Proportion Found/Binding: 4/1 (warp unit). Warp step: 2 x 4 foundation ends (between 2 binding warp ends). Count per cm: 24-26 warp units. Selvage: right and left selvage: 0.4-0.5 cm. Foundation warp: scarlet silk followed by 0.3 cm cream silk: Z-twist. Binding warp: ivory silk, last 8 threads are paired. Selvage cords: none. *Weft:* 2 weft systems: Foundation weft: cream silk: 2 S-twist. Supplementary wefts: Pattern wefts: ivory silk: 2 S-twist. Constantly used. Pale blue silk: 2 S-twist. Constantly used. Brocading wefts: yellow silk: 2 S-twist thread, brocading weft accompanies metal thread. Intermittently used. Metal thread: gilded silver strip loosely wrapped in S around yellow silk core (S-twist). Intermittently used. Proportion: one foundation weft, 2 pattern wefts

and, when necessary, the intermittent brocading yellow and metal thread wefts make up one pass. Sequence: opposite weft sequence. According to the pattern, the brocading metal thread is the first weft in the pass followed by the accompanying yellow weft, the ivory and blue pattern weft. When the metal thread and the yellow weft are not needed in the pattern, the first weft in the pass is the ivory weft. The final weft in the pass is the foundation weft. Weft step: one pass. Count per cm: 15 passes. *Weave: Lampas* structure. Foundation weave: warp-faced 5-end satin weave, interruption of 2, formed by the foundation warp and the foundation weft. The latter is also bound in 1/3 Z-twill weave by the binding warp. Supplementary weave: the binding warp binds the supplementary wefts in 1/3 Z-twill. These supplementary wefts are on the surface as required by the pattern.
Remarks: coarse fabric.

Natural dye analysis: cf. article 5, table 4.

Condition: Worn.

L.2.14.
Fragments of length, sewn together, with flowers on an undulating vine

Date: Second half of the 16th or 17th century

Inv. IS.Tx. 1259

Dimensions: 134 x 65 cm

Acquisition: Lent by I. Errera and bequeathed in 1929.

Bibliography: ERRERA 1927, cat. 272 A, p. 246 (defined as *"travail oriental du XVIe siècle"*).

The crimson ground of this textile is densely filled with large flowers on undulating vines, all rendered by crimson, green/blue and black silk threads, and by gilded silver threads. The vines are decorated with a garland and bear stems with leaves and with two kinds of flowers: either a lotus or a bunch of flowers, both in a serrated medallion, nodding alternatingly left and right.

The development of the "wavy vine layout" can be followed on tilework realised in the course of the second half of the 16th century[77]. The prominently present vine, as also the lotus flowers in the serrated leaves, suggest a date in the second half of the 16th century for this textile. But the pattern of flowers on parallel undulating vines remained popular in the *kemha* weaving in the 17th century. The presence of Mexican cochineal as dye stuff for the crimson parts points to a later period, although it does not exclude a date in the second half of the 16th century.

Technical analysis:
Pattern repeat: Dimension of pattern: height: 35.5 cm. Width: 17 cm. Straight repeat of pattern unit in warp direction. Simple cords needed for pattern unit: 17 x 24: 408 approximately. 4 pattern units in the width. Straight arrangement in weft direction.
Weave structure: *Lampas. Warp.* 2 warp systems: Foundation warp: crimson silk: firm Z-twist. Binding warp: cream silk: Z-twist. Proportion Found/Binding: 3-4/1 (warp unit). Warp step: 3-4 foundation ends (between 2 binding warp ends). Count per cm: 24 warp units. Selvage: left and right selvage: 0.5 cm. Foundation warp: 30 ends of crimson silk, Z-twist, followed by small group of ivory silk, Z-twist. Binding warp: cream silk: Z-twist. Selvage cords: none. *Weft:* 2 weft systems: Foundation weft: pink silk: 3 Z-twist. Supplementary wefts: Pattern wefts: Latté: green silk: 2 Z-twist. Intermittently used. Blue silk: 2 Z-twist. Intermittently used. Black silk: 2 Z-twist. Constantly used. Yellow silk: 2 Z-twist thread accompany the brocading metal thread. Intermittently used. Brocading weft: metal thread: gilded silver strip loosely wrapped in S around a yellow silk core (S-twist). Intermittently used. Proportion: one foundation weft, one pattern weft (black), the brocading metal thread weft and the accompanying yellow pattern weft make up one pass. In other places the metal thread and the yellow pattern weft are intermittent and one of the latté wefts has been used to

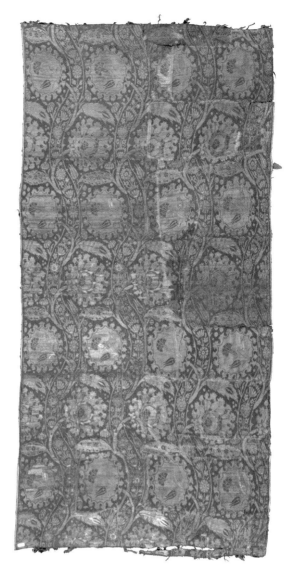

cat. L.2.14

complete the pass. Sequence: opposite weft sequence. The brocading metal thread is the first weft in the pass, followed by the accompanying yellow weft, the black weft and finally the foundation weft. However, when metal threads are not needed, the black weft is the first weft in the pass, followed by one of the latté wefts with the foundation weft again as the last weft. Weft step: 1 pass. Count per cm: 18-20 passes. *Weave: Lampas* structure. Foundation weave: warp-faced 5-end satin weave, interruption of 2, formed by the foundation warp and the foundation weft. The latter is also bound in 1/3 Z-twill weave by the binding warp. Supplementary weave: the binding warp binds the supplementary wefts in 1/3 Z-twill weave. These supplementary wefts are on the surface as required by the pattern. Selvage: *lampas* structure. Foundation weave on the surface.

Natural dye analysis: cf. article 5, table 4.

Condition: This piece is reconstructed from numerous fragments originating from the same textile and sewn together. Some missing parts are overstitched.

L.2.15.
Length with decorated ogival lattice containing medallions with flowers

Date: Second half of the 16th century

Inv. IS.Tx.1261

Dimensions: 192.5 x 68 cm (both selvages preserved)

Acquisition: Purchased by I. Errera at the Besselièvre Auction in Paris, lent to the museum and bequeathed in 1929.

Bibliography: ERRERA 1927, cat. 213 B, p. 195-196 (defined as *"travail oriental du XVI^e siècle"* with a reference to the catalogue *Collection de M. Besselièvre. Étoffes européennes et orientales des XVI^e et XVII^e siècles et autres,* Paris, Hôtel Drouot, possibly cat. 57, p. 10 in the catalogue of the second auction in 1912).

Colour plate on p. 144.

On a crimson ground, an ogival lattice containing medallions with a bouquet of rosettes is rendered in gold thread and decorated with cartouches wherein a rosette and two leaves, all in blue, pale green, crimson and ivory silk. The medallions affect the form of pomegranates linked by stems which run behind the lattice but break through its white dentate edges.

This is an example of *kemha* of the second half of the 16th century with a decorated ogival lattice containing medallions and bunches of flowers. No identical or similar pieces have been found though, but the spaced layout and the quality of the design and weave point to an early date.

Technical analysis:
Pattern repeat: Dimension of pattern: height: 54.5 cm. Width: 34 cm. Reverse repeat of pattern unit in warp direction (17-17). Simple cords needed for pattern unit: 17 x 24: 408 approximately. 2 pattern repeats in the width. Straight weft arrangement.
Weave structure: *Lampas. Warp:* 2 warp systems: Foundation warp: crimson silk: strong Z-twist. Binding warp: cream silk: Z-twist. Proportion Found/Binding: 3-4 /1. Warp step: 3-4 foundation ends (between 2 binding ends). Count per cm: irregular, strong deformation at the selvages: Left side: 40 warp units/cm. Right side: 38 warp units/cm. Central: 22-24 warp units/cm. Selvage: left and right: 0.3 cm. Foundation warp: crimson silk Z-, 5 threads (4Z-), 10 Z-, 10 2Z-, 10 Z-. Binding warp: cream silk 2 Z-, last 3 threads: 3 Z-. Selvage cords: none *Weft:* 2 weft systems: Foundation weft: ivory silk: 2 Z-twist. Supplementary wefts: Pattern wefts: pale green silk: 3 Z-twist. Intermittently used. Blue silk: 3 Z-twist. Constantly used. Ivory silk: 3 Z-twist. Constantly used. Yellow silk: 2 thin Z-twist threads accompany the brocading metal thread. Constantly used. Brocading weft: metal thread: gilded silver strip loosely wrapped in S around a yellow silk core (2 S). Constantly used. Proportion: one foundation weft, 3 or 4 pattern wefts (one intermittently used) and the brocading metal thread weft make up one pass. Sequence: opposite weft sequence. The brocading

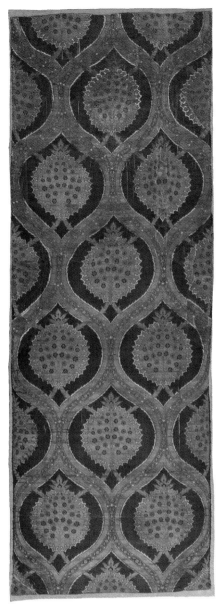

cat. L.2.15

metal thread is the first weft in the pass, followed by the accompanying yellow weft, the ivory weft, the blue weft and, were necessary, the green weft. The foundation weft is the final weft in the pass. Weft step: 1 pass. Count per cm: 26 passes. *Weave: Lampas* structure. Foundation weave: warp-faced 5-end satin weave, interruption of 2, formed by the foundation warp and the foundation weft. The latter is also bound in 1/3 Z-twill weave by the binding warp. Supplementary weave: the binding warp binds the supplementary wefts in 1/3 Z-twill. These supplementary wefts are on the surface as required by the pattern. Selvage: *lampas* structure. Foundation weave on the surface.

Natural dye analysis: cf. article 5, table 4.

Condition: Good but overstitched on damaged parts.

L.2.16.
Length with decorated ogival lattice containing medallions

Date: Second half of the 16th century

Inv. IS.Tx.1280

Dimensions:139 x 67 cm (both selvages preserved)

Acquisition: Purchased by I. Errera from Dikran-Khan-Kelekian in Paris in 1900 and donated to the museum.

Bibliography: ERRERA 1927, cat. 213, p. 194-195 (defined as *"travail persan (?) du XV^e-XVI^e siècle"*).

On a crimson ground, the ogival lattice contains lobed medallions filled with an arabesque central design surrounded by cloud bands. It is rendered in gold threads and decorated with a finely drawn garland in blue, crimson and ivory silk.

This is a high quality *kemha*, but the crimson ground foundation warp is worn out which uncovers the cream foundation weft. This disturbs the otherwise excellent design of this fabric which can surely be dated to the flowering period of *kemha* production in the second half of the 16th century.

Technical analysis:

Pattern repeat: Dimension of pattern: height: 61-63 cm; width: left: 33 cm; right: 32.2 cm. Reverse repeat of pattern unit in warp direction. Simple cords needed for pattern unit: 16.5 x 24: 400 approximately. 2 pattern repeats in the width. Straight arrangement in weft direction.

Weave structure: *Lampas. Warp*: 2 warp systems: Foundation warp: crimson silk: I2S-ply. Binding warp: cream silk: Z-twist. Proportion Found/Binding: 3-4/1. Warp step: 3-4 foundation ends (between 2 binding ends). Count per cm: 22-24 warp units. Higher density at selvages: 32 warp units. Selvages: left side: 1 cm. Foundation weft: 8 crimson threads: I2S-ply followed by group of cream silk. Binding warp: cream silk: 2 Z-twist. Right side: 0.85 cm. Foundation warp: 11 crimson threads followed by cream silk. The last 10 threads: 2 Z-twist. Binding warp: cream silk, 2 Z-twist. *Weft*: 2 weft systems: Foundation weft: cream silk: 2 Z-twist. Supplementary wefts: Pattern wefts: Blue silk: 2 Z-twist, constantly used. Ivory silk: 3 Z-twist, constantly used. Yellow silk: 2 Z-twist, accompanies the brocading metal thread. Constantly used. Brocading weft: metal thread: gilded silver strip wrapped in S around yellow silk core (S-twist). Constantly used. Proportion: one foundation weft, 3 pattern wefts and the brocading metal weft make up one pass. Sequence: opposite weft sequence. The brocading metal thread is the first weft in the pass, followed by the accompanying yellow weft, the ivory pattern weft and the blue pattern weft. The foundation weft is the final weft in the pass. Weft step: one pass. Count per cm: from 17 passes at the bottom to 19-20 at the head

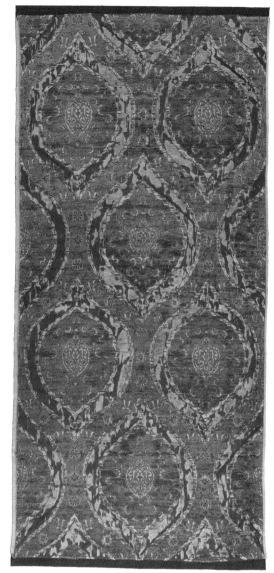

cat. L.2.16

of the fabric. *Weave: Lampas* structure. Foundation weave: irregular warp-faced 5-end satin weave formed by the foundation warp and the foundation weft. The latter is also bound in 1/3 S-twill weave by the binding warp. Supplementary weave: the binding warp binds the supplementary wefts in 1/3 S-twill weave. These supplementary wefts are on the surface as required by the pattern.

Selvage: 0.9 cm; *lampas* structure. Foundation weave on the surface.

Remarks: irregularities in foundation weave: a mixture of irregular warp-faced satin 5 and 4/1 twill.

Natural dye analysis: cf. article 5, table 4.

Condition: Poor.

III. Distinctive weaves

D.W.1.
Square *lampas* with ogival lattice and flowers

Date: 17th-18th century (?)

Dimensions: 119 x 124 cm (both selvages preserved)

Inv. IS.Tx.1233

Acquisition: Purchased by I. Errera from Benguiat in London in 1894 and donated to the museum.

Bibliography: ERRERA 1927, cat. 277, p. 249 (defined as *"travail oriental du XVI^e siècle"*).

Colour plate on p. 145.

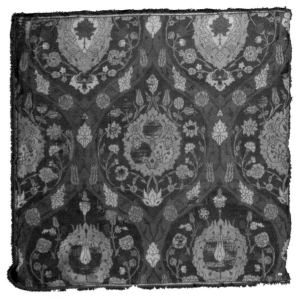

cat. D.W.1

On a purple ground, a heavy crimson ogival lattice with flowers and pomegranates in yellow, ivory, blue and crimson, and resting on pale green stems, forms the pattern of this further unusual silk. As far as known, the almost square format has no parallels within the preserved Ottoman silk textiles, except for what the embroidered ones is concerned. The original function of this fabric is therefore an enigma: it was possibly ment as a cover or wrapping cloth[78]. Worn areas show that it has been used as a furniture cloth, but this may have been at a later moment in the West. A red silk lining is sewn with red silk threads onto the fabric, the lining being bordered by passementerie.

The design of the fabric is truly Ottoman with its decorated lattice containing a bunch of flowers surrounding a serrated medallion with either three pomegranates or a tulip. The stems grow from a lotus palmette and the edges of the lattice and medallions with lobes are inspired by Chinese clouds. The large-scale pattern with bright contrasting colours, the purple prominently present in the ground and the loose design are brainteasers though. The technical features, differing from those of the *lampas* weaves, do not help to situate this silk better. The use of the natural Mexican cochineal dyestuff, dating roughly between the second half of the 16th and the mid-19th century, gives at least a chronological frame for this rare cloth.

Passementerie:

Fringe: width 2,1 cm, woven heading 0,7 cm.

Fringe sewn on with an overhand stitch in white silk, on four sides. A red silk main warp and a supplementary warp (both 2S-Zply) work with a red silk weft (2 2S- Zply are plied in S direction to form a cord) in plain weave (6 per cm). The supplementary warp forms small block patterns of floats over 3 wefts. The weft forms loops on one side. There is a last warp thread in thin white silk to prevent unrav-

elling. 2 or 3 loops (in no apparent order) are tied with small tassels. The fringe is hard to date or to locate. It could have been made in Europe or in Turkey. The fact that it is sewn on with a contrasting white silk, makes it improbable that this would have been done in Western Europe[79].

Technical analysis:

Pattern repeat: Dimension of pattern: height: not complete. Width: 61 cm. Reverse repeat of pattern unit in warp direction. Simple cords needed per pattern unit: 31 x 14= 434 approximately. 2 pattern repeats in the width. Straight arrangement in weft direction. Remark: pattern height (119 cm) is not complete although this fabric supposes to be one piece. At the top and the bottom of the fabric a white line from selvage to selvage closes the figuration.

Weave structure: Extended tabby with supplementary wefts. *Warp*: 1 warp systems: Foundation warp: purple silk: 2 S-ply (1 foundation warp). Warp step: 4 foundation warp threads. Count per cm: at selvage: 52 paired threads; centre: 56 paired threads. Selvage: figuration till last warp thread. Last 4 warp threads: 2 x 2 S-ply. *Weft*: 2 weft systems: Foundation weft: dark blue silk: multiple strands. Brocading wefts: Crimson silk: multiple strands, I-twist. Constantly used. Yellow silk: multiple strands, I-twist. Constantly used. Ivory silk: multiple strands, I-twist. Intermittently used. Pale blue silk: multiple strands, I-twist. Intermittently used. Pale green silk: multiple strands, I-twist. Intermittently used. Proportion: one pick of the foundation weft, one pick of the 2 con-

stantly used brocading wefts and, where necessary in the pattern, one pick of the intermittent brocading wefts make up one pass. Sequence: opposite weft sequence. The final pick in the pass is the foundation weft. Weft step: 1 pass. Count per cm: 14 passes. *Weave*: Foundation weave: extended tabby of foundation warp (paired threads) and foundation weft. The foundation warp also binds the brocading wefts in 1/7 Z-twill. At the backside these wefts float.

Natural dye analysis: cf. article 5, table 5.

Condition: Worn areas.

D.W.2.
Banner

Date: Late 17th or 18th century

Inv. IS.Tx.1223

Dimensions: 196 x 256 cm

Acquisition: Purchased by I. Errera from *"le Révérend P. Petit"* in Istanbul in 1903, lent to the museum and bequeathed in 1929.

Bibliography: ERRERA 1927, cat. 77 B, p. 96 (defined as *"travail oriental du XIVe-XVe siècle, peut-être plus moderne"*); LAFONTAINE-DOSOGNE 1988, fig. 30 (dated to the 17th-18th century); VAN RAEMDONCK M., An Ottoman silk banner. Proceedings of the 11th International Congress of Turkish Art (ICTA-XI), Utrecht, 23-28/8/1999, in *Electronic Journal of Oriental Studies*.

Colour plate on p. 146.

Measuring 196 cm in height and 256 in width, this banner has an off-white field, originally watered, cut in two unequal sections by a green bar and surrounded by a green border both sewn on the field and decorated either with inscriptions or with rosettes and tulips in silver thread. Woven into the field are medallions containing inscriptions and/or flower and crescent motifs rendered by pink, green and red silk and by gold thread.

The profession of faith is repeated in 13 cartouches placed under each other in the cross band which divides the field. It is reversed and starts with *"and Muhammad is the prophet of Allah"* followed by *"There is no god but Allah"*. The uneven number of cartouches may seem illogical, but top and bottom of the band are bordered by zigzag designs showing that the pattern was designed as such. The crescent in the rectangular section near the guard contains the prayer *"The favour of God Almighty upon them all!"* The inscriptions in two small medallions, repeated six times each in the main field, contain *"Those who died as a martyr for Me, will be revenged"* and *"The Exalted, the Most High"*.

This is a large military banner of the *sandjaq*-type. The earliest clear iconographical source which shows a banner of this type is an engraving, now lost, by Johann Ulrich Kraus copied after a drawing done by Bartholomäus Sixtus Kummer in Augsburg after 1685, the date of the siege of the fortress of Neuhäusel at which the banner was captured[80]. According to the text on the engraving, the flag was made of green silk and gold threads. Its overall form must have been the same as the one of the Brussels piece. The external borders were missing though, or were not represented in the engraving, while the moiré-effect was clearly reproduced. Although represented upside down, the division into two unequal parts by a cross-band, the spreading of the medallions in three rows, the crescents, star-rosettes, stylised floral designs are still clearly visible and found also on the Brussels flag. Only the sunburst motive with alternating straight and bent shafts in the medallions does not appear on our piece.

At least one banner of this type has been preserved, dated to the second half of the 17th century and kept in the Badisches Landesmuseum in Karlsruhe[81]. In an inventory of 1842 it was identified as the Turkish flag of the *serasker* (military commander) captured by Markgraf Ludwig Wilhelm in the battle of Slankamen on 19 August 1691. The apparent similarities are striking, both with the one in the engraving and with the banner in Brussels. The overall shape is identical, the spread and the decoration of the medallions are similar. Moreover, the field and borders of the banner in Karlsruhe are woven in the same technique as those of the Brussels flag. Both textiles are reversible. The ribbed effect needed for moiré is equally present. The inventory in Karlsruhe mentions even the word *moiré*, although only in connection with the blue band around the guard. The borders have the same width as in the Brussels banner and are similarly decorated with rosettes and stylized tulips. A difference is though, that the queer vertical band has not been sewn on the field as in the banner of Brussels, but has instead been woven into the ground. So has the *shahada* not been put into cartouches as in the flag in Brussels, but is grouped and woven in a normal and in a mirror image in a vertical direction. But on the whole, crescents, star-rosettes, small eight-petalled flowers and zigzag borders, lobbed medallions and Arabic inscriptions, all are found on both banners. They seem to form the classical iconographical repertory of this type of Ottoman banners dated towards the end of the 17th century.

As far as we know, there is but one banner explicitly dated to the 17th century. It is not a military banner but a pilgrim flag, kept in the Fogg Art Museum in Cambridge Mass.[82]. The inscription mentions the date 1683 and situates its origin not in the heartland of the Ottoman Empire, but in the provinces of Tunisia or Algeria. This flag differs in a number of

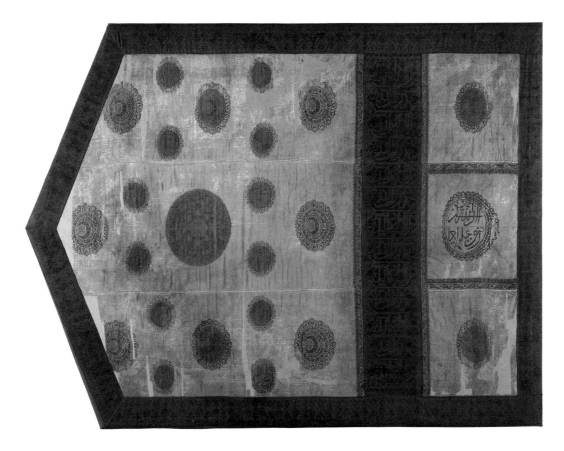

cat. D.W.2

points from ours. Among other things, we should mention the sword with the bifurcated blade, known as the *Dhu'l-faqar*, which appears on a series of Ottoman banners mostly dated to the 17th century. The rectangular decorations are also different, but on the other side lobbed medallions, reciprocating trefoils or tulips are shown like on the banner in Brussels.

Another Fogg Art Museum banner[83] belongs visibly to the same group as the one of Brussels. It should be mentioned though, that its circular ornaments are sewn on the ground instead of woven into it. A technological analysis of the weave of field and ornaments, and of the seams, is therefore essential in order to know when this sewing was done. This could confirm the thesis that the original decorations were reused. Anyway, the crescents, festoons, reciprocating trefoils and tulips, zigzag-lines and cartouches with the *shahada,* here in reversed order as in our flag, are all in compliance with the usual repertory of the banners from the end of the 17th century. One can notice the sunburst pattern to.

A second group of banners has been clearly dated to the beginning of the 19th century this time. One example, kept in the Khalili collection, is dated by the inscription AH 1235 (AD 1819-20)[84]. The general form and decoration are still very similar to those of the late 17th century specimens, but the exterior borders contain repeated inscriptions, a feature we didn't find in the earlier group. The field of the Khalili banner may also have been watered because deep folds in the middle of the bands are visible on the photograph which suggests that it got that treatment. This could indicate that the tabby was ribbed like it was the case in the mentioned ones and that the weaving technology was similar. This should be confirmed by a technological analysis though. On the whole, the technological characteristics could tell in the first place whether the 19th banners were woven in the same way as those of the earlier group.

It is tentatively concluded that, apart from the border inscriptions, the iconography and style of the military banners of the *sandjaq*-type have changed little between the end of the 17th and the beginning of the 19th century. Technical analyses of a representative group of preserved pieces are not available at this moment. So, if there are no historical documents dating the flag neither a date inscribed on it, which is the case for the banner in Brussels, only an approximate date can be given. With this in mind, we can conclude that the banner of Brussels belongs to the early group and is dated to the end of the 17th or possibly to the 18th century.

As concerning the place of manufacture, it is certain that this sort of weave requires another type of loom than the one needed for contemporary *lampas* weaves. The technology is so fundamentally different that these two types of fabrics must originate from other workshops. There must have been specialised workshops for flags and these have existed also in the provinces of the Ottoman Empire. Finally, it is probable that, when flags wore out, decorated parts were reused and sewn on a newly woven field.

Composition: The rectangular section at the right side: 3 panels off-white silk next to each other: (h: 52 cm: width: 53, 62.5, and 52 cm, only the middle piece has 2 selvages.). Each panel has a medallion formed by discontinuous supplementary wefts (brocading wefts). The medallion in the middle is different of the side medallions. Main field: 3 panels off-white silk next to each other: (h: max 135.5 cm (middle); width: 53, 63.5 and 53.5 cm) only the middle panel has 2 selvages (complete width: 64 cm). Here too, the side panels have the same pattern and have been narrowed by 5 cm on both sides. The centre of the middle panel has a different medallion. The rectangular section and main field originally belonged to one fabric. The different patterns have been planned for this special arrangement. In the middle of each piece you can see a fold, which suggest that this fabric was watered (moiré). Between the rectangular section at the right side and the main field, a wide green silk band has been sewn (long: 167 cm, width: 29.5 cm). This band has both selvages with a complete width of 30 cm. The pattern (text), with straight repeat, is woven perpendicular to the warp and has to be turned by 90° to stand up. The banner is completely bordered by a green silk band (1/2 width: 14.5 cm: band cut in two: only 1 selvage). These borders have a floral motif (pattern: h: 805 cm, width: 14 cm) with vertical symmetrical axis, suitable to be cut in the middle but probably with a straight warp repeat (see vertical cross band).

Technical analysis:
1: The rectangular section at the right side and the main field. Structure: extended tabby with brocading wefts. *Warp*: Foundation warp: off-white silk, S (0.2 mm), paired threads. Warp step: 2 paired warps. Count per cm: 24 paired threads. Selvage: 6 selvage cords (bundle of warp threads together). *Weft*: Foundation weft: off-white silk, x S- threads together (thick: 0.6 mm). Brocading wefts: only in the pattern areas. Pale pink (faded?), green and red silk: bundle of 5 S- threads. Metal thread: gilded metal strip in Z-wrapping (loosely) around an off-white silk cord (3 S-threads together). Weft sequence: one foundation weft followed by one coloured silk weft and the metal brocading weft make up one pass. In the rectangular section the medallion of the middle panel has an "opposite" weft sequence. Weft step: 1 pass. Count: 8 passes/cm. *Weaves*: Foundation weave: extended tabby. Supplementary weave: brocading wefts are very irregular bound by the foundation warp in 1/5 twill weave at both sides. Selvage: extended tabby.

2: Vertical cross band and green borders. Structure: extended tabby with pattern weft. *Warp*: Foundation warp: green silk S- (0.1-0.2 mm): paired threads (= 1 main warp thread). Warp step: 2 paired threads. Count per cm: 48 paired threads. Selvage: 6 green cords Z-ply (thick). *Weft*: Foundation weft: green silk, bundle of threads together: 0.6-0.7 mm. Pattern weft: metal thread: silver metal strip (0.2 mm) in Z-wrapping around off-white silk cord 2S (0.2-0.3 mm). Weft sequence: one foundation weft followed by one pattern weft. (1 pass). Weft step: 1 pass. Count: 15 passes/cm. *Weave*: Foundation weave: extended tabby. Supplementary weave: the pattern weft is irregular bound in 1/5 twill by the main warp at both sides. Selvage: extended tabby. The metal thread bound only by the last 2 cords.

Construction of the banner: The main part of the banner, the off-white silk fabric, has been special designed and woven in one piece for the construction of the banner. This fabric has been cut and mounted and completed by green bands. All seems are original. Green bands: sewing thread: green silk Z2S. Off-white panels: sewing thread: white silk Z2S.

Natural dye analysis: cf. article 5, table 5.

Condition: Faded. The banner has a backing cloth: sewing threads: beige silk 2(S2Z), light brown: S2Z, green silk: S2Z and 2(S2Z).

Notes

1. Inv. TSM 13/1423 in GÜRSÜ 1988, cat. 78, illustrated on p. 80.
2. Inv. 15789 in ERBER 1993, cat. G3/2, p. 108-109.
3. Inv. 12.49.5, Rogers fund in *Türkische Kunst und Kultur aus osmanischer Zeit,* Recklinghausen, 1985, fig. 5 and p. 29.
4. Inv. 55, Putna Monastery, Romania and inv. 1125b, Rila Monastery, Bulgaria in ATASOY 2001, fig. 6 and 7, p. 241.
5. Inv. 00976 in ERBER 1993, cat. G3/1, p. 106-107.
6. Inv. 1951.151.1 in ATASOY 2001, plate 70.
7. Inv. 1970.65.9 in ATASOY 2001, plate 71.
8. Inv. 2459 in SURIANO 1999, cat. 37.
9. See ATASOY 2001, p. 182-190.
10. FALKE 1936, Abb. 532, p. 54 (said to come from the Kelekian collection).
11. KING 1980, cat. 1, p. 14; KING 1985, cat. 342, p. 331 (said to have belonged formerly to the collection of Baron Edmond de Rothschild).
12. This information has been supplied by Frieda Sorber, curator of the textile collection in the Mode Museum of Antwerp.
13. Inv. 13/1909 in ATASOY 2001, plate 88.
14. Inv. 2459 Carrand in SURIANO 1999, cat. 37.
15. Inv. 1970.65.9 in ATASOY 2001, plate 71.
16. See in ATASOY 2001, p. 231.
17. Cf. ATASOY 2001, p. 205, C.
18. ATASOY, p. 162-163 with reference to DALSAR F., *Türk Sanayi ve Ticaret Tarihinde Bursa'da Ipekçilik,* Istanbul, 1960, p. 88, doc. 1.
19. Inv. 1889.38 in ERBER 1993, cat. G 2/2, p. 94-95; same pattern and features as IS.Tx.1202 but without small border.
20. Inv. 17.120.122.
21. Inv. 616 in ATASOY 2001, plate 97.
22. Inv. Tex. 30 in FOLSACH 1993, cat. 24, p. 106-107.
23. ATASOY 2001, plate 105, p. 340 where other examples with this motif are enumerated.
24. Inv. 13/1444 in ATASOY 2001, fig. 338, p. 314-315.
25. See also under cat. V.2.17.
26. Inv. 600 in ATASOY 2001, fig. 245, p. 316-317.
27. For the other one, see cat. V.2.16.
28. Inv. 00200 in ERBER 1993, cat. G 10/2, p. 180-181.
29. Inv. 615 in ATASOY 2001, fig. 347, p. 317.
30. Inv. XIX-4525 in ATASOY 2001, fig. 348, p. 317.
31. Inv. 1384 in GULBENKIAN 2001, cat. 57, p. 144.
32. Inv. 2465 Carrand in SURIANO 1999, cat. 29.
33. Inv. 13/1470 in ATASOY 2001, fig. 319, p. 308.
34. Inv. 99 Francetti in SURIANO 1999, cat. 35. *Remark*: the technical analysis of the fragment in the Francetti collection is incomplete and does not agree with the analysis of the fragment, inv. IS.Tx.1231, in the collection of the Brussels Museum. In velvet, inv. IS.Tx.1231, there is no binding warp (see above), the foundation weft is paired schappe silk instead of linen and the weave of the selvage is satin 4/1 instead of 3/1. The author does not mention a squeezing or supporting weft. Nevertheless, as the two fragments come from the same collector, we assume that the two fragments have the same construction. See also: ATASOY *et al.,* 2001, pl. 74, analysis p. 335.
35. Inv. 145-1891 in ATASOY 2001, plate 73.
36. ATASOY 2001, p. 335.
37. ATASOY 2001, fig. 316, p. 307.
38. KING 1980, cat. 20.
39. Inv. 2404 and 2281, Sergiev-Posad Museum Preserve (Zagorsk) in ATASOY 2001, fig. 57, p. 249 and fig. 62, p. 250.
40. This information is supplied by Ingrid De Meûter, curator of the Textile Collection of the Museum Department of Decorative Arts.
41. See ATASOY 2001, p. 227. The palmettes and flowers on our velvet can moreover be compared to those on a length in the Abegg-Stiftung, Riggisberg-Berne, inv. 235, plate 68, p. 119. It is dated around 1500, but there is uncertainty about its provenance which could, according to the author, be Italian. Similar poly-lobed medallions are indeed found in Italian silks, while the arabesques on our velvet are Islamic in character.
42. Inv. 1.44, Textile Museum, Washington, in MACKIE 1973, cat. 2 (in silver on a maroon ground, defined as "Bursa, possibly second half 15th century"); a fragment in the Victoria & Albert Museum, London, Inv. 356-1897 and one in the Kunstmuseum Düsseldorf, Inv. 8765, in *Osmanische Samte und Seiden,* exhibition catalogue, Krefeld, 1978, p. 20 (defined as "*Samtbrokat, 2. Hälfte 15. Jh.*").
43. Cfr one used for the lining of a ceremonial shield preserved in the Topkapı Palace Museum, Istanbul Inv. 1/2545 in ATASOY 2001, fig. 290, p. 299 (dated circa 1500) and another one in a German private collection, in ERBER 1993, cat. G 1/2 (dated to the second half of the 15th century).
44. For example in velvet IS.Tx.1201, cat. V.2.11, where the dots are mingled up with the crescent motif.
45. GÜRSÜ 1988, p. 180.
46. We thank the curator of the China collection in our museum, Mr. Jean-Marie Simonet, for this information. See also: OKUMURA S., The Origin and Development of the Chintamani Motif, in *Oriental Carpet and Textile Studies,* Volume VI, California, 2001, p. 124-127.
47. The Iranian hero Rustam is traditionally wearing a cloth with tiger stripes. An early representation in Islamic art is the one on a page of Firdausi's *Shahnameh* of 1379, preserved in the Chester Beatty Library, London, showing "Rustam and the white demon", published in: ROBINSON B., *Persian Miniature Painting,* London, 1967, pl. 7; however, in the *Encyclopédie de l'Islam,* 1995, p. 656, the same author mentions an older manuscript, one of the *Djâmi' al-tawârîkh* of Rashîd al-Dîn dated 1306 (University Library of Edinburgh, ms. Arab 20, fol. 6b) where the hero wears a tiger skin over his Mongol clothes.
48. ATASOY 2001, p. 299.
49. Inv. 0.192-XVI. The structure of this velvet is however different from the one of the velvet under consideration, but identical to the one of cat. V.2.9, with a red velvet ground and a pattern in brocaded silver thread and ivory pile.
50. ATASOY 2001, fig. 332, p. 312.
51. Inv. 48.137, Detroit Institute of Arts in ATASOY 2001, plate 101.
52. Inv. TK-2802, Kremlin Armoury Museum, Moscow in ATASOY 2001, cat. 43, p. 247 (dateable before 1642).
53. Inv. 2287, Sergiev-Posad Museum Preserve (Zagorsk) in ATASOY 2001, cat. 48, p. 248 (dateable before 1652).
54. I. Errera mentioned that she was obliged to M. Sobernheim of Berlin for the reading of the inscriptions.

The translation here is based on *The holy Qur'an,* English translation and commentary by S.V. Mir Ahmed Ali, Karachi, s.d.

55. SPUHLER 1978, cat. 138, p. 222-223.

56. An exception is tomb cover inv. 13/1957, Topkapı Palace Museum, Istanbul, which is datable between 1520 and 1691, the inscription mentioning Süleyman as reigning sultan, in ATASOY 2001, cat. 10, p. 241-242.

57. For example: inv. T.M.1.84, Textile Museum, Washington in DENNY 1972, fig. 24, p. 66 (dated to the 16th century); inv. 1063-1900, Victoria & Albert Museum, London in HAYWARD 1976, cat. 33, p. 86 (dated to the 18th century); inv. 08.178.2, Metropolitan Museum of Art, New York in MEISTERWERKE 1981, cat. 114, p. 268-269 (dated to the 18th century); inv. 1506, Calouste Gulbenkian Collection, Lisbon in GULBENKIAN 1978, cat. 57 (dated to the 17th century).

58. Inv. 20/1971, David Collection, Copenhagen in FOLSACH 2001, cat. 650, p. 381 (dated to the 18th century).

59. Private collection in PETSOPOULOS 1982, cat. 160 (dated to the 18th century).

60. Inv. 66083, Museum voor Volkenkunde, Rotterdam in *Dromen van het Paradijs. Islamitische kunst van het Museum voor Volkenkunde,* Rotterdam, 1993, cat. 117, p. 137-138 (dated to the second half of the 17th century).

61. The reading and translation of this prayer are based on those in HAYWARD 1976, cat. 32, p. 86.

62. The cenotaph cover mentioned in HAYWARD 1976, cat. 32, p. 86 (dated to the 18th century), also in *Islamic Art and Manuscripts,* Tuesday 1 May 2001, CHRISTIE'S; two seamed pieces in the Musée Historique des Tissus, Lyon in WELCH 1979, cat. 34, p. 101 (dated to the 18th century); and inv. 13/1690, Topkapı Palace Museum, Istanbul in ATASOY 2001, fig. 280, p. 297 (dated to the 17th or 18th century).

63. The reading and translation of this prayer are based on those in HAYWARD 1976, cat. 32, p. 86.

64. *Idem.*

65. Inv. 780-1892, in ATASOY 2001, fig. 284, p. 297.

66. For the international Timurid style in Ottoman tiles see NECIPOGLU G., From International Timurid to Ottoman: a change of taste in sixteenth-century ceramic tiles, in *Muqarnas,* vol. 7, Leiden, 1990, p. 136-138.

67. In DIMAND M.S., *A handbook of Muhammadan Art,* New York, 1944, p. 264, fig. 172.; Museo Poldi Pezzoli. *Tessuti-sculture-metalli islamici,* Edizione Electa spa, Milano, 1987, p. 101, fig. 33; LENTZ T.W. and LOWRY G.D., *Timur and the Princely Vision. Persian Art and culture in the Fifteenth Century,* Smithsonian Institution Press, Washington, 1989, p. 218, fig. 80.

68. See in NEUMANN R.-MURZA G., *Persische Seiden. Die Gewebekunst der Safawiden und ihrer Nachfolger,* Leipzig, 1988, p. 67; the piece with gold thread is preserved in the Kunstgewerbemuseum of Berlin.

69. Inv. 13/1515 in ATASOY 2001, plate 14.

70. For example inv. 345, Abegg-Stiftung, Riggisberg, in ATASOY 2001, plate 39; see also p. 284-285, for an overview of pieces with this layout.

71. Inv. 18.201, in ATASOY 2001, fig. 220, p. 274.

72. For example inv. IS.Tx.562, dated to the 14th century, in DE JONGHE D.-VAN RAEMDONCK M., Het islamitisch zijdeweefsel Tx.1739 uit de Koninklijke Musea voor Kunst en Geschiedenis. Een technologische en kunsthistorische studie, in *Bulletin van de KMKG,* 65, Brussel, 1994, fig. 20, p. 105.

73. Inv. 13/46 in ATASOY 2001, plate 21.

74. See ATASOY 2001, p. 290-291, where is said that the Ottomans adapted this pattern from Italian, especially Venetian damasks and where other Ottoman examples are shown dated to the second half of the 16th century.

75. ATASOY 2001, plate 49.

76. For an overview of different versions see ATASOY 2001, p. 276-277.

77. ATASOY 2001, p. 233-234.

78. Cfr embroidered wrapper *bohça* in *Topkapı Sarayı. Costumes et tissus brodés,* Paris, 1987, cat. 96 and one with passementerie in ATASOY N., *Splendors of the Ottoman Sultans,* Wonders, Memphis, 1992, p. 242. We thank Frieda Sorber, curator of the textile collection in the Mode Museum of Antwerp, for this information.

79. This information has equally been supplied by Frieda Sorber.

80. PETRASCH E. *et al., Die Karlsruher Türkenbeute. Die "Türckische Kammer" des Markgrafen Ludwig Wilhelm von Baden-Baden,* München, 1991, p. 43.

81. Inv. D 21 in PETRASCH E. *et al., op. cit.,* cat. 7, p. 71-73.

82. Inv. 1958.20 in DENNY W. B., A Group of Silk Islamic Banners, in *The Textile Museum Journal,* Washington, D.C., vol. 1, no. 1, 1974, p. 67 and fig. 2.

83. DENNY W. B., *op. cit.,* p. 67 and fig. 1.

84. Inv. TXT224 in ROGERS J. M., *Empire of the Sultans. Ottoman Art from the collection of Nasser D. Khalili,* exhibition catalogue, Geneva, 1995, cat. 76, p. 131 and fig p. 128-129.

Glossary

Most of the technical terms are used according to the CIETA terminology, or derived entirely or in part from BURNHAM D.K., *Warp and Weft: A Textile Terminology*, Royal Ontario Museum, Toronto, 1980. Some have been defined according to the specific contexts in which they occur in the textiles. When mentioned for the first time in the text they are indicated by an asterisk.

Binding point
Point at which a warp thread is fixed by a pick, or a pick by a warp thread.

Binding warp
A secondary warp that binds weft floats.

Brocading weft
Supplementary weft introduced only in the areas of pattern, which they produce.

Comber unit
- The whole of leashes constituting an autonomic section of the monture.
- The width of the fabric corresponding to this section of the monture.

Décochement
In satin weave, the number of warp threads between the adjacent binding points of successive picks. It includes also the warp thread on which the next binding point is done. The décochement in regular satin weave is at least 2. It is counted from the lower left to the upper right on the weft face of the textile, and from the lower right to the upper left on the warp face.

Drawboy
A weaver's assistant responsible for operating the figure harness on a drawloom.

Drawloom
A handloom for weaving figured textiles, equipped with a figure harness that controls some or all of the warp thread and permits the automatic repeat of a pattern both vertically and horizontally.

Extended tabby
Tabby in which warp threads or weft picks, or both, move in groups of two or more.

Figure harness
The harness that executes the pattern in figured textiles. It controls the warp as required for the formation of the pattern. It permits the mechanical repeat of the pattern in the width and the length of the fabric.

Foundation fabric
Fabric from one warp and one weft on which with supplementary warps or/and wefts pattern are created.

Foundation warp
Warp of the foundation fabric.

Foundation weft
Weft of the foundation fabric.

Foundation weave (ground weave)
Any weave that serves as a foundation for pattern, texture, or pile.

Harness
A group of shafts, that perform one function in the weaving of textiles.

Interruption (décochement)
Numerical method of recording the bindings of a weave. In satin weave, the number of warp threads between the adjacent binding points of successive picks. It is counted from the lower left to the upper right on the weft face of the textile, and from the lower right to the upper left on the warp face. The décochement number is always one greater than the interruption number because it includes also the warp thread on which the next binding is done.

Lampas
Term used exclusively for a figured weave in which a pattern, composed of weft floats bound by a binding warp, is added to a foundation weave formed by a foundation warp and a foundation weft.

Lash
String loop attached to the simple cords of a drawloom that enables the drawboy to select and raise the warp threads in order to fashion the pattern shed. The lashes are arranged in the simple before weaving, according to the required pattern.

Leash
Term used to distinguish the heddle of a drawloom.

Monture
The whole of leashes of the figure harness in a drawloom.

Multiple strands

A thread composed of two or more strands together, not twisted together: 4 S- (4 S- twisted threads next to each other).

Opposite weft sequence

The succession of the wefts in the pass. In contrast to the "normal" sequence, the foundation weft is the last weft in the pass.

Pass

One complete cycle of picks carried through the shed that produces, by varied interlacements with the warp, the weave and pattern in the full width of the fabric. It is constantly repeated in the weaving.

Pattern unit

Unit composed of one or more motifs which, by repetition, constitute the pattern of a textile.

Pattern weft

Supplementary weft, running the whole width of the fabric from selvage to selvage.

Pick

A single passage of the shuttle carrying the weft thread through the shed. By extension, it is the weft thread so carried.

Pile rod

Fine metal rod or wire over which the pile warp is lifted to form the velvet pile. The rod may be round in section. If the pile is to be cut into tufts, the rod has a longitudinal channel along which a knife can be run.

Pile warp

A supplementary warp whose ends form a pile above a ground fabric.

Point paper plan

A pattern on graph paper, which serves as guide for setting up the simple on a drawloom.

Pulley cord

Part of the figure harness on a drawloom; the section of cord between the necking cord and the pulley.

Repeat

The pattern unit used to produce a repeating pattern
- *Straight repeat*
Pattern repeat without any symmetry axis.
- *Vertical point repeat* or *reverse repeat*
Pattern repeat with a vertical symmetry axis.
- *Vertical and horizontal point repeat*
Pattern repeat with a vertical and horizontal symmetry axis.
- *Repeat in quincunx*
Pattern repeat in witch the pattern elements are lozenged repeated.

Satin weave

A simple weave based on a unit of five or more threads, and a number of picks equal to the number of warp threads, in which each warp thread binds only one pick. The binding points are set over two or more warp threads on successive picks and are uniformly distributed in an unobtrusive manner to give a smooth appearance (see also: *décochement*)

Selvage

The longitudinal finished edge of a textile closed by weft loops.

Shed

The space made by the separation of warps into two layers thus permitting the passage of the shuttle, which carries the weft.

Simple (cords)

In a drawloom the cords which are controlling the warp threads of the figure harness.

Squeezing weft

Weft added to the foundation weft in most of the velvet fabrics. A pick of the squeezing weft is entered on one side of the pile rod in the same shed as the foundation pick on the other side of the pile rod, in order to squeeze together this two picks, securing in this way each tuft of pile.

Step

The smallest gradations of a design: the smallest number of warp threads (warp step) or the smallest number of picks or passes (weft step) that forms one step in the outline of a design.

Supplementary weave

The binding of the binding warp and the supplementary wefts.

Supplementary wefts

Non-structural wefts added to create a pattern on the ground weave or to perform a special function.

Supporting weft

Weft added to the structure of some velvet fabrics in order to support the pile warp floats on the backside of the fabric.

Tail cord

Part of the figure harness on a drawloom. After the pulley cord passes through the pulley box, it is called a tail cord and it extends out to a firm attachment. The simple cords are attached to the tail cords.

Twill weave

A simple weave based on a unit of three or more warp threads and three or more picks, in which each warp thread binds only one pick per unit. The diagonal alignment of binding points is indicated by the slant of letters Z or S. The twill weave is described in

diagrammatic form. For example, 3.1 Z twill indicates that each warp thread passes over three picks and under one pick and that the diagonal alignment of binding points is to the right.

Twist

The twist of a thread around its axis resulting from spinning, throwing, or plying. The direction of the twist is indicated by the letter "S" or "Z"; the spiral of the thread corresponds to the central bar of the letters. For yarns without apparent twist, the letter "I" may be used.

Velvet

A warp-pile weave in which the pile is produced by a pile warp that is raised in loops above a ground weave through the introduction of rods during the weaving. The loops may be left as loops or cut to form tufts.

Watered fabric (moiré)

Textiles in which a rippled or watered effect is produced by pressing certain ribbed fabrics in such a way as to flatten parts of the ribs and leave the rest in relief. The flattened and unflattened parts reflect the light differently.

Weave

System of interlacing the threads of warp and weft according to defined rules in order to produce all or part of a textile.

Weft sequence

The succession of foundation weft and supplementary wefts in the pass.

Bibliography

Only those works cited regularly in the catalogue are listed here. For the specific bibliography, see the footnotes to the articles.

ATASOY 2001:
ATASOY N., DENNY W.B., MACKIE L.W., TEZCAN H., *IPEK. The Crescent & the Rose. Imperial Ottoman Silks and Velvets,* Azimuth Editions Limited, London, 2001.

DENNY 1972:
Denny W.B., Ottoman Turkish textiles, in *Textile Museum Journal,* vol. III, no. 3, December 1972, p. 55-66.

DENNY 1982:
DENNY W.B., Textiles, in PETSOPOULOS Y. (ed.), *Tulips, Arabesques and Turbans: Decorative Arts of the Ottoman Empire,* London, 1982, p. 103-111.

ERBER 1993:
ERBER C. (ed.), *Reich an Samt und Seide,* Bremen, 1993.

ERRERA 1927:
ERRERA I., *Catalogue d'Étoffes Anciennes et Modernes,* 3rd edition, Brussels, 1927.

FALKE 1936:
VON FALKE O., *Kunstgeschichte der Seidenweberei,* 3rd edition, Berlin, 1936.

FOLSACH 1993:
VON FOLSACH K., KEBLOW BERNSTED A.-M., *Woven treasures. Textiles from the World of Islam,* Copenhagen, 1993.

FOLSACH 2001:
VON FOLSACH K., *Art from the World of Islam,* exhibition catalogue, Copenhagen, 2001.

GULBENKIAN 1978:
Tecidos da Colecção Calouste Gulbenkian, Lisbon, 1978.

GULBENKIAN 2001:
Un jardín encantado. Arte islámico en la Colección Calouste Gulbenkian, exhibition catalogue, Fundación Santander Central Hispano, Madrid, 2001.

GÜRSÜ 1988:
GÜRSÜ N., *The Art of Turkish Weaving. Designs through the Ages,* Redhouse Press, 1988.

HAYWARD 1976:
The Arts of Islam, exhibition catalogue, London, 1976.

KING 1980:
KING D., *Imperial Ottoman Textiles,* Colnaghi, London, 1980.

KING 1985:
KING D., Tapis et textiles, in *Trésors de l'Islam,* exhibition catalogue, Genève, 1985.

LAFONTAINE-DOSOGNE 1983:
LAFONTAINE-DOSOGNE J., *Textiles islamiques. 2. Proche-Orient et Méditerranée,* Bruxelles, 1983.

MACKIE 1973:
MACKIE L., *The Splendour of Turkish Weaving,* Washington, 1973.

MEISTERWERKE 1981:
Islamische Kunst, Meisterwerke aus dem Metropolitan Museum of Art New York. The Arts of Islam, Masterpieces from The Metropolitan Museum of Art New York, exhibition catalogue, Berlin, 1981.

SPUHLER 1978:
SPUHLER F., *Islamic Carpets and Textiles in the Keir Collection,* London, 1978.

SURIANO 1999:
SURIANO C.M., CARBONI S., PERI P., *La seta islamica, temi ed influenze culturali. Islamic Silk Design and Context,* Florence, 1999.

WELCH 1979:
WELCH A., Calligraphy in the Arts of the Muslim World, in *The Asia Society,* 1979.

Concordance

Inventory	Catalogue number	Catalogue ERRERA 1927
IS.Tx.450	V.2.9	130 F
IS.Tx.660	L.2.7	102 A
IS.Tx.664	V.3.22	120
IS.Tx.681	L.1.1	321 A
IS.Tx.758	L.2.8	213 C
IS.Tx.785	V.1.1	220
IS.Tx.792	V.3.23	137
IS.Tx.806	V.3.24	271 A
IS.Tx.807	L.2.9	277 B
IS.Tx.808	L.2.10	277 A
IS.Tx.809	L.2.11	213 A
IS.Tx.811	L.2.12	267 A
IS.Tx.820	V.2.10	220 F
IS.Tx.1200	V.1.2	222
IS.Tx.1201	V.2.11	266 A
IS.Tx.1202	V.2.12	269
IS.Tx.1203	V.2.13	267
IS.Tx.1204	V.2.14	268
IS.Tx.1205	V.3.25	271
IS.Tx.1206	V.1.3	220 D
IS.Tx.1207	V.1.4	270
IS.Tx.1208	V.2.15	272
IS.Tx.1209	V.2.16	274
IS.Tx.1210	V.2.17	273
IS.Tx.1211	V.2.18	276
IS.Tx.1212	V.2.20	275
IS.Tx.1213	V.1.5	278
IS.Tx.1215	V.2.21	320
IS.Tx.1216	L.1.2	321
IS.Tx.1217	L.1.3	322
IS.Tx.1218	L.1.4	323
IS.Tx.1219	L.1.5	265 A
IS.Tx.1223	D.W.2	77 B
IS.Tx.1228	L.1.6	265
IS.Tx.1229	V.1.6	220 A
IS.Tx.1231	V.2.19	220 C
IS.Tx.1232	V.1.7	220 B
IS.Tx.1233	D.W.1	277
IS.Tx.1257	L.2.13	382 B
IS.Tx.1259	L.2.14	272 A
IS.Tx.1261	L.2.15	213 B
IS.Tx.1262	V.1.8	220 E
IS.Tx.1280	L.2.16	213

Colour plates

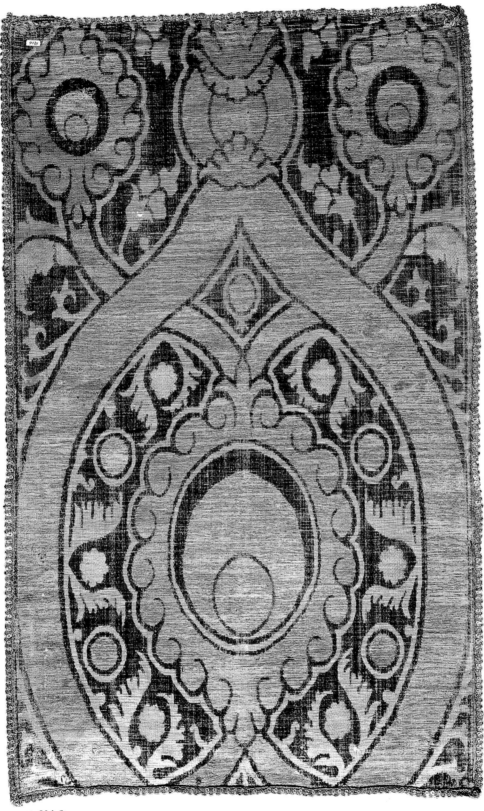

cat. V.1.3

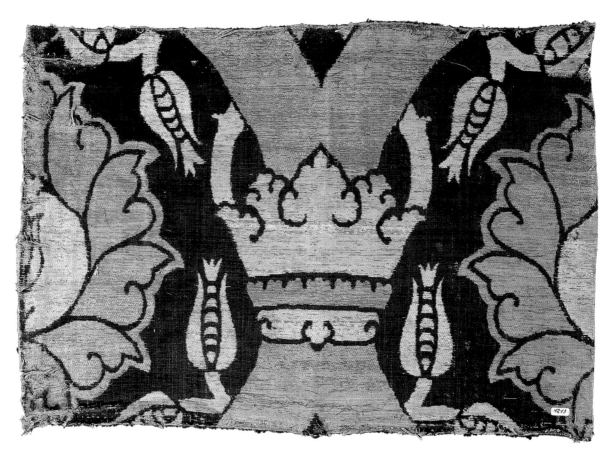

cat. V.1.5

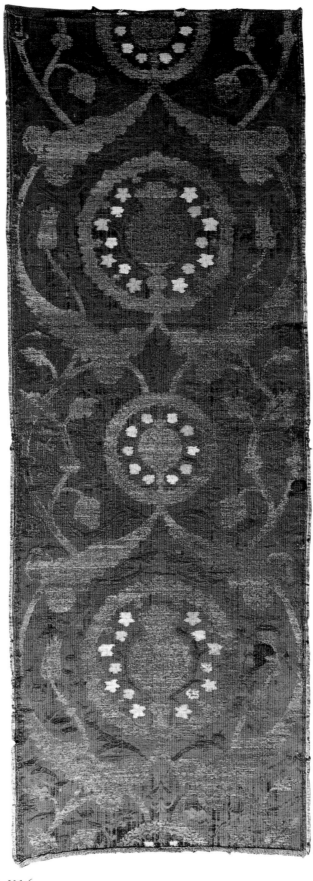

cat. V.1.6

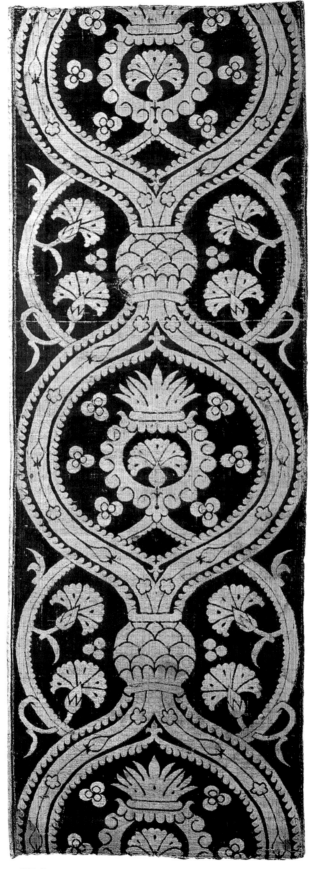

cat. V.1.8

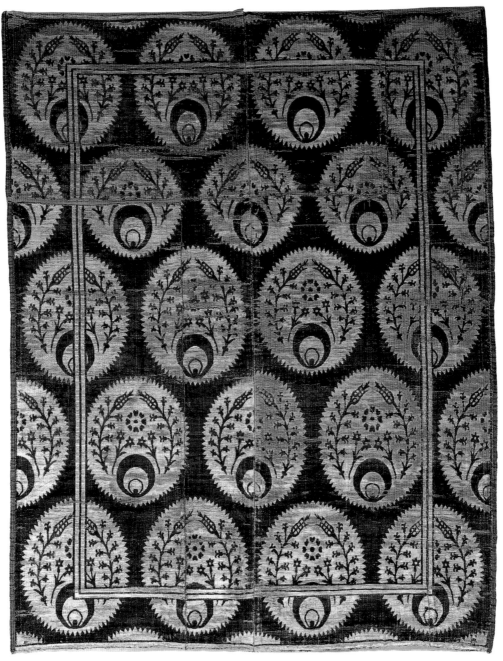

cat. V.2.11

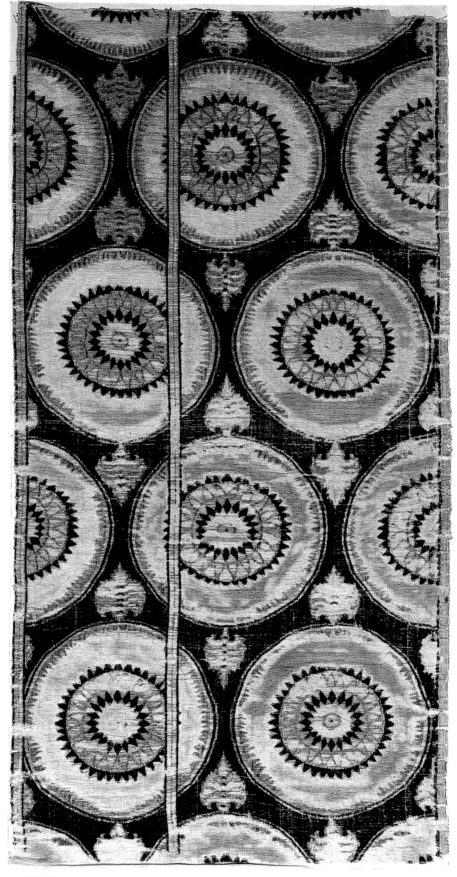

cat. V.2.12

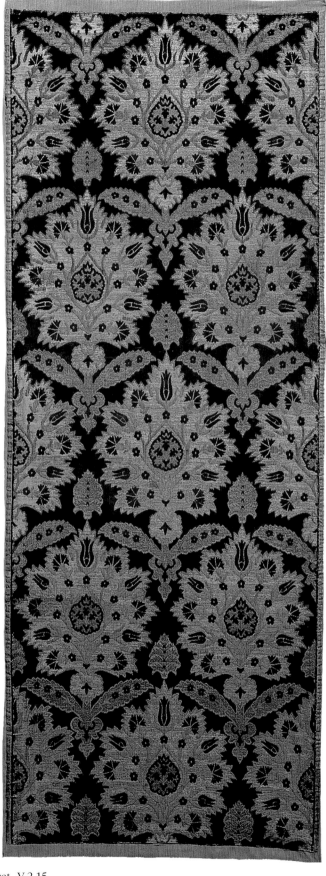

cat. V.2.15

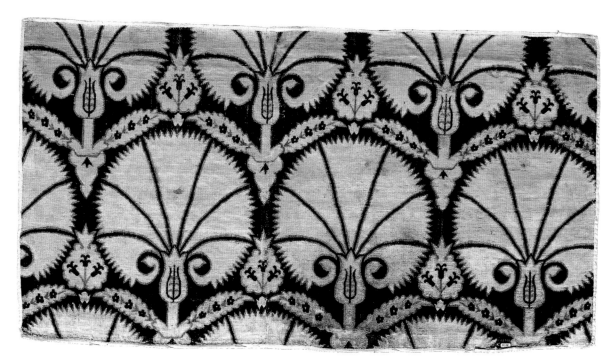

cat. V.2.17

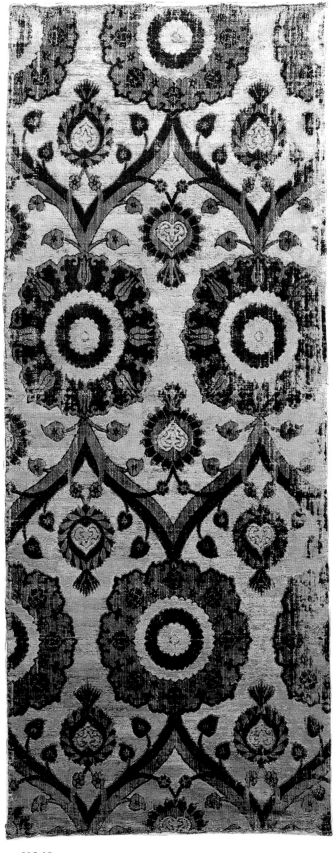

cat. V.2.19

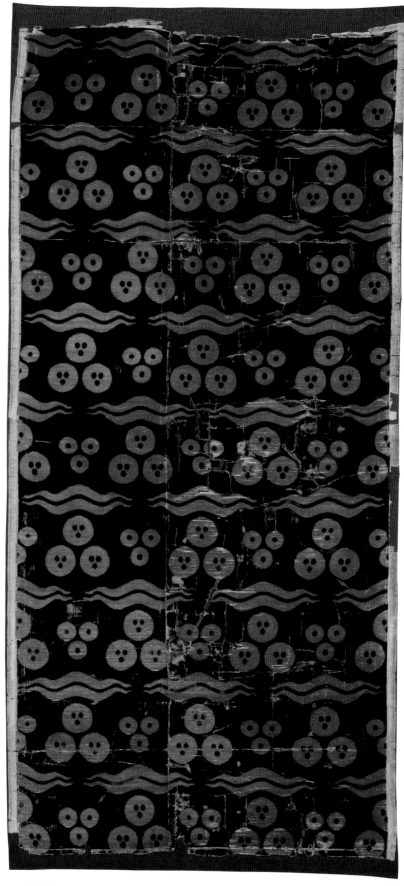

cat. V.3.23

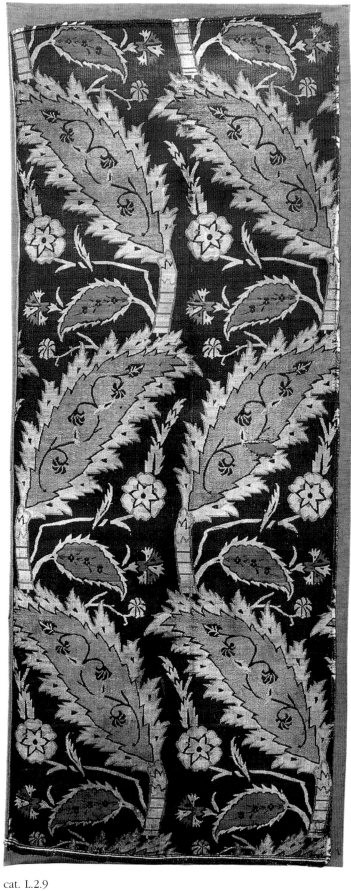

cat. L.2.9

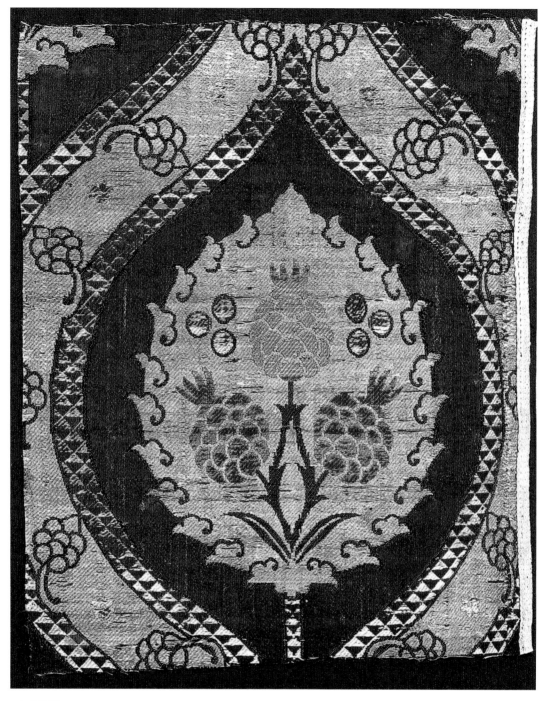

cat. L.2.11

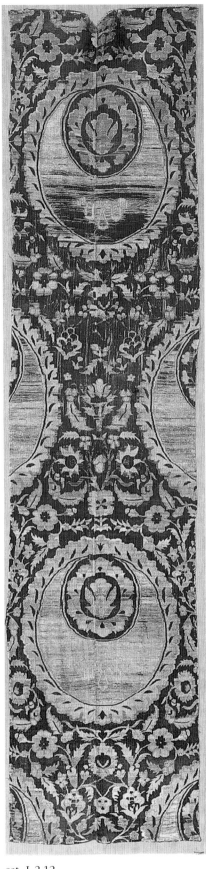

cat. L.2.12

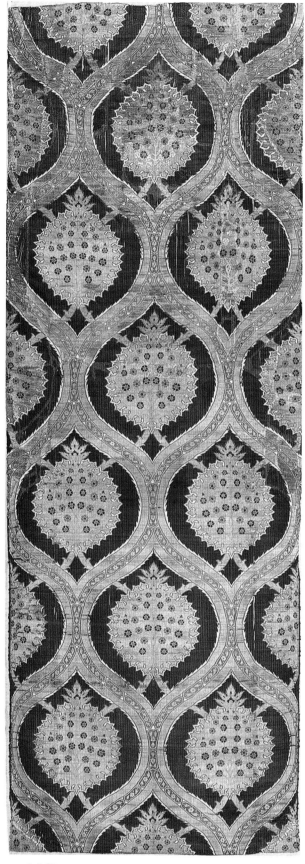

cat. L.2.15

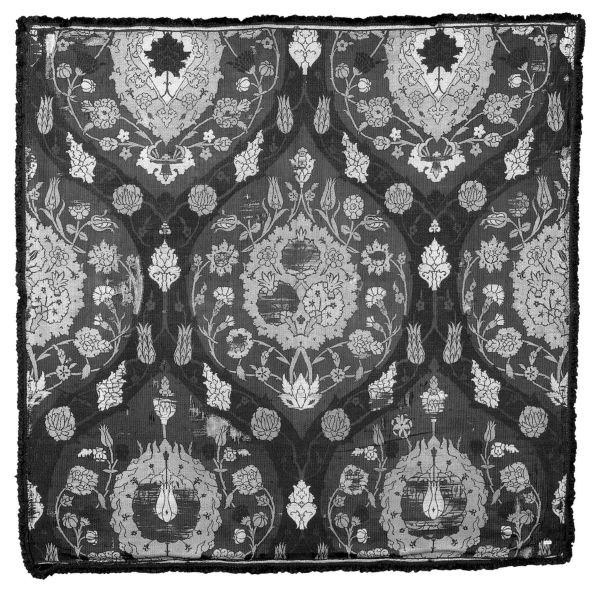

cat. D.W.1

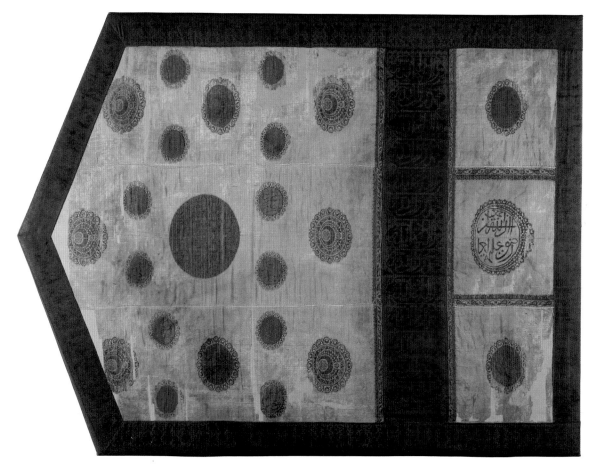

cat. D.W.2

 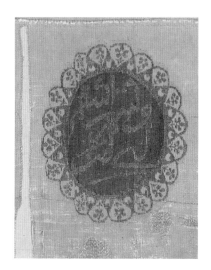

Colour plates